The Artist as Eyewitness

THE CHICANO ARCHIVES

This series brings together resources related to major Chicano special collections. The goal is to facilitate access to these collections and thereby stimulate new critical and historical research based on archival sources. Each book includes original scholarship, one or more finding aids, reproductions of key documents and images, and a selected bibliography. The series draws primarily on collections in the UCLA Chicano Studies Research Center Library. Because preserving Chicano history requires efforts and coordination across multiple institutions, the series includes projects undertaken in collaboration with other Chicano archives.

Series Editors

Chon A. Noriega
Xaviera S. Flores

www.chicano.ucla.edu

The Chicano Archives, Volume 8

The Artist as Eyewitness
Antonio Bernal Papers, 1884–2019

Edited by Charlene Villaseñor Black

UCLA Chicano Studies Research Center
Los Angeles
2021

Copyright © 2021 by the Regents of the University of California
All rights reserved. Printed in the United States of America

CSRC Director: Chon A. Noriega
Senior Editor: Rebecca Frazier
Copyeditor: Catherine A. Sunshine
Production: William Morosi

Cover: Antonio Bernal, untitled mural in Del Rey, California, 1968.
Enamel on plywood, two sections of three panels each, each section approximately 6 × 15 feet.

Library of Congress Cataloging-in-Publication Data

Names: University of California, Los Angeles. Chicano Studies Research
 Center, author. | Villaseñor Black, Charlene, 1962- editor.
Title: The artist as eyewitness : Antonio Bernal papers, 1884-2019 / edited
 by Charlene Villaseñor Black.
Other titles: Antonio Bernal papers, 1884-2019
Description: Los Angeles : UCLA Chicano Studies Research Center Press,
 2021. | Series: The Chicano archives ; volume 8 | Includes
 bibliographical references. | Summary: "The first survey of the life and
 work of Antonio Bernal (b. 1937). Bernal is often identified as a
 muralist-his 1968 mural in Del Rey, California, has been cited as the
 first Chicano mural-but his career has been wide-ranging. Included are
 essays on Bernal's career, his visual art, and his unpublished novel;
 reproductions of his artwork and a selection of his writings; and a
 finding aid to the collection. Research for the volume was supported by
 The Antonio Bernal Papers, a special collection at the UCLA Chicano
 Studies Research Center"-- Provided by publisher.
Identifiers: LCCN 2021036701 | ISBN 9780895511744 (paperback)
Subjects: LCSH: Bernal, Antonio, 1937---Criticism and interpretation. |
 Bernal, Antonio, 1937---Archives. | Artists--United States--Archives. |
 Mexican American artists--Archives. | University of California, Los
 Angeles. Chicano Studies Research Center--Archives.
Classification: LCC NX512.B47 U55 2021 | DDC 751.7/3092--dc23
LC record available at https://lccn.loc.gov/2021036701
ISBN: 978-0-89551-174-4

♾ The paper used in this publication meets the minimum requirements
of the American National Standard for Information Sciences—
Permanence of Paper for Printed Library Materials, ANSI Z39.48-1992.

To find out more about the CSRC Library, contact:
Xaviera S. Flores, Librarian and Archivist
Tel: 310-206-6052
Fax: 310-206-1784
librarian@chicano.ucla.edu
UCLA Chicano Studies Research Center Library
144 Haines Hall
Los Angeles, CA 90095-1544
www.chicano.ucla.edu/library

UCLA Chicano Studies Research Center
193 Haines Hall
Los Angeles, California 90095-1544 USA
www.chicano.ucla.edu

UNIVERSITY OF
WASHINGTON PRESS
Seattle uwapress.uw.edu

Distributed by the University of Washington Press
PO Box 50096
Seattle, Washington 98145-5096
www.washington.edu/uwpress

Contents

Acknowledgments

In late December 2017, scholar, filmmaker, and former UCLA student Carissa Garcia contacted me about preserving the work of artist Antonio Bernal. A few days later, I discussed the possibility with Chon A. Noriega, then the director of UCLA's Chicano Studies Research Center (CSRC). Given the importance of Bernal's 1968 Del Rey mural, we recognized the need and urgency of such a project, and the plan for this volume was born. I am grateful to Carissa for reaching out to me, for her estimation of the importance of Bernal's artwork and archive, and for putting me into contact with the artist. I am grateful to Chon for his vision for and support of this project over the last several years. I owe an immense debt to the staff at the CSRC, especially to editors Rebecca Frazier and Cathy Sunshine and designer Bill Morosi, as well as Darling Siañez, Rebecca Epstein, and Xaviera Flores. Thank you for your expertise and support. It was a pleasure to work with authors Gabriela Rodriguez-Gomez and Miguel Samano; your commitment to research and love of your subject matter inspired me along the way.

Most importantly, I wish to thank Antonio Bernal, whom I have had the pleasure to get to know over the course of this project. Thank you for entrusting us with your artwork, writings, and life story. Thank you for sharing with us your eyewitness experiences, political views, and philosophy of artmaking, as well as your personal experiences, family photographs, and zest for life. I greatly appreciated our visits, our phone calls, and our email exchanges, and my life is richer for having known you. Please consider this volume a small token of our esteem for you and an expression of our hope that your archive will inspire more work on your remarkable life, art, and writing.

Charlene Villaseñor Black
July 2021

Series Editor's Note

Antonio Bernal is perhaps most widely known as the painter of the first Chicano mural. Often called the Del Rey mural, it was created in 1968 in the small town in Fresno County for which it is named. This book starts with that historical fact, then aims to deepen our understanding of the mural as well as Bernal's other work as a muralist. But above all this book provides an introduction to Bernal's diverse career as a visual artist and writer. Born in 1937 in Los Angeles and raised in Mexico City, Bernal is a world traveler who speaks four languages and who has always lived in a Mexican or Mexican-descent community. He is part of a generation born during the Great Depression that experienced firsthand the impact of global capitalism and nationalist ethnopolitics. In the United States that included the forced repatriation of Mexican Americans and the internment of Japanese Americans, both as matters of national policy. If Bernal identifies in broad political and cultural terms as a socialist and a Mexican, he also lives by the credo that "no one is one thing." With that in mind, this book proposes the artist as eyewitness to history, including the Chicano Movement, larger social and political protests in the United States and Mexico, and social and political change in Cuba in the 1990s.

This collection of essays, edited by Charlene Villaseñor Black, examines Bernal's work from several distinct perspectives. In the lead essay, Black provides an overview of Bernal's life and creative work as an actor, artist, muralist, novelist, political writer, and Spanish teacher. She draws upon her interviews with Bernal as well as his unpublished novel, revealing the various lenses through which he serves as an eyewitness who places the Chicano community in the context of international struggles. Gabriela Rodriguez-Gomez examines Bernal's two murals, produced two decades apart and in different settings (rural and urban), providing a first in-depth consideration of these two works together. Her study foregrounds the portable nature of the Del Rey mural, while she also draws attention to the mural's female and indigenous figures that have often been overlooked in existing scholarship. If "no one is one thing," then scholars need to examine the multiplicity and complexity in the artwork itself. Miguel Samano contributes two essays. The first considers the Del Rey mural in light of concurrent discourses around Chicano muralism, the artist's own unheeded proposals about art and identity, and the mural's likely role as a backdrop in performances by El Teatro Campesino. Samano's historical reconstruction reveals the importance of not just figuring out what happened but also the different ways in which a political and artistic movement was debated and its future imagined. Samano's second essay examines Bernal's novel *Breaking the Silence: A Novel of the Twentieth Century* (2008), arguing that Bernal is innovative in restoring to the novel (as literary genre) a sense of the open-endedness of lived experience. He argues that Bernal's goals here are more political and pedagogical than simply literary—that is, he presents the narrative as a way of teaching readers "methods for de-novelizing their own experiences of time." Finally, this book includes a selection of Bernal's writings from 1973 to 2000. While these selections stem from his work as teacher and political commentator, they also can also be seen as in dialogue with his artwork, which is featured in the plate sections of this book.

This publication includes a finding aid for the Antonio Bernal Papers at the UCLA Chicano Studies Research Center prepared by CSRC Librarian and Archivist Xaviera Flores. The collection includes correspondence, writings, photographs, and audiovisual material documenting Bernal's life, artwork, and family history. The collection ranges from recent oral histories conducted for this book to family papers and photographs that date from the 1880s. We hope that this book serves as a springboard for further research that draws upon these archival holdings. The Antonio Bernal Papers represent an important resource for scholarship not only on the artist but also on the times and places in which he lived.

Chon A. Noriega
Director (2002–21), Chicano Studies Research Center
University of California, Los Angeles

Crossing Borders, Resisting Answers

The Life of Antonio Bernal, Witness to the Chicano Movement

Charlene Villaseñor Black

In an interview conducted in Fresno, California, in July 2018, the artist, activist, and former teacher Antonio Bernal (b. 1937) resisted being categorized as "the first Chicano muralist," a title bestowed upon him by Shifra M. Goldman and Tomás Ybarra-Frausto, early pioneers in the documentation of Chicana/o art.[1] They were writing of Bernal's Del Rey mural, created in 1968 as a backdrop for performances of El Teatro Campesino in California's Central Valley, where he was an actor (plates 1, 2).[2] Although initially puzzling, Bernal's reaction to being categorized in such a way ultimately made sense. This was a person who described himself as "between anarchist and socialist," who questioned and struggled against labels: someone whose life had been unconventional, rich, varied, colorful, and vibrant.[3]

He had authored a novel, written numerous political commentaries, and kept a blog; painted murals, in addition to creating oil paintings, collages, and other artworks; worked as an actor in Mexico and the United States; and taught Spanish at Garfield High School in East Los Angeles. He was on stage at the San Francisco Opera house with Renata Tebaldi in a production of Giuseppe Verdi's *Simon Boccanegra*. He shared space with Jane Fonda at an antiwar rally on the steps of Los Angeles City Hall and sang "Guantanamera" with Pete Seeger at the Hollywood Bowl. He was proud to be friends with the Andalusian flamenco dancer Carmen Amaya, known as "La Capitana." His life was defined by crossing borders and boundaries, by resisting easy answers, and by a commitment to truth telling. His novel, begun in 1999 and completed in 2008 but still unpublished, is titled *Breaking the Silence*, a phrase that sums up his approach to his activism, teaching, and varied creative practices.

Bernal's rich life story was interwoven with the dramatic events of the civil rights movements of the 1960s. He was a member of the Congress of Racial Equality (CORE), friends with members of the Black Panthers, a member of El Teatro Campesino, a Brown Beret, and a participant in *el movimiento Chicano*, the Chicana/o civil rights movement. His biography demonstrates that there is no singular, narrow definition of what it means to be "Chicano," and it underscores the importance of keeping the hemispheric and global contexts of the movement in mind (figs. 1, 2).

Bernal was born Forrest Antonio Bernal Hopping to Forrest Hopping Sr. (1894–1967), a US citizen of Anglo descent, and María Luisa Bernal (1900–95), born in Hermosillo, Mexico. His parents met at the famous restaurant La Golondrina on Olvera Street in Los Angeles, where María Luisa, a performer and singer with an operatic voice, was performing (fig. 3). Smitten, Forrest Hopping went over to sit with

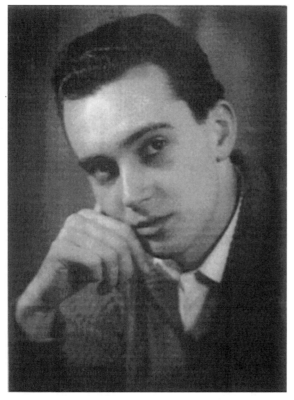

Figure 1. Antonio Bernal, 1961. Image courtesy of the artist.

her. Following their marriage, Antonio's sister, Ana María Hopping, arrived in 1932, and in 1937 Antonio was born in Altadena, now a suburb east of Los Angeles.

Their father, known as Ricardo F. Hopping in his professional life, worked as an artist, interior decorator, and stage hand, creating props for movie sets in Hollywood.[4] As reported in the *Fresno Bee* in 1962, Hopping Sr. was also the "art director for El Pueblo de Los Angeles, the state historical monument which centers around Olvera Street and the Old Plaza in Los Angeles" (fig. 4). The same news article reveals that Hopping Sr. had been an interior designer in Mexico, working for elite members of society, including Carmelita Rubio de Díaz, widow of dictator Porfirio Díaz, and King Carol II of Romania, who had fled to Mexico during World War II and was living in Coyoacán. Hopping Sr. also worked on designing

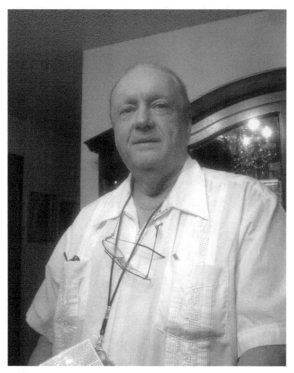

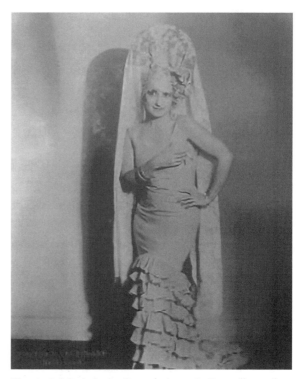

Figure 2. Antonio Bernal, 2015. Image courtesy of the artist.

Figure 3. María Luisa Bernal, Antonio Bernal's mother, 1930. Image courtesy of the artist.

the United States Embassy in Mexico City. In a photograph that accompanies the news story, Bernal's father stands with a pre-Columbian sculpture described as representing a corn god. He was in the process of building an adobe house for the family in Three Rivers, California, a house believed to still be standing.[5]

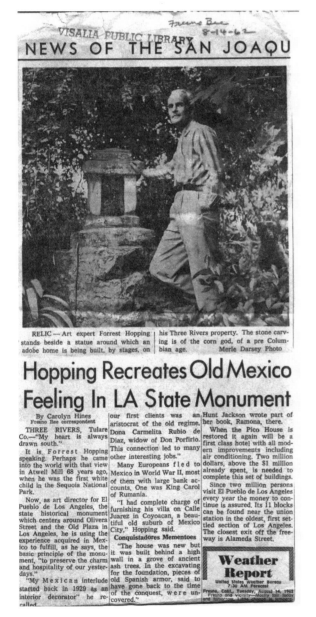

RELIC — Art expert Forrest Hopping stands beside a statue around which an adobe home is being built, by stages, on his Three Rivers property. The stone carving is of the corn god, of a pre Columbian age. Merle Darsey Photo

Hopping Recreates Old Mexico Feeling In LA State Monument

By Carolyn Hines
Fresno Bee correspondent

THREE RIVERS, Tulare Co.—"My heart is always drawn south."

It is Forrest Hopping speaking. Perhaps he came into the world with that view in Atwell Mill 68 years ago, when he was the first white child in the Sequoia National Park.

Now, as art director for El Pueblo de Los Angeles, the state historical monument which centers around Olivera Street and the Old Plaza in Los Angeles, he is using the experience acquired in Mexico to fulfill, as he says, the basic principle of the monument, "to preserve the charm and hospitality of our yesterdays."

"My Mexican interlude started back in 1929 as an interior decorator" he recalled.

our first clients was an aristocrat of the old regime, Dona Carmelita Rubio de Diaz, widow of Don Porfirio. This connection led to many other interesting jobs."

Many Europeans fled to Mexico in World War II, most of them with large bank accounts. One was King Carol of Rumania.

"I had complete charge of furnishing his villa on Calle Juarez in Coyoacan, a beautiful old suburb of Mexico City," Hopping said.

Conquistadores Mementos

"The house was new but it was built behind a high wall in a grove of ancient ash trees. In the excavating for the foundation, pieces of old Spanish armor, said to have gone back to the time of the conquest, were uncovered."

Hunt Jackson wrote part of her book, Ramona, there.

When the Pico House is restored it again will be a first class hotel with all modern improvements including air conditioning. Two million dollars, above the $1 million already spent, is needed to complete this set of buildings.

Since two million persons visit El Pueblo de Los Angeles every year the money to continue is assured. Its 11 blocks can be found near the union station in the oldest, first settled section of Los Angeles. The closest exit off the freeway is Alameda Street.

Weather Report
United States Weather Bureau
7:30 AM Forecast
Fresno, Calif., Tuesday, August 14, 1962
Fresno and vicinity—Mostly fair today and tomorrow. Little change in temperature.

Figure 4. Forrest Hopping, Antonio Bernal's father, shown in a clipping from the *Fresno Bee*, August 14, 1962. Image courtesy of the artist.

Bernal describes his father as an "atheist-socialist." Indeed, Hopping Sr. had been born in the Kaweah Colony, a utopian-socialist settlement founded in 1886 at Atwell Mill in the Sequoia National Forest, west of Fresno. Located along the Kaweah River, the "Kaweah Cooperative Commonwealth of California" was started by Burnette G. Haskell, James J. Martin, and Charles F. Keller. It was modeled on the socialist ideas of Laurence Gronlund, author of *The Cooperative Commonwealth in Its Outlines*, which was translated into English and first published in the United States in 1884.[6] The number of inhabitants at the site varied, from around 160 in the summer of 1886 to about 300; in total, 400 people are believed to have lived there at some time. Life in the colony was challenging: inhabitants built roads, housing, and other infrastructure. Yet documents of the time record leisure and intellectual activities as well. A band and an orchestra gave concerts, and residents enjoyed dances, picnics, and athletic activities; there was a schoolhouse for children and academic classes for adults, and literary, scientific, and other intellectual discussions were held. The colonists had a library and published a newspaper. The colony rejected the use of money and instead the members exchanged work hours as currency.[7]

The Hopping family was an important and influential part of the Kaweah Colony. Bernal's grandfather, George Hopping, was an early member and supporter who provided financial subsidies. He sent his children to live at Kaweah Colony while he remained in New York, eventually moving to the colony himself in the early 1890s.[8] On September 25, 1890, the US Congress voted to create Sequoia National Park, precipitating the eventual closure of the Kaweah Colony, which was within the park's boundaries. By 1891 most of the inhabitants had left the site, but some stayed throughout the 1890s. Bernal's father was born there in

Ricardo F. Hopping, Noted Decorator, Dies

Ricardo F. Hopping, interior decorator for old-time film stars and Mexican notables, died in a Fresno hospital Tuesday of leukemia and complications of pneumonia.

Mr. Hopping, 70 lived in Los Angeles much of his life, decorating the homes of actresses Dolores Del Rio, Ruth Chatterton and Jeanette McDonald and actors Ralph Forbes, Conrad Nagel and Ramon Navarro, among others.

In the 1940s he also redecorated the American Embassy in Mexico City and the houses of several Mexican government officials.

He was connected with the development of Olvera St. and worked closely with Mrs. Christina Sterling, the "Mother of Olvera St.," as art director of El Pueblo de Los Angeles.

Mr. Hopping had been retired for the last several years, living in Three Rivers, Tulare County, the location of the old Kaweah colony of socialists founded by his parents.

He was born Forrest deGrasse Hopping, descendant of a French count. Ricardo was a nickname that became formalized.

Mr. Hopping is survived by his wife, Louise; a daughter, Ann of Fresno; a son, Forrest of Fresno; a sister, Laura of Twain Harte, and a brother, Phillip of Santa Barbara.

Inurnment was in Fresno Wednesday.

Figure 5. Obituary for Forrest Hopping, published in the *Los Angeles Times*, January 5, 1967. Image courtesy of the artist.

1894, and it is clear that the utopian, Marxist, anarchist ideas of his forebears influenced Bernal's own political beliefs (fig. 5).

Within months of Antonio's birth in 1937, his parents left Los Angeles for Mexico City. They settled in Colonia Mixcoac, a pleasant colonial enclave in the southern part of the metropolis, where they lived in a former convent. Thus, although he was born in Altadena, California, Bernal's earliest formative years were spent in Mexico. As he states, paraphrasing Mexican singer Chavela Vargas, who was born in Costa Rica, "Un mexicano nace donde la de su chingada gana" (a Mexican is born

wherever the f*** he pleases). He would return to Mexico frequently throughout his life.

When asked whether he identifies as "Chicano," Bernal responded:

> The question always comes up, are you a Chicano? The answer is I don't believe in labels, because no one is one thing. I am Mexican first and foremost. Those are my people. I also speak 4 languages (English, Spanish, French, and German). I have acted on stage and did Hamlet in English on Mexican TV (Canal 11). I also wrote a novel, based on my family, which I translated, so it's in English and Spanish. I taught Spanish at Garfield High School for 23 years so I could support my wife and 3 children. I am also a Socialist and have many writings on the subject. . . . I saw Hugo Chavez and Fidel Castro in person (at different times). I went to Cuba for 10 years running in the 90s (periodo especial) and have many friends and letters from there. I have been several times in London, Paris, Berlin and Rome (once). Spent 7 weeks in Nairobi and Mombasa. Have been to Caracas several times, and know Buenos Aires, Rio de Janeiro and Santiago pretty well. Have also been in Santo Domingo and Panama. My father was of English extraction and spoke good Spanish, introduced me to Dolores del Rio and he knew other Hollywood luminaries of the period such as Ramón Navarro, Ruth Chatterton, Ralph Forbes, and many others. My mother was born in Hermosillo, Sonora. Of course I'm a Chicano, but I'm also other things. I have always lived in a Mexican neighborhood, whether in Mexico, Los Angeles, or Fresno, and Mexicans/Chicanos are the very air I breathe. If I had to live in, say, Kansas, I would die of sadness.[9]

In 1945 Bernal's family moved back to the United States, to Santa Barbara, California, where he attended Harding Grammar School (now Harding University Partnership School). Three years later, in 1948, the family was in Three Rivers, near Sequoia, close to the location of the Kaweah Colony, his father's birthplace. Bernal attended Three Rivers Grammar School

and later Woodlake Junior High, then Mount Whitney High School in nearby Visalia, California. Bernal completed what he considers his first artwork, a watercolor still life, at the age of ten, while in elementary school. His teacher at the time was deeply impressed by the painting. Talent in the arts clearly ran in the family, as Bernal's father was a visual artist and his sister Ana painted as an amateur. She was featured in a library scrapbook in 1956 with a charming mural she had painted in the Visalia Public Library of a deep-sea diver and an octopus guarding a treasure chest, themed to suggested summer reading for children.[10]

Bernal also revealed early ability as a performer—not surprisingly, since his mother was a talented entertainer. His earliest career goal was to follow in her footsteps. He first performed as an actor in 1954, at the age of seventeen, in Oscar Wilde's 1895 play *The Importance of Being Earnest, a Trivial Comedy for Serious People*. It was a formative experience. Bernal strongly desired a life on the stage, and after graduating from high school in 1956 he dedicated some years to training as an actor and dancer.

The years after high school are often transitional ones, as young people sort out their path in life. Bernal attended the College of the Sequoias in Visalia briefly and traveled to Mexico. In 1957 he returned there with his father and met Mexican actress Socorro Avelar (1925–2003), with whom he would remain friends for the rest of her life. Later that same year, he returned to California, this time to San Francisco. After a stint working at the Bechtel Corporation as a file clerk, in 1959 he began to study dance with the San Francisco Ballet. In San Francisco he met Langston Bowen (1932–2006), a muralist, actor, and peace activist. He also made the acquaintance, in 1960, of the renowned flamenco dancer Carmen Amaya (1913–63). He saw her again many times, and a few years later, in 1963, he went backstage

Figure 6. Antonio Bernal, *Carmen Amaya*, 1960. Charcoal on paper, 16 × 20 inches. Private collection, Spain. Image courtesy of the artist.

in Mexico City to greet her. That was the last time they met, as Amaya died shortly afterward (fig. 6).[11]

By 1960 Bernal was back in Mexico, first in Valle de Bravo, on the shore of Lake Avándaro in the state of México, where he was among the Mazahua indigenous people. He traveled around, visiting Akumal, on the Riviera Maya in Quintana Roo, and Acapulco. He called on his friend Nicté-Ha, a cabaret entertainer and actress who billed herself as "la princesa Maya Nicté-Ha." He then settled in Mexico City's Colonia Roma and was in touch again with the actress Avelar, whom he had met in 1957 on a trip with his father. Bernal devoted his next years to acting in Mexico. He began studying at Mexico City's Escuela Nacional de Arte Teatral, part of the Instituto Nacional de Bellas Artes y Literatura (INBA). There

he focused on acting on the stage, performing in Shakespeare's *Twelfth Night* and *The Waltz of the Toreadors* (1951) by Jean Anouilh. He presented a Hamlet soliloquy on Mexican television. He met and became friends with many of Mexico's actors, including luminaries from the Golden Age of Mexican cinema (1933–64): Amparo Rivelles (1925–2013), Enrique Aguilar (1935–71), Jacqueline Andere (b. 1938), Roberto Dumont, Xavier Marc (b. 1948), Raúl Dantés, Héctor Bonilla (b. 1939), Rita Macedo (1925–93), Ignacio López Tarso (b. 1925), Fernando Wagner (1905–73), Alejandro Jodorowsky (b. 1929), Carmen Montejo (1925–2013), Socorro Avelar (1925–2003), Hortensia Santoveña, Pilar Souza (1923–99), Ada Carrasco (1912–94), Ofelia Guilmáin (1921–2005), and others.

In his own estimation, however, he "failed at acting," and he left Mexico in 1961 to return to California at his sister Ann's request. By 1962 he was on scholarship at the California Art Center, then located in Los Angeles (now the ArtCenter College of Design in Pasadena), and he soon became deeply involved in various civil rights struggles of the time. Bernal recalls becoming "radicalized" during these years, and in 1963 he became involved in the Congress of Racial Equality. He graduated in 1966 from the California Art Center. In 1967 his father, Hopping Sr., died. That same year Bernal moved to Fresno, where he worked various jobs, including a stint with the city's welfare department.

Bernal was witness to the momentous events of 1968: the massacre at Tlatelolco, the Democratic National Convention in Chicago, the murders of Martin Luther King Jr. and Robert Kennedy. That same year he became involved with El Teatro Campesino, becoming a key participant in the Chicano movement. In 2012 Bernal shared his memories of being part of El Teatro Campesino and an activist for the United Farm Workers in a piece titled "Le Campesino."

> It was 1968–69. I had finished college and couldn't find a job, so naturally I went to live with my sister, who was working. I heard about a Teatro that was performing in the Fresno area, and I went to see it. It blew my mind away. I had been raised in Mexico, and the Mexican feel of the thing was magical. I liked the fact that there was a feeling of family with the Mexican agricultural workers, and at the same time there were Anglos in the group who were just as much family. I joined and became part of the grape strike. We toured the area with Cesar's message; "sign the contract," which always stopped the show as people burst into applause. I painted what became known as the "del Rey mural," showing la soldadera, Zapata, Villa, Cesar, Tijerina, Malcolm and MLK. On the other side of the building I plagiarized one of the Bonampak murals. By this time the Teatro had become famous, and we received an invitation to an International Theater Festival in Nancy, France. Before I knew it I was in a bus along the Seine with Notre Dame in front of me, as we sped on to the German border. We took the message of "le campesino," as they called us, far and wide, performing in theaters, on the streets, and even at the Sorbonne. After it was over we all went our separate ways, Luis and Lupe got married, Donna Heber went to London and became a model briefly, Augie Lira dropped out, Luis and Danny started making movies in Hollywood. The farm workers continued working as they always had, their lives made better by the union until the growers could figure out how to circumvent the rules and keep them as an underclass. La lucha continua.[12]

Bernal refers, in this testimonio, to the Teatro Campesino's trip to Nancy and Paris, France, for the World Theatre Festival in 1969, the year of the Woodstock music festival and anti–Vietnam War rallies throughout the United States. During the trip he served as the Teatro's translator. He fell ill in Paris,

split with the company, and returned to the United States.

In 1970 Bernal moved back to Los Angeles, settling in East LA. He worked for the Economic and Youth Opportunities Agency, which administered Head Start and the Teen-Post program, among others, and he also taught basic education to prisoners. Enamored of Marxism and Mao Zedong, who was popular among some leftists, he became involved with various radical groups, most notably the Brown Berets, the Black Panthers, and the Congreso Obrero, his ideological mentors. He took part in numerous protests. On August 29, 1970, he was a participant in the National Chicano Moratorium, the protest in which journalist Ruben Salazar was killed. Bernal was involved with other prominent activists, including Dorothy Healey, Rose Chernin, and Herbert Biberman, all members of the Communist Party. In 1971 Bernal traveled to Mexico and participated in the bloody Jueves de Corpus student demonstration (the Corpus Christi Massacre) in Tacuba, Mexico City, and broke his foot running from the police and sniper fire.

During these years, Bernal turned to teaching as a livelihood. In 1973 he was an instructor in Chicana/o studies at California State University, Los Angeles. That same year, he met Belén Miranda, who would become his wife and with whom he raised three children, Hugo, Alex, and Gabriela. The following year he left for Mexico City, where the family lived in Colonia Narvarte, Ciudad Azteca, and finally Jardines de Santa Clara. In 1975 their son Alex was born. Bernal held a variety of jobs in Mexico City. He worked at a language institute in Colonial Roma (1977) and at the embassy school, Relaciones Culturales (1978). He also taught at Escuela Mexicana Americana, but he was fired after he became a union organizer in 1979.

By 1983 Bernal had moved his family back to East LA and begun teaching at Garfield High School, where he would remain for twenty-three years, retiring in 2005. He and his wife, Belén, divorced in 1985. At Garfield, Bernal taught Spanish to the predominantly Mexican American student body. He also painted a mural there, still preserved on the second floor of the high school. In fact, he flourished as a painter during the 1980s and 1990s. Several of his paintings were used in antiwar, anti-imperialist demonstrations (fig. 7). He was at this time deeply involved in activist circles and the Chicana/o community. In 1990 he wrote an opinion piece for the *Los Angeles Times* on the label "Hispanic," used to identify what he called the "Latino" population (fig. 8).[13] His thoughtful critique rests on condemnation of settler colonialism in the United States and invokes the indigenous heritage of Latina/os.

True to his anarchist nature and ever faithful to his progressive politics, Bernal found himself in conflict over the years with Garfield's school administrators. But he loved his students, and the feeling was mutual. During his first semester of teaching he threw away what he called the "gringo" Spanish-language textbook, instead presenting the great hispanophone writers such as Lope de Vega, Sor Juana Inés de la Cruz, Elena Poniatowska, Federico García Lorca, Carlos Fuentes, Gabriel García Márquez, and others, whose writings he used to teach literature and grammar. He taught his students Sor Juana's famous poem, *Hombres necios* (*Foolish Men*) of 1689 and her powerful 1690 defense of a woman's right to be an intellectual, *La Respuesta* (*The Response of the Poet*), written in response to the Catholic Church's attempts to silence her. Bernal references both of these works in a painting that commemorates the brilliant muse, which he created

Figure 7. Antonio Bernal's son, Alex, carries the artist's *Star Wars* (1978) while marching in a demonstration against the US invasion of Iraq. The photograph was taken in Hollywood, California, in 2003. Image courtesy of the artist.

The Importance of Distinguishing Between the Words *Hispanic* and *Latino*

Calendar's recent articles on La Raza prompt me to try to clarify why the distinction between the word *Hispanic* and the word *Latino* is important.

The people who are currently in power in this country are mostly of northwestern European ancestry. After the Renaissance, the English were locked in a struggle with Spain and Portugal over the dominion of the Western Hemisphere.

Spaniards were the frame of reference for the English who came to the New World, and, deluded by the language there,

Anglos called the natives *Hispanics*, even if they were Spanish-speaking Indians, with whom the *criollos* intermarried soon enough.

This had the convenient effect of negating the existence of the indigenous people, who numbered and continued to number in the millions (there are today 1 million Nahuatl speakers in Mexico alone, according to Encyclopaedia Britannica).

This ties in neatly with the [false] rationale that there were almost no Indians in the New World, that the land was empty and for the taking. It ignores the

obvious achievements of the Indians, making them invisible—unpersons.

Yet the fact remains that the genetic pool of the non-Anglos on the North American continent is overwhelmingly Indian. The famous dark skin, which Anglos are almost at pains to point out, did *not* come from the Moor.

Spaniards were feared and hated by native peoples, and revolutions were fought to throw off the yoke of exploitation over most of the continent. To call someone [who is not a Spaniard] *Hispanic* is simply an insult.

Why is *Latino* correct? First of all, because that is what we call ourselves. It is not a word given to us by people who are historically hostile to us.

It acknowledges the use of French, Portuguese and Spanish, all widely spoken in the hemisphere, and it affirms our American-ness—that is, our Indianness.

Latinoamericano is a word to be used with pride. Latinos have fought injustice, repelled foreign invasions, and have, for the most part, replaced feudalism with liberal republics. We have won

Nobel prizes and made outstanding contributions in art, science and medicine, as well as contributed to the wealth of the world with our labors.

If we are called Hispanics, however, all this is negated. We are no more Spaniards than Bush is British.

How would U.S. Americans feel if all their achievements were considered to be European, and not native?

I salute The Times for using the word *Latino*.

ANTONIO BERNAL
Montebello

Figure 8. Article by Antonio Bernal, published in the *Los Angeles Times*, September 9, 1990. Image courtesy of the artist.

while teaching at Garfield (fig. 9). Based on Miguel Cabrera's iconic posthumous portrait of 1750, Bernal's painting makes Sor Juana's sexuality explicit: he renders her seated in her study, surrounded by books, with her raised hands forming the shape of a vagina.

In order to actively engage his student, he had them create films in Spanish: they would write the script and then act in the production, which was filmed. He also asked his class to rewrite classic literary texts by setting them in the students' contemporary barrio. In one such

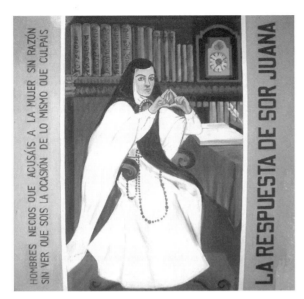

Figure 9. Antonio Bernal, *La Respuesta*, 1984-2005. Oil on canvas, 48 × 36 inches. Location unknown. Image courtesy of the artist.

assignment they rewrote Fernando de Rojas's *La Celestina* (1499). In another they wrote a play titled *Barrio Maravilla: Comedia en tres actos basada en "Fuente Ovejuna" de Lope de Vega* (which is included in this volume). He required his students to read aloud in class and to participate in group reports. His teaching methods, which he described to me in an email (May 31, 2018), were unconventional but effective.

> Grades are stupid, and I never had the petty attitude that they were to be used as reward and punishment as some teachers do. The administrators never had any idea what I was doing, all they saw was a lot of enthusiasm, but they hated my politics and tried to get me fired, but couldn't find a reason. Dealing with those people was a constant struggle—working with the kids, in spite of the occasional complaints, was a delight. I am still friends with some, and we still correspond on the net.

Always a restless soul, in the 1990s Bernal began to travel even more. He made regular trips to Cuba, visiting the island ten years in a row beginning in 1989; he experienced the "special period" of economic strictures during the 1990s and saw Fidel Castro in person. In the fall of 1995 his mother passed away. He was trekking the world into the mid-2000s, visiting Africa, Europe, Mexico, and South America. His artistic production flourished.

In February 2016 Bernal moved back to Fresno, this time to retire. Living in the same city as his sister Ann (Ana), he is close to his family's roots. He continues in 2020 to write, to be politically active, and to paint. He publishes new political writings on his blog (http://antonio-diferencia.blogspot.com/), turning his attention to global politics, capitalism, socialism, and democracy.

He is currently at work on a painting, *America the Beautiful*, whose title is intentionally ironic: the work condemns homelessness, poverty, and joblessness in the United States. The unfinished painting reminds me of the character Lauro in Bernal's loosely autobiographical, as-yet unpublished novel, *Breaking the Silence*.[14] Lauro, seemingly based on Bernal himself, attends Chouinard Art Institute in the early 1960s, where students and instructors compete to create something innovative and novel. Jaded by the constant push for newness, Bernal writes of Lauro: "He would see the Mexican and Central American laborers in MacArthur Park and knew that Jackson Pollock would be a joke to them. How to reach them? How to synthesize?" Bernal confesses that while *America the Beautiful* may be his final work, he also has plans to do an *homenaje* to migrant farmworkers, inspired by his friends in Fresno. Those plans, coupled with the recent discovery of the Del Rey mural (long presumed lost or destroyed, it had been stored and forgotten), continue his legacy as an eyewitness to the Chicano movement.[15]

Bernal recently offered to me the following observations on being "Chicano" (email, October 10, 2019):

> I have been thinking about this Chicano thing. The key is that Chicano is nationalist, and I am

internationalist. However, the key is also that one does not nullify the other. Internationalism implies solidarity, comradeship, a connection with all people everywhere. Chicano nationalism is an acknowledgement of the culture and the history that formed us, the thing we all have in common, the thing we refuse to give up in favor of gabacho temptations.

He then quoted the New Testament, Matthew 16:6, "Then Jesus said unto them, Take heed and beware of the leaven of the Pharisees and of the Sadducees," and 16:12, "Then understood they how that he bade them not beware of the leaven of bread, but of the doctrine of the Pharisees and of the Sadducees."

Chicano nationalism, like all nationalisms, can end up as rightwing fascism. That is why it is important to keep the leaven of bread, but reject the temptations of the market, the Sadducees and Pharisees—becoming slaves of capitalism, going into debt, having credit cards and cell phones, and doing everything Wall Street requires of us. We have a tradition that goes back 10,000 years and we will not give it up for a few gadgets. Respect for our traditions implies respect for the traditions of others, and this in turn—paradoxically—makes us internationalists.

Once again, a passage from Bernal's unpublished novel crystalizes for me the point of view of this artist, writer, activist, and teacher. I offer it as a final summation on this transformative, border-crossing, relentlessly questioning eyewitness to the Chicano movement. The novel's final lines are spoken by the character of Marcos, a radical activist whose transnational life has crossed the borders of both Mexico and California:

If we speak the truth they'll kill us, if we don't speak the truth we'll die in silence. We all have to give voice to the irresistible and unstoppable emotions which rent the air in their demand to feel whole, to feel human, to have some peace, finally.

—The revolution, he said aloud to no one in particular, is the purest form of poetry.

Notes

1. Shifra M. Goldman and Tomás Ybarra-Frausto, "The Political and Social Contexts of Chicano Art," in *Chicano Art: Resistance and Affirmation*, ed. Richard Griswold del Castillo, Teresa McKenna, and Yvonne Yarbro-Bejarano, 83–95 (Los Angeles: Wight Art Gallery, University of California, 1991), 86.

2. An earlier Chicana/o mural, by Colorado artist Carlota EspinoZa, is documented in 1966. See Vizcaíno-Alemán (2019).

3. An earlier version of this essay was published as the Editor's Commentary in *Aztlán: A Journal of Chicano Studies* 45, no. 2 (2020): 1–12. The essay draws on information obtained from personal interviews with Antonio Bernal, conducted in 2018 and 2019 in Fresno by Gabriela Rodríguez-Gómez and me, with the assistance of Xaviera Flores; through email communication with Bernal; and from Bernal's personal archive, donated to and housed at the UCLA Chicano Studies Research Center. My thanks to Carissa Garcia, filmmaker and scholar in Fresno, who put me in touch with Bernal.

4. "Ricardo F. Hopping, Noted Decorator, Dies," *Los Angeles Times*, January 5, 1967. The obituary suggests that Ricardo F. Hopping was the name Forrest Hopping Sr. used in his professional life. The obituary notes that he was born Forrest deGrasse Hopping, a "descendant of a French count."

5. Carolyn Hines, "Hopping Recreates Old Mexico Feeling in LA State Monument," *Fresno Bee*, August 14, 1962.

6. Laurence Gronlund, *The Cooperative Commonwealth in Its Outlines: An Exposition of Modern Socialism* (Boston: Lee and Shepherd, 1884).

7. See Robert V. Hine, *California's Utopian Colonies* (New Haven, CT: Yale University Press, 1953); Paul Kagan, *New World Utopias: A Photographic History of the Search for Community* (New York: Penguin, 1975), 78–100; and *William Tweed, Kaweah Remembered: The Story of the Kaweah Colony and the Founding of Sequoia National Park* (Three Rivers, CA: Sequoia Natural History Association, 1986), 84–101.

8. See Hine, *California's Utopian Colonies*, 83–84; and Jay O'Connell, *Co-Operative Dreams: A History of the Kaweah Colony* (Van Nuys, CA: Raven River, 1999), 175–77.

9. Email to author, February 3, 2018.

10. See "Ann Hopping with Artwork, Visalia Public Library, Visalia, Calif." on Calisphere, https://calisphere.org/item/ark:/13030/c82b8w62/. The photograph, dated May 24, 1956, appears in a scrapbook, catalogued as art of the Collection of Tulare County Local History Photographs. After a long career as a librarian, Ann (Ana) Hopping retired to the Fresno area, where she resides today.

11. This is drawn from an email that Bernal sent to someone else, part of which he forwarded to me on August

10, 2018: "Acabo de ver la biografia de Carmen Amaya en You Tube, y queria comunicarle a Francisco Hidalgo que yo la conoci en 1960 en San Francisco. Yo era un joven ignorante, impresionable y Carmen siempre fue una gran figura para mi—No solo por su baile, que era fenomenal, sino por su humanidad, su sabiduria, y su trato gentil con un tonto muchacho enamorado de la farandula. La ultima vez que la vi fue en la ciudad de Mexico. Despues de la actuacion me meti en el camerino como solia hacer, para saludarle. Estaba sola, tenia la cabeza entre los brazos, en actitud cansada. Cuando me vio me saludo inmedi-atamente, con alegria, a pesar de que habia pasado un buen tiempo que no nos habiamos visto. 'Has bailado como nunca' le dije. 'No lo creas.' 'Bueno, te dejo para que descanses.' Poco tiempo despues estaba en el autobus y alguien portaba un periodico. 'CARMEN AMAYA HAS DIED.' Se me partio el corazon. Era una gran figura, una gran mujer y un gran ser humano. Siempre la recuerdo." (The original does not contain diacritics.)

12. Bernal's testimony was posted on March 13, 2012, on the UFW Stories website (www.ufwstories.com), which is no longer available.

13. Bernal updated the article in 2000; titled "Why Hispanic?," it is included in this volume in the chapter titled "Antonio Bernal's Writings."

14. The manuscript of Bernal's unpublished novel is housed at the UCLA Chicano Studies Research Center archive, and it is available as a post on the artist's blog.

15. I am grateful to Carissa Garcia for this infor-mation and await the upcoming publication on the mural's rediscovery, current state, and future conserva-tion efforts. A copy of the mural was copleted in Del Rey in May 2021 and unveiled at an event honoring Bernal. The project coordinator was Vickie Treviño, and artist Mauro Carrera led the effort. See Elisa Navarro, "City Celebrates Completed Recreation of Del Rey Mural from 1968," ABC30 website, May 18, 2021, https://abc30.com/fresno-county-del-rey-mural-artists-muralists/10657574/.

History sin Fronteras

Antonio Bernal's Chicano Murals in Del Rey and East Los Angeles

Gabriela Rodriguez-Gomez

In 1968, Antonio Bernal Hopping began painting a mural for El Centro Campesino Cultural, El Teatro Campesino's headquarters in Del Rey, California (plates 1, 2). Completed in 1968, the untitled mural was described as the one of the earliest Chicano-themed murals by Alan W. Barnett in 1984 and by Shifra M. Goldman and Tómas Ybarra-Frausto a year later.[1] Several years later the mural was shown in a video titled *Through Walls*, which was part of the groundbreaking exhibition *Chicano Art: Resistance and Affirmation, 1965–1985* (1990–93).[2] The Del Rey mural became a canonical example of early Chicano muralism in the disciplines of art history and Chicana/o studies. In 1989, Bernal began painting a second mural—his only other—at Garfield High School in East Los Angeles. Although separated by more than two decades, both murals amplify the ideals of the Chicano movement. They promote awareness of Indigenous and Mexican histories and, in the Del Rey mural, social justice movements in the United States. From his experiences as a child in Mexico City and a as teacher in Los Angeles's public schools, Bernal understood history from a transnational perspective. This point of view is evidenced in the strategic and purposeful mixing in both murals of historical and cultural icons from different communities and different eras. His contribution to the Chicano mural movement conveys his personal experiences with social justice and cultural change. Through his murals, Bernal brings the Chicana/o past into the present by envisioning collective activism.

Little has been written about Bernal and his work. Most of the existing scholarship focuses on the right panel of the Del Rey mural to explain the emergence of Chicano iconography, and nothing has been published about the mural at Garfield High School. My analysis fills these gaps, providing a description of and historical context for each of the two murals. In addition, I apply a Chicana/x feminist art-historical lens to locate the agency and power of the women, Indigenous, and mestizo/a people in Bernal's murals who were largely absent from written history. I write about a history without borders—sin fronteras—where women, Indigenous, and mestizo/a people are the protagonists within social movements and are creators of their own narrative.

Two interviews with Bernal, one conducted by art historian Shifra M. Goldman in 1987 and the second conducted by Charlene Villaseñor Black and myself in 2018, provide important information about Bernal's approach to art and politics.[3] Bernal was a lifelong activist, and among his friends were members of the Black Panthers, the Congress of Racial Equality (CORE), the Brown Berets, and El Teatro Campesino. Both interviews have

contributed insights about the visual narrative of the murals, the artist's compositional strategies, and his participation in social-political and cultural movements.

The Emergence of Chicano Art

The Chicano art movement began in the mid-1960s, coinciding with the social and political activism of the Chicano movement, and "Chicano art" began to emerge as a new category of American art. Goldman and Ybarra-Frausto described the first period of the Chicano art movement, from 1965 to 1975, as being "marked by a totally noncommercial community-oriented character." The movement coalesced around collectives of Chicana/o artists whose work was marked by a "high sense of idealism" that stemmed from Chicano nationalism and separatism and was sometimes influenced by a romantic view of history and culture.[4] Activists' calls for *la raza* to reclaim its culture and its historical memory were enforced by authors and artists, and the symbiosis of art making and political awareness led to a growing interest in public art. Murals and posters were apparatuses for socio-political messaging, and they often incorporated an Indigenist and transnational aesthetic.

By 1968 the Chicano art movement had gained momentum, signaling an important "grassroots explosion" of artistic production that, Goldman noted, had been "dubbed a 'renaissance.'"[5] Artists juxtaposed Mexica (Aztec) or Maya deities with figures from Mexican history, creating a representation of culture and history that was based on idealized images of the past and the present. Goldman, writing in 1994, noted that

> Chicanos looked to Mexico for inspiration; to its pre-Columbian, colonial, and revolutionary cultures; to Olmec, Maya, and Aztec art; to the image of the Virgin of Guadalupe, patron saint

of Mexican Independence, which was carried at demonstrations and painted on innumerable walls and canvases, and to Emiliano Zapata, leader of revolutionary Mexican farmers and landless peasants.[6]

Works that incorporated Indigenous Mexican motifs infused representations of contemporary political and social struggles with "a strong religious, spiritual, or mystical component."[7] This neo-Indigenist aspect of Chicano art conveyed a direct lineage from the Mesoamerican past to the Chicano present and served as a positive affirmation of Chicana/o and Mexican American heritage. The incorporation of motifs that referenced the past "instilled pride and a sense of historical identity" in Chicana/o artists and the community they represented.[8]

Early Chicana/o muralism was part of the activism that produced what Alan W. Barnett described as "posters, demonstrations, educational innovations, vocational experiments, community-initiated services, civil-rights and antiwar agitation, and a communitarian kind of farmworker organizing."[9] Barnett identified Bernal's mural in Del Rey, a rural farming community, as one of the "first documented community-based Chicano murals."[10] It represented a "new art form" that engaged viewers because it spoke directly to their experiences.[11] Community members who viewed these murals were an integral part of art and social movements. Goldman noted that the work in Del Rey, which she identified as a "very early two-panel mural," displayed a "clear exposition of the pictorial sources and ideological associations" that Chicana/o artists would utilize throughout the 1970s.[12] Since the analyses by Barnett and Goldman appeared, in 1984 and 1985, respectively, Bernal's Del Rey mural has been widely acknowledged as an early example of Chicano muralism.

Public art during the Chicano movement included not only posters and murals but also

the performances of Chicano theater troupes, especially those by El Teatro Campesino, founded in 1965. The United Farm Workers' struggle to unionize farmworkers in California's Central Valley prompted Luis and Danny Valdez to create a traveling musical theater that entertained the workers while spreading the union's message. The company presented actos, or skits, that satirically critiqued working conditions for farm laborers, the class divide, and historical narratives. The actos were appreciated and enjoyed by not only the farmworkers but also the working-class community. According to Goldman and Ybarro-Frausto, Teatro Campesino's performances were the "first cultural expression" of the Chicano movement.[13] Through regional performances, national, and international tours El Teatro Campesino publicized the UFW's strikes and boycotts and exposed audiences to the struggles of the farmworkers. Chicano movement–era artists, performers, and local and regional activists took up a call to action, whose goal was to establish cultural pride and a sense of history within the Chicana/o and Mexican American community.

The Del Rey Mural

In 1967 El Teatro Campesino moved their headquarters to Del Rey, in California's Central Valley, where the company would be close to the farms that employed the Chicana/o and Mexican American campesinos, or farmworkers, who were active in the UFW. Del Rey had a population of about one thousand, but during the harvest season that number doubled. El Teatro Campesino established El Centro Campesino Cultural, where its members offered free activities to farmworker families.[14] An article in *People's World* published in 1968 described El Centro Campesino Cultural as a "ramshackle building, which appears to be one

hundred years old, on the corner of Wildwood and Morro." The center was staffed by eight people, artists and educators who engaged with "the local farmworker community about the struggles for social justice using art and performance."[15]

After graduating from art school in 1966, Bernal moved to Fresno, and by 1967 he had joined El Teatro Campesino's acting team and become acquainted with the Valdez brothers.[16] In 1968, Bernal began painting the mural for the theater troupe's headquarters in Del Rey.[17] Each of the mural's two sections were painted on three adjoined wood panels, with each section measuring six feet high by fifteen feet long. The two sections were mounted on white-painted wood paneling that was was attached to the building's exterior walls, with one section on either side of the entrance.[18] Bernal noted that he did not have any prior experience with mural painting. He created the work as "cheaply as possible," scraping the wood panels and using enamel house paint for the white base before he applied color to the surface.[19] Chicana/o artists were often forced to work resourcefully, using materials that were donated, found, or purchased with limited funds. In a letter written in 1990 to Elizabeth Shepherd, curator at UCLA's Wight Gallery and co-organizer of the *Chicano Art: Resistance and Affirmation, 1965–1985* (or *CARA*) exhibition, Bernal explained that the mural was not intended to be a permanent installation. He described the creation of the two sections, or panels, as on a "fly-by-night basis, with no previous planning or thought as to their subsequent fate."[20]

A short article in the *Fresno Bee* on August 25, 1968, announced that the panels would be unveiled at a street festival and described the work as "murals, portraying Mexican folk heroes" (fig. 1).[21] The article states that "a performance by El Teatro Campesino" would

Figure 1. Clipping from the *Fresno Bee*, August 25, 1968. Courtesy of El Teatro Campesino Archives, CEMA 5, Department of Special Collections, University Libraries, University of California, Santa Barbara.

and described the audience who attended as campesinos who "came from the fields to sit and watch this thing, you know. The guys [El Teatro Campesino performers] put paper all over it and then tore down the paper, and everybody clapped."[23] Later he noted that they came up to him and shook his hand. Bernal smiled as he remembered the moment, noting that the experience was "really nice."

When El Teatro Campesino moved its headquarters to Fresno in 1969, Bernal's panels were left behind. They remained in place into the 1970s, when they were photographed by psychologist and mural photographer Robert Sommer. His photographs show damaged plywood and faded paint (see plates 1, 2). An undated and heretofore unpublished photograph shows the dilapidated condition of the vacant building (fig. 2). Another image, a black-and-white photograph displayed inside El Teatro Campesino's current headquarters in San Juan Bautista, California, shows the mural in much better condition (fig. 3). Although the photographer and the date are unknown, the black-and-white photograph must have been taken immediately after the mural's unveiling in 1968. The building does not show the wear and tear evident in later photos, and the details of the mural can be seen clearly. This photograph enables a fresh analysis of the Del Rey mural.

Left Panel

On the left panel are eight anonymous Indigenous figures who appear to be making their way to the entrance of El Centro. When Bernal's mural was unveiled, the figures would have stood out from the neutral background, and the warm brown tone of their skin would have contrasted with the blue, red, and green of their clothing. Goldman stated that there was "little doubt" that this scene was "borrowed from the Maya murals of Room 1 in the temple

occur in front of the center that evening. It is unknown if the performance occurred, but later Bernal noted that the mural had "no more significance than a stage prop, as it was used partly as a backdrop for the plays," suggesting that the panels may have been used for other performances.[22] During our interview in 2018, Bernal recalled the unveiling event

Figure 2. El Teatro Campesino's headquarters in Del Rey, California, in the 1970s, with Antonio Bernal's mural. The photographer is unknown. Image courtesy of *CARA (Chicano Art: Resistance and Affirmation)* Records, part I, collection 10, UCLA Chicano Studies Research Center.

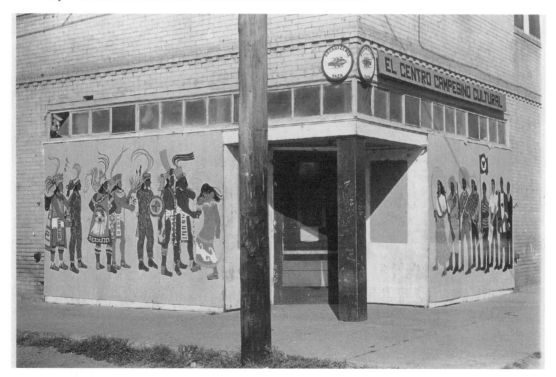

Figure 3. El Teatro Campesino's former headquarters in Del Rey, California, circa 1968, with Antonio Bernal's mural. The photograph hangs in El Teatro Campesino's current headquarters in San Juan Bautista, California. The photographer is unknown. Image courtesy of Luis Valdez and El Teatro Campesino.

at Bonampak," an archeological site in Chiapas, Mexico.[24] She described the figures as "flat" and likened them to "pre-Columbian aristocrats."[25] The section of the Bonampak murals that Goldman referenced is the upper register of the east wall, which contains portraits of Maya nobility.[26] Bernal's male figures wear feathered headdresses, which Goldman noted are similar to those worn by "all the standing male dignitaries at Bonampak."[27] In her 1987 interview with Bernal, Goldman also pointed out that the attire of the eight figures was a "pastiche" comprising a "mixed quality of costumes," which suggests that the Maya were not Bernal's sole inspiration for the figures on the left panel.[28]

Dylan A. T. Miner identified the figures as "Mexica figures" that "dance in a procession" toward the entrance of El Centro.[29] Two of the male figures are wearing feathered body suits that resemble the warrior regalia of the Mexica portrayed on folio 67r of the Codex Mendoza (fig. 4).[30] Miner was also the first to recognize the figure at the head of the line as a female Mexica danzante, or dancer.[31] The beautiful danzante wears a blue blouse, or huipil, and skirt, or cueitl, decorated with a white stylized glyph that resembles the xicalcoliuhqui stepped fret design seen in Mesoamerican art. Other interesting details include the sandals, or cactli, in a matching blue color and, around her neck, what seems to be a Latin or Christian cross. Her body is turned toward the men who also face toward her, but she is looking to her left, toward the entrance of the cultural center. The smoke from the incense burner carried by the noble behind her wafts above her head.

The lineup of male figures are dressed in loincloths and cloaks, and three carry offerings or ceremonial objects. The male in the center holds three ears of corn in his left hand and in his right hand he holds three sprigs with leafy clusters. In his interview with Goldman in 1987, Bernal identified this as

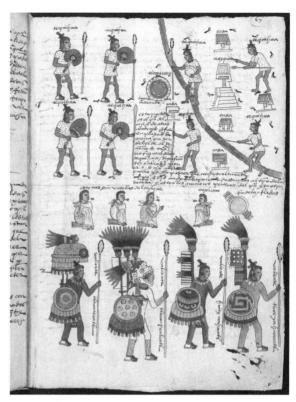

Figure 4. Folio 67r from the Codex Mendoza, ca. 1541. Ink on European paper. Image courtesy Bodleian Library, Oxford University.

marijuana, which he included "as a joke" to spark the interest of viewers and to add humor to the scene. Goldman described the corn as a symbol of nourishment for the body and the marijuana as nourishment for the mind.[32] During our interview, Bernal reiterated that this detail was meant to be humorous. It also marks the historical moment of the late 1960s, when psychedelics and ethnobotanicals were explored liberally.

The other two men carry objects that have not been discussed in previous analyses of the Del Rey mural. The clarity of the black and white photograph allows them to be identified as objects related to religious ceremonies. The Maya noble at the front grips a smoking incense holder. Copal was frequently burned during Mesoamerican rituals, including ceremonies to honor warriors killed in battle.[33] The second

object, carried by the Maya noble at the end of the line, depicts the Mexica goddess known as a Cihuateotl (deified woman) in Nahuatl. Cihuateteo, which were created when women passed away during childbirth, were the "female counterparts of the male warriors in the Mexica society."[34] Offerings were made to the Cihuateteo "at home and at crossroad shrines" to appease them and to "prevent and presumably cure the diseases they were thought to cause."[35] The Cihuateotl in Bernal's mural, with its skull necklace, closely resembles a Cihuateotl in the collection of the Museo Nacional de Antropología in Mexico City, indicating Bernal's familiarity with artifacts in the national collection.[36] The marijuana and the corn may be understood as offerings for Cihuateotl, but they also represent nourishment for the mind and body. The offerings of food and the ceremonial objects suggest that the Maya and Mexica figures, led by the danzante, are engaged in a ritual that either honors both the dead and the living or celebrates the cycle of death and renewal.

In his painting of Maya elites, Mexica warriors, and a Mexica female danzante, Bernal created a neo-Indigenist alliance brought together to honor the united cause of Mexican American and Chicana/o empowerment. The procession of Indigenous figures visualizes a community-centered optimism about the future that promotes a collective power. Bernal points to a coalition with a cultural identity that draws on the Indigenous past to create the possibility for this type of unity in the present.

Right Panel

The right panel of the Del Rey mural depicts eight figures from the Mexican Revolution and the US civil rights movements of the 1960s. These figures, which include Chicana/o, Mexican, and African American leaders, face toward the entrance of El Centro, balancing the figures in the companion panel. Leading these figures

is a soldadera—a female revolutionary soldier—holding a sword and wearing a bandolier and sombrero.[37] Her placement signifies her role as a leader and a heroine who is equal to her male comrades, and her stance conveys this authority. Goldman pointed out that the sword held by the soldadera is similar to the sword carried by Emiliano Zapata in the famous photograph in Augustín Victor Casasola's archive.[38] Scholar Michael Cucher states that the upraised position of the soldadera's sword "disrupts biological assumptions about the connections between power, heroism, and men's bodies."[39]

Shifra Goldman was the first to associate this figure with La Adelita, whose story is told in "La Adelita," the famous corrido about the Mexican Revolution of 1910. Over time, "Adelita" came to represent any of the women who participated in the Mexican Revolution.[40] Bernal confirmed in 2018 that this woman is a soldadera. He knew that the farmworkers who saw the mural would recognize the image and immediately understand her as a powerful figure.[41] Although La Adelita became an idealized Mexican icon, the soldaderas she came to represent were real women who fought as soldiers or aided as nurses during the Mexican Revolution.[42] Bernal stated that he was concerned not with the divisions between women and men but with the collective socio-political gains that had been made by historical figures.

The eight men illustrated in the right panel are lined up behind the soldadera. On the far right are two prominent African American leaders: Martin Luther King Jr. and Malcolm X, who wears a Black Panther T-shirt and carries an M14 rifle. Malcolm X's right hand rests on the shoulder of Reies López Tijerina, who holds a copy of the Treaty of Guadalupe Hidalgo. Tejerina organized La Alianza Federales de Mercedes in February 1963 to demand repatriation of land confiscated from former Mexican citizens after the treaty ended the

Mexican-American War.[43] Preceding López Tijerina is César E. Chávez, dressed in a red flannel shirt. He holds shears used to cut grape vines in his right hand and, in his left, the UFW flag, which became a potent symbol of the farmworkers' struggle.[44] Adjacent to Chávez, Bernal depicted the nineteenth-century outlaw—or "legendary freedom fighter"—Joaquín Murrieta, who became a symbol of resistance during the Chicano movement.[45] Bernal worked at Centro Joaquín Murrieta de Aztlán in Los Angeles during the early 1970s, so he understood the historical and cultural importance of figures like Murrieta.

Continuing up the line, Bernal painted Emiliano Zapata wearing a sash and bandolier and holding a Mauser rifle in his right hand, as seen in the photograph in the Casasola archive.[46] Next is Francisco "Pancho" Villa, whose División del Norte—along with Zapata's Ejército Libertador del Sur—fought government forces during the Mexican Revolution. By placing the soldadera alongside Villa and Zapata, Bernal re-imagined social hierarchies that were paramount in revolutionary Mexico and distributed the representation of power across the right panel to represent a united front.

Martin Luther King Jr. and Malcolm X, also placed side by side, represent the different philosophies espoused by Black leaders during the civil rights movement. The figure next to King Jr. has not always been explicitly identified in published analyses of the Del Rey mural. He has been described, for example, as a "black militant" or a "composite Black Panther/ Malcolm X figure."[47] Bernal confirmed that the figure is Malcolm X during our interview, saying that he placed him in the arrangement to demonstrate not only the impact that he and King had on the era's civil rights movements but also to call attention to the realities that activists faced. César E. Chávez and Reies

López Tijerina form a similar dualism. Chávez modeled his activism on organizing nonviolent protests against commercial growers in California, whereas López Tijerina organized raids in New Mexico to retaliate against established governmental policies.

By portraying the four leaders—King Jr. and Malcolm X and Chávez and Tijerina—in juxtaposed pairings, Bernal intended to show and to help the viewer understand the "dialectics" of the civil rights movements. He explained that "the opposite and contradictory is also dynamic, which causes progress. . . . It allows humanity or history to move forward, otherwise, it becomes completely stagnant."[48] From his perspective, the inclusion of historical figures dedicated to nonviolent protest (King Jr. and Chávez) alongside those who practiced militancy (Malcolm X, Villa, and Zapata) expresses the importance of collective activism even when agendas or practices differ. Reed points out that the right panel symbolizes "solidarity-in-difference": these figures of different races and genders represent a "united front of resistance."[49] The Black civil rights movement, regardless of the ideological conflicts within it, was a "model of struggle" that inspired and motivated participants in the Chicana/o movement.[50]

During the 2018 interview, Bernal mentioned the sadness he felt when Malcolm X and Martin Luther King Jr. were assassinated in 1965 and 1968, respectively, and he noted the importance of Malcolm X's speeches and writings in his own life.[51] He referred specifically to "The Ballot or the Bullet" (1964), the speech in which Malcolm X declared, "I must say this concerning the great controversy over rifles and shotguns. . . . In areas where the government has proven itself either unwilling or unable to defend the lives and property of Negroes, it's time for Negroes to defend themselves."[52] I interpret the rifles in the mural as a direct reference to the speech

and as a reflection of the realities of civil rights activism in the 1960s. The rifle held by Malcolm X suggests that the powerful actions that spark change may not always be interpreted as peaceful. Bernal stated in our interview, "I played 'Ballad of the Bullets' for everybody in the group, the Congress of Racial Equality—CORE. A lot of people call him a militant . . . No. The people that were there considered him a brother, one of ours. We were one of his, whatever you want to say. There was no question about militancy. To say that Malcolm was militant, or black militant—that is only one aspect of something that is much more complicated."[53] The presence of guns in the mural may indeed be a sanction of militancy, even violence, but the narrative that Bernal presented was truthful. His portrayal of the four civil rights leaders expressed his conviction that although nonviolent activism was important, given the hard realities of revolution, self-defense was essential, whatever the cost.

The Del Rey mural portrays a collective Chicana/o identity that is influenced by a range of cultures and ideologies from the past and the present. The finely dressed Mesoamerican figures on the left panel, who approach the entrance of El Centro Campesino Cultural, correspond with the nineteenth- and twentieth-century revolutionary leaders on the right panel, who walk toward the entrance in solidarity. The left panel conveys an awareness of the sacrifices and victories of men and women that should be recognized and honored. The right panel acknowledges that embarking on the path toward justice and peace requires action from everyone from the Chicana/o, Mexican American, and Hispanic communities. Taken together, the two panels of the Del Rey mural represent a call for justice, one that urges communities of color to build coalitions without racial, social, political, and cultural borders.

Garfield High School Mural

Bernal's second mural, also untitled, was painted in 1989–90 at Garfield High School in East Los Angeles (fig. 5). Bernal had returned to Los Angeles in 1980, and by 1983 he was teaching Spanish and English as a second language at Garfield to students from diverse ethnic backgrounds, primarily those of Chicana/o and Latina/o descent.[54] In the letter he wrote to Shepherd in 1990, Bernal described the mural as a creative experiment undertaken "with the participation of Garfield students as artists or as models." It had, he said, "an enduring and didactic purpose" to educate his students. He recounted that when he asked students to explain why May 5 was important in Mexican history, he found that many students were unfamiliar with the history of Cinco de Mayo.[55] They did respond immediately, though, when he asked about a certain New York celebrity.

> They don't know what Cinco de Mayo means (a successful repulsion of foreign intervention), who Sor Juana was, have never read García Marquez. They know, however, exactly who Donald Trump is. I believe I can do a lot to educate Latinos (and Anglos, let's face it!) about the achievements of a great people—the Latin Americans—through art, in and out of the barrio.[56]

Bernal expressed optimism about the mural's potential, stating, "The purpose here is to try to stem the drenching onslaught of cultural imperialism which keeps Latino kids ignorant of who they are."[57]

The mural is located at the north end of the central hallway in Garfield High School's 100 Building, near classroom 127.[58] It was started in 1989, and the date May 5, 1989—Cinco de Mayo—appears on the mural, but the mural was still in progress in 1990, as evidenced by a photograph taken by Bernal probably in 1990 (fig. 6). Painted on two adjacent walls,

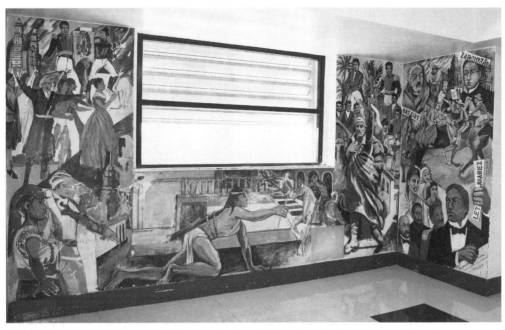

Figure 5. Antonio Bernal, untitled mural at Garfield High School in East Los Angeles, 1989–90. Acrylic on concrete, 7 × 12 feet (north wall) and 7 × 3 feet (east wall). The photograph shows the damage the mural has sustained. Photographed by the author in 2018.

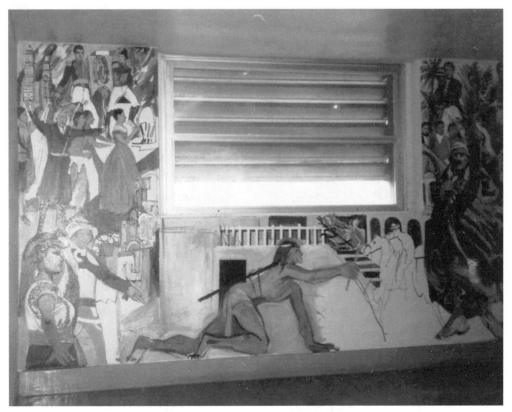

Figure 6. Antonio Bernal, untitled mural at Garfield High School, East Los Angeles, California, 1989–90. Acrylic on concrete, 7 × 12 feet (north wall) and 7 × 3 feet (east wall). Photographed by the artist in ca. 1990, while the mural was being painted. Photograph courtesy of Antonio Bernal.

the mural is organized into three sections that cover three themes: the Mexican War of Independence, France's interventions in Mexico, and the movement known as La Reforma. Bernal's plans for the mural were never fully realized.

> This mural shows some figures from the French invasion, from the Independencia, notably El Pípila and Morelos, and will finish with the Revolution of 1910. On an adjoining wall, I plan to show the U.S. invasion of Mexico, and further on another wall, scenes of barrio life in the U.S., as well as figures of many Latin Americans, José Martí, Gabriela Mistral, etc.[59]

Bernal's mural at Garfield places men, women, Indigenous, and mestizo/a figures as active participants in movements that focused on independence and government reform. The mural offers a narrative of collective resistance and activism that spans more than a half-century of Mexican history. Charlene Villaseñor Black and I viewed the mural with Bernal during our 2018 interview.

North Wall

On the left side of the north wall is Miguel Hidalgo y Costilla, who is shown standing before his parish church in Dolores on September 16, 1810. He is issuing "el grito de Dolores," the call to arms that launched Mexico's rebellion against Spanish rule (fig. 7). In his right hand he holds a placard that states, "Viva Mexico mueran los gachupines 1810" (Long live Mexico death to Spaniards 1810), and in his left hand he holds a banner bearing the image of the Virgen de Guadalupe.

Directly to Hidalgo's right is Josefa Ortiz de Domínguez, known as "La Corregidora" (a reference to her husband's position as magistrate of Querétaro), whose home became the headquarters for conspirators who were planning independence from Spain. She wears a green dress with a white fichu and holds a card

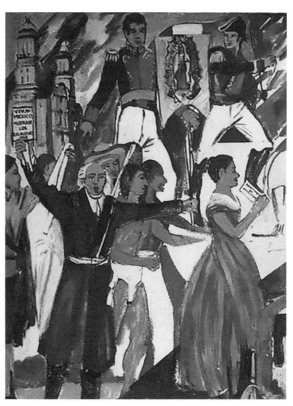

Figure 7. Antonio Bernal, detail of untitled mural at Garfield High School, East Los Angeles, California, 1989–90. Acrylic on concrete, 7 × 12 feet (north wall) and 7 × 3 feet (east wall). The photograph shows the portrait of Miguel Hidalgo y Costilla (north wall). Photographed by the author in 2018.

labeled "conspiración de Querétaro." Each of the military figures at the top—Juan Aldama on the left and Ignacio Allende on the right, who holds the Mexican flag—had an important role. Aldama traveled to Dolores to warn Hidalgo when the conspirators were betrayed, triggering the rebellion, and Allende eventually succeeded Hidalgo as the insurrection's leader.

These historical figures demonstrate the involvement of political, military, and clerical members of criollo society in the fight for independence. The figures who are painted behind and below Hidalgo represent the Indigenous and mestizo/a populace of Dolores, Mexico. They appear to be in movement, marching to show their solidarity with Hidalgo's

proclamation and indicating the importance of their participation in the revolt against Spanish rule. Beneath Hidalgo, an anonymous Indigenous or mestiza woman faces the center. She wears a green rebozo and a huipil, the traditional shirt worn by Maya in Southern Mexico and Guatemala. Directly behind her are two anonymous figures that represent the diversity of the Mexican populace, which included mestiza/os, criolla/os, and Indigenous peoples. One of these figures guides the viewer, pointing downward to the scene under the window.

Below the window Bernal illustrated the story of Juan José de los Reyes Martínez Amaro, or "El Pípila," a mestizo miner whose bravery allowed Hidalgo's troops to take the Alhóndiga de Granaditas in Guanajuato, where a Spanish garrison was positioned. Bernal depicts El Pípila semi-nude, wearing only a white loincloth that emphasizes his indigeneity. He is crawling on his knees, with the colonial arches of the Alhóndiga behind him, and carrying the torch used to set fire to the entry door. The slab of stone strapped to his back protected him from Spanish musket fire.[60] The portrayal of El Pípila represents what art historian Guisela Latorre has characterized as a "Chicana/o Indigenist" approach in muralism. Chicana/o Indigenism "emerged as a methodology of decolonization that sought to create not a false consciousness but alternative models of oppositional thinking."[61] The depiction is an assertion of "agency from the margins."[62] Bernal used this scene to create an interconnected composition that not only signals a transition in time from one wall to the other but also recognizes the roles of Indigenous and mestiza/o peoples in Mexico's history.

Standing prominently on the right side of the central wall is the Roman Catholic priest José María Morelos, Hidalgo's successor after Hidalgo was executed in July 1811 (fig. 8). In September 1813 Morelos convened the

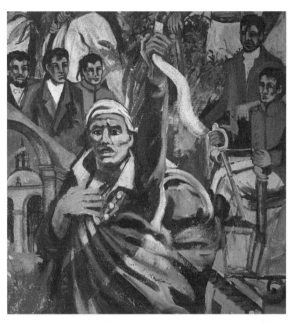

Figure 8. Antonio Bernal, detail of untitled mural at Garfield High School, East Los Angeles, California, 1989–90. Acrylic on concrete, 7 × 12 feet (north wall) and 7 × 3 feet (east wall). The photograph shows the portrait of José María Morelos (north wall). Photographed by the author in 2018.

Congreso de Chilpancingo, which drafted a constitution for an independent government. Morelos's "Sentimientos de la Nación" provided a blueprint for the document. The figures behind and above Morelos allude to his victories as a military leader. Morelos was executed on December 22, 1815, after being captured by the Spanish and defrocked by the Catholic Church.[63] Bernal painted Morelos with a dark brown skin tone and a white scarf over his head, perhaps to signal his mestizo, Indigenous, and African ancestry, which was not acknowledged by his classification as "Spanish." Morelos is portrayed with one arm over his chest and the other raised upward, drawing the viewer's eye to the portrait of Vicente Guerrero in the top right corner. Guerrero assumed leadership of Morelos's troops as the battle for independence continued. In 1828 he was elected president, only to be ousted that same

year. Alongside Guerrero is Martín Javier Mina y Larrea, a member of the insurgency, and below are anonymous figures in military dress, standing with their gaze fixed on Morelos.

East Wall

The mural on the east wall reflects Bernal's concern that his students did not understand the significance of Cinco de Mayo. The upper portion of the mural focuses on two episodes during the French intervention (1861–1867), in which Napoleon III, aligned with Mexican conservatives who were challenging the government of Benito Juárez, attempted to establish a regency in Mexico.[64] Bernal portrays two generals whose leadership led to victory in separate battles. In the top right corner is a portrait of Ignacio Zaragoza Seguín, the Mexican general whose greatly outnumbered troops defeated the French at the Battle of Puebla on May 5, 1862. At the left is François-Achille Bazaine, whose French troops laid siege to Puebla for two months, finally capturing the city in May 1863.

Above and below the portrait of Zaragoza are figures that represent the Mexican cavalry, which included volunteers as well as regular troops. The bravery of the cavalry was a decisive factor in Mexico's Cinco de Mayo victory.[65] Below the portrait of Bazaine are three Zouaves, France's elite infantry troops, dressed in their distinctive uniforms.

The costumes of the anonymous female figures and the couple in the next register suggest the social divisions in nineteenth-century Mexico. The woman directly underneath the portrait of Bazaine wears a black lace mantilla over a peineta (a large ornamental comb), a style that was popular with Spanish noblewomen. The women below her wear rebozos, the large shawl used by women of all classes throughout Latin America, which could be wrapped around the head and upper body.

Bernal did not identify these women during our interview, but I view them as representative of women from different social and economic classes who were aware of the political changes in Mexico but could not participate in the electoral process. The women wearing rebozos look toward Benito Juárez while the Spanish noblewoman faces the opposite direction. The gaze of the Indigenous and mestiza women toward Juárez is, in my view, a representation of hope, or even optimism, for change during the social, racial, and economic divisions of that era.

The lower part of the mural focuses on La Reforma, a period of civil war that began in 1854 and ended in 1876, when Porfirio Díaz took over Mexico's government. Most prominent is Benito Juárez, the principal leader of the reform movement and president of Mexico from 1861 to 1872 (fig. 9). To the left of Juárez is an unidentified military officer. Bernal identified the next two figures as Mexican intellectuals who helped shaped the movement: writers Ignacio Ramírez, whose pen name was "El Nigromante" (The Necromancer), and Guillermo Prieto. Both served in Juárez's cabinet. The paper clenched in Juárez's left hand is inscribed with "Ley Juárez," a reform adopted in 1855 that abolished special treatment under the law for the clergy and the military. Juárez's powerful gesture conveys his commitment to reform. In his right hand, Juárez holds a paper bearing the names of Bernal's two student assistants, Raul Ruiz and Alejandro Villanueva. Their names precede the phrase "under the direction of" and Bernal's signature.

The portrait of Juárez concludes the narrative of the Garfield High Mural. The theme of Mexico's nineteenth-century struggle for an independent and stable democracy offers the Chicana/o students at Garfield High School a sense of their heritage and communicates a message of resistance and social justice that echoes from the nineteenth century to today.

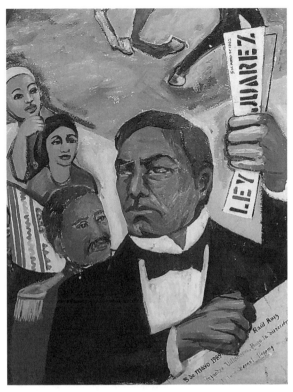

Figure 9. Antonio Bernal, detail of untitled mural at Garfield High School, East Los Angeles, California, 1989–90. Acrylic on concrete, 7 × 12 feet (north wall) and 7 × 3 feet (east wall). The photograph shows the portrait of Benito Juárez (east wall). Photographed by the author in 2018

To include Benito Juárez, and other prominent figures associated with La Reforma movement in Mexico, demonstrates a moment in history when change was possible and ideas about revolution were gaining momentum. During our interview, Bernal acknowledged that he had planned to include a portrayal of the Mexican Revolution. Pointing to the blank left wall, he said, "I didn't finish it. I was going to paint Zapata and Pancho Villa over here."[66]

Conclusion

The use of thematic historical references with portraits of notable figures was a strategy used by Chicano artists to reclaim their cultural heritage to Mexican history, but it was also

employed to establish a Chicana/o identity and community in the United States. One example is Willie Herrón's mural *La Doliente de Hidalgo* (The Sorrow of Hidalgo, 1976), which he painted on the façade of Farmacia Hidalgo, located in the East Los Angeles neighborhood of City Terrace.[67]

Rather than holding a banner bearing the likeness of the Virgen de Guadalupe, as the priest is often depicted—and as shown in Bernal's Garfield mural—Herrón's figure holds a flaming torch in his right hand, while his left fist is raised over his head. This gesture is symbolic of his historic cry for independence, but it also references José Clemente Orozco's fresco *Hidalgo and National Independence* (1937–8), located above the main staircase of the Governor's Palace in Guadalajara. In Herrón's mural, smoke from the torch flows toward the emotional faces of the anonymous figures to the right of Hidalgo, who are chained to the Spanish soldier painted above the store's entrance.

The Virgen de Guadalupe in *La Doliente de Hidalgo* is an actual presence, not a symbol or an image placed on a banner, in the story of Mexico's independence. She is to the left of Hidalgo, with her eyes closed in prayer. The rays that emanate from her robe and the flames of the torch create an orb of light behind Hidalgo's head. The light and the rainbow at the far left suggest a new direction for Los Angeles in the mid-1970s and hope for its future. The sense of optimism in Herrón's and Bernal's murals is powerful enough to capture the attention and imagination of younger generations. The murals educate as they challenge exclusionist history and show that a new direction toward justice is possible.

Bernal also had another concern, one that motivated his second mural. Intending to educate the teenage viewers at Garfield High School, Bernal drew on his own understanding of his Mexican identity to create his

narrative of Mexico's independence movement. He wanted his students to learn from history, not simply repeat it. This analysis of Antonio Bernal's murals at Del Rey and Garfield High School explores the artist's recuperation of cultural memory without borders or limits to what can be achieved toward justice. I take a fresh look at the iconography of the Del Rey mural and introduced the Garfield High School mural as an extension of the Chicano art movement. My analysis shows that the artist took a transnational, cross-cultural approach as he articulated notions of self-affirmation and self-determination. I view Bernal's murals as instructive tools to show Mexico's history as a complex and dynamic story and to consider thinking about the relationship between the US and Mexico today.

Both murals convey the power of collective activism. They promote a hemispheric consciousness in which women, Indigenous and mestizo/a peoples, historical revolutionaries, and civil rights leaders are shown as agents of change for a just future. One portable, the other in situ, both murals declare the important message of *el movimiento* and recognize its potential to be rediscovered and transformed. Yet the current condition of both murals is a serious concern. The Del Rey mural, which had been presumed lost or destroyed, was recently located by Carissa García.[68] It had been stored without regard to environmental conditions and is at risk of erasure because of its fragile condition. The Garfield High School mural has substantial water damage and noticeable paint loss. It is unstable and is also at risk of erasure. It is imperative that academic and local communities find a way to preserve the murals before they deteriorate further. Digital technology is part of the solution, but only an investment in ongoing preservation will allow both artworks to be available for educating future generations.

Notes

1. I would like to acknowledge the guidance and support of Charlene Villaseñor Black and the Chicano Studies Research Center's librarian, Xaviera Flores. I sincerely appreciate the thoughtful and careful editing by Rebecca Frazier. Muchisimas gracias, my sincerest thanks, to Chicano artist Forrest Antonio Bernal Hopping for sharing knowledge and insight about his murals and the Chicano art movement. I also want to express my appreciation for the following libraries and archives: UC Santa Barbara Special Collections Library, El Teatro Campesino in San Juan Bautista, and Garfield High School, especially librarian Jeff Garcia. Research for this chapter was made possible by financial support from the UCLA Chicano Studies Research Center, the UCLA Institute of American Cultures, and the UCLA Graduate Division. I would like to thank colleague Carissa Garcia for the insight and local knowledge of the mural's legacy. Lastly, gracias to my husband Tony Gomez, and Ramiro and Teresa Rodriguez, mi papá y mamá, for the long discussions about my research.

Alan W. Barnett, *Community Murals: The People's Art* (Philadelphia: Art Alliance Press, 1984), 65–67; and Shifra M. Goldman and Tómas Ybarra-Frausto, *Arte Chicano: A Comprehensive Annotated Bibliography of Chicano Art, 1965–1981* (Berkeley: Chicano Studies Library, 1985), 34.

2. *Through Walls* played continuously in the "Murals" section of the exhibition at UCLA's Wight Art Gallery; see Alicia Gaspar de Alba, *Chicano Art: Inside/Outside the Master's House: Cultural Politics and the CARA Exhibition* (Austin: University of Texas Press, 1998), 3. The video, which was written and directed by Carlos Avila, produced and edited by Bill Wolfe, and narrated by Paulina Sahagun, features interviews with artists whose murals appeared in a slide show that was an element of the exhibition. *Through Walls*, VHS cassette, 8:15, 1990, *CARA* (*Chicano Art: Resistance and Affirmation*) Records, Part II, collection 11, box 44, Chicano Studies Research Center, University of California, Los Angeles. The videotape was produced by UCLA Instructional Media and copyrighted by Wight Art Gallery and the *CARA* National Advisory Committee. I viewed the video in 2018 at the Chicano Studies Research Center. Both parts of the mural are shown with voice-over narration by artist Emanuel Martinez, but neither the title of the mural nor Bernal's name is mentioned. The segment, which begins at around 3:16, includes this observation by Martinez: "Through murals they explored their spiritual and cultural connections to a Toltec, Aztec, and Mexican heritage. By affirming their history, artists endeavored to instill a sense of pride in the diverse Chicano communities throughout the country." The Del Rey mural was not included in the slide show and it is not listed in the catalog's exhibition checklist, which lists fifty-four murals. The *CARA* exhibition opened at Wight Art Gallery on December 9, 1990, and subsequently traveled to nine other cities: Denver,

Albuquerque, San Francisco, Fresno, Tucson, Washington, DC, El Paso, New York City (The Bronx), and San Antonio; see Richard Griswold del Castillo, Teresa McKenna, and Yvonne Yarbro-Bejarano, eds., *Chicano Art: Resistance and Affirmation, 1965–1985* (Los Angeles: UCLA Wight Art Gallery, 1991), 2.

3. Antonio Bernal Hopping, interview by Shifra M. Goldman (written notes), November 14, 1987, Montebello, California, box 27, folders 1-2, Shifra M. Goldman Papers, CEMA 119, Department of Special Collections, University Libraries, University of California Santa Barbara (hereafter cited as Goldman Papers); and Forrest Antonio Bernal Hopping, interview by Charlene Villaseñor Black and Gabriela Rodriguez-Gomez, July 23, 2018, Radisson Hotel Fresno Conference Center, Fresno, California (digital audio recording in the author's possession).

4. Goldman and Ybarra-Frausto, *Arte Chicano*, 32.

5. For "grassroots explosion" see Shifra M. Goldman, "How, Why, and When It All Happened: Chicano Murals of California," in *Signs from the Heart: Chicano California Murals*, ed. Eva Sperling Cockcroft and Holly Barnet-Sánchez (Venice, CA: Social and Public Art Resource Center), 23. For Chicano "renaissance" see Shifra M. Goldman, *Dimensions of the Americas: Art and Social Change in Latin America and the United States* (Chicago: University of Chicago Press, 1995), 300–1.

6. Goldman, *Dimensions of the Americas*, 300.

7. Shifra M. Goldman and Tomás Ybarra-Frausto, "The Political and Social Contexts of Chicano Art," in Griswold del Castillo, McKenna, and Yarbro-Bejarano, *Chicano Art*, 89.

8. Ibid., 88.

9. Barnett, *Community Murals*, 45.

10. Ibid., 65.

11. Ibid, 66.

12. Goldman, *Dimensions of the Americas*, 301.

13. Goldman and Ybarra-Frausto, *Arte Chicano*, 34.

14. Sam Kushner, "Comment: Campesino Culture," clipping from *People's World*, Los Angeles, Saturday, May 4, 1968, series 3, box 3, folder 8, El Teatro Campesino Archives, CEMA 5, Department of Special Collections, University Libraries, University of California, Santa Barbara (hereafter El Teatro Campesino Archives).

15. Kushner, "Comment: Campesino Culture." Kushner noted, "Here, Valdez and a staff of eight teach, organize, and act."

16. Antonio Bernal, curriculum vitae for 1987, box 27, folder 1, Goldman Papers. The document, which Bernal sent to Goldman, includes these dates: he left Los Angeles in 1966; moved to Fresno in 1967; then attended California State University, Fresno; attended California Art Center from 1962 to 1966. See also Charlene Villaseñor Black's biography in this volume.

17. Goldman and Ybarro-Frausto date the mural to 1968; see Goldman and Ybarro-Frausto, *Arte Chicano*, 34.

18. The dimensions were noted by Shifra M. Goldman in two separate sources. The dimensions given here are from Goldman, "How, Why, Where, and When It All Happened," 26. Goldman noted another measurement of 9 × 20 feet on the slide showing the mural. Shifra M. Goldman slide collection, series 2, box 5, Goldman Papers.

19. Bernal, interview by Goldman. Goldman wrote, "With team: Teatro people (about 2–3), but individualism such that A. B. did not develop or secure enough to allocate responsibilities."

20. Antonio Bernal, letter to Elizabeth Shepherd (curator, UCLA Wight Gallery), April 15, 1990, box 23, folder 3, *CARA* (*Chicano Art: Resistance and Affirmation*) Papers, 1985–1994, Part I, collection 10, Chicano Studies Research Center, University of California, Los Angeles.

21. Clipping from the *Fresno Bee*, August 25, 1968, series 3, box 3, folder 11, El Teatro Campesino Archives.

22. Bernal, letter to Shepherd. Whether the mural was used in other performances is a topic for further study.

23. Bernal, interview by Black and Rodriguez-Gomez, July 23, 2018.

24. Goldman, *Dimensions of the Americas*, 399.

25. Goldman, "How, Why, Where, and When It All Happened," 300.

26. See Mary Miller and Claudia Brittenham, *The Spectacle of the Late Maya Court: Reflections on the Murals of Bonampak* (University of Texas Press, 2013), 74–75. See also pages xvii (fig. 2), 39 (fig. 49), 72 (fig. 122), and 181 (infrared images of rooms 1, 2, and 3).

27. Goldman, *Dimensions of the Americas*, 399.

28. Bernal, interview by Goldman, November 14, 1987.

29. Dylan T. Miner, *Creating Aztlán: Chicano Art, Indigenous Sovereignty, and Lowriding Across Turtle Island* (Tucson: University of Arizona Press, 2014), 101. Miner observes that "although seven of the figures are men, they are being led by a woman *danzante*."

30. Frances S. Berdan and Patricia Reiff Anawalt, *The Essential Codex Mendoza* (Berkeley: University of California Press, 1997), 204.

31. Miner, *Creating Aztlán*, 101.

32. Bernal, interview by Goldman. Goldman's note states, "as a joke."

33. In an email correspondence with Antonio Bernal, October 12, 2020, he stated that the Maya noble at the front is holding a rattle. After reviewing the black and white photograph from El Teatro Campesino, I conclude that the figure is holding an incense holder.

34. Manuel Aguilar-Moreno, *Handbook to Life in the Aztec World* (New York: Facts on File Books, 2006), 199.

35. Cecelia F. Klein, "The Devil and the Skirt: An Iconographic Inquiry into the Pre-Hispanic Nature of the Tzitzimime," in *Ancient Mesoamerica* 11, no. 1 (2000): 9.

36. A photo of this Cihuateotl may be found here: http://www.mesoweb.org/es/materiales/MNA/92.html. Photographed by Jorge Pérez de Lara.

37. For a historical assessment of the soldadera, see Vicki L. Ruiz and Virginia Sánchez Korrol, *Latinas in the United States: A Historical Encyclopedia* (Indiana University Press, 2006), 690; and Elizabeth Salas, *Soldaderas in the Mexican Military: Myth and History* (Austin: University of Texas Press, 1990).

38. Goldman, *Dimensions of the Americas*, 399, 407n5. This photograph, which was previously attributed to German photographer Hugo Brehme and dated to 1911, is now considered the work of an unknown American photographer. See Mayra Mendoza Avilés, "El Zapata de Brehme: Análisis de un caso," *Alquimia* 36 (May–August 2009): 83–85, https://mediateca.inah.gob.mx/islandora_74/islandora/object/issue%3A624.

39. Michael Cucher, "Concrete Utopias from the Central Valley to Southern California: Repurposing Images of Emiliano Zapata in Chicana/o Murals," *Aztlán: A Journal of Chicano Studies* 43, no. 1 (2018): 41.

40. Alicia Arrizón, "*Soldaderas* and the Staging of the Mexican Revolution," in *The Drama Review* 42, no. 1 (1998): 90.

41. Bernal, interview by Black and Rodriguez-Gomez.

42. Vicki L. Ruiz and Virginia Sánchez Korrol, *Latinas in the United States: A Historical Encyclopedia* (Indiana University Press, 2006), 690. See also, Elizabeth Salas, *Soldaderas in the Mexican Military: Myth and History* (Austin: University of Texas Press, 1990).

43. The Treaty of Guadalupe Hidalgo was signed on February 2, 1848, and was not implemented until July 4, 1948. See the US National Archives website: https://www.archives.gov/education/lessons/guadalupe-hidalgo.

44. Goldman, *Dimensions of the Americas*, 301, 399.

45. Miner, *Creating Aztlán*, 101.

46. Mendoza Avilés, "El Zapata de Brehme, 83–85.

47. Cucher, "Concrete Utopias," 39; and Reed, *Art of Protest*, 123.

48. Bernal, interview by Black and Rodriguez-Gomez.

49. Reed, *Art of Protest*, 124.

50. Ibid., 123.

51. Bernal, interview by Black and Rodriguez-Gomez.

52. Malcolm X, "The Ballot or the Bullet" (1964), in *Malcolm X Speaks: Selected Speeches and Statements*, ed. George Breitman (New York: Grove Press, 1994), 43. Malcolm X also stated, "I hope you understand. Don't go out shooting people."

53. Bernal, interview by Black and Rodriguez-Gomez.

54. Bernal, interview by Goldman.

55. Bernal, letter to Shepherd.

56. Ibid. Bernal also noted, "I am currently teaching Spanish there, and as an experiment I ask them who Hemingway was. They all know that, but when I ask them who Neruda was, no one knows."

57. Ibid.

58. The central wall measures approximately 7 by 12 feet; the right wall measures approximately 7 × by 3 feet, 9 inches.

59. Bernal, letter to Shepherd.

60. Jaime E. Rodríguez O., *The Independence of Mexico and the Creation of the New Nation*, ed. Jaime E. Rodriguez O. (Los Angeles: UCLA Latin American Center Publications, 1989). See also Isauro Rionda Arreguín, *El Pípila: Héroe popular de la insurgencia* (Mexico: Archivo General del Estado de Guanajuato, 2002).

61. Guisela Latorre, *Walls of Empowerment: Chicano/a Indigenist Murals in California* (Austin: University of Texas Press, 2008), 5.

62. Ibid., 2.

63. Michael C. Meyer, William L. Sherman, and Susan M. Deeds, *The Course of Mexican History* (New York: Oxford University Press, 2011), 225–26.

64. Jack Autrey Dabbs, *The French Army in Mexico 1861–1867* (The Hague: Mouton & Co. Publishers, 1963), 28–32.

65. Meyer, Sherman, and Deeds, *Course of Mexican History*, 301.

66. Bernal, interview with Black and Rodriguez-Gomez.

67. An article in the *Los Angeles Times* states that Herrón was restoring the mural in 1990 and that partial funding for the restoration came from the Social Public Art and Resource Center (SPARC); see Zan Dubin, "Artist Giving a Face Lift to Mural of Mexican Hero," *Los Angeles Times*, August 17, 1990, https://www.latimes.com/archives/la-xpm-1990-08-17-ca-669-story.html. However, a story in the *Eastsider* in January 2021 about a restoration planned by the artist states that the mural has never been fully restored; see Antonio Mejías-Rentas, "Chicano Muralist Prepares to Restore His City Terrace Landmark," *The Eastsider*, January 20, 2021, https://www.theeastsiderla.com/neighborhoods/east_los_angeles/chicano-muralist-prepares-to-restore-his-city-terrace-landmark/article_066f1be4-5ac0-11eb-b3e7-1f2acbdf7aed.html. The building now houses Mercado Hidalgo.

68. Carissa García is an alumnus of UCLA's Chicana/o/x studies and Central American studies programs. The mural was located in 2018.

History's Happenings

Antonio Bernal's Del Rey Mural, Possibly in Performance, August 25, 1968

Miguel Samano

> Now that we had a name, some of the fragmented pieces began to fall together— who we were, what we were, how we had evolved. We began to get glimpses of what we might eventually become.
>
> —Gloria Anzaldúa, "How to Tame a Wild Tongue"

When El Teatro Campesino commissioned Antonio Bernal to paint a mural for its cultural center in Del Rey, California, sometime in early 1968, neither they nor he could have known that the resulting work would be a precursor of the Chicana/o muralism that would proliferate nationally two years later.[1] Consisting of two sections, each comprising three plywood panels painted with enamel, the mural flanked the entrance to El Centro Campesino Cultural, which occupied a storefront converted by El Teatro when the company moved to the small agricultural town in September 1967 (plates 1, 2).[2] The left section cites a Maya mural at Bonampak, Mexico, that portrays a procession of Maya elites wearing feathered headdresses, with the figures arranged in a single horizontal band. Bernal's rendering contains an important difference, though: a woman leads the procession.[3] This figure ties the left section to its companion on the right, in which a sequence of male figures from the nineteenth century to the late 1960s also

follows the lead of a woman warrior. This section depicts a progression of "admired leaders" for Mexican-descent peoples (as the majority of Del Rey's inhabitants were).[4] First, from left to right, are La Adelita, Emiliano Zapata, and Francisco "Pancho" Villa from the Mexican Revolution of 1910; all are accoutered with weapons and bandoliers. Following them are California bandit-hero Joaquín Murieta, César Chávez of the United Farm Workers (UFW), and Reies López Tijerina of the New Mexican land grant movement; these figures represent *mexicanos* on the US side of the border. Last in line are Malcolm X and Martin Luther King Jr., heroes in the nationwide movement that demanded increased civil rights for people of color. In sum, writes Shifra M. Goldman, Bernal "painted two murals on the outside walls of the Teatro Campesino headquarters that exemplify the iconography prevalent in the politicized [Chicano] murals of the 1970s."[5]

But Bernal's right mural section is also exceptional. As Goldman notes in her 1990 retrospective account of art iconography during the Chicano movement (c. 1965–early 1980s), this section is unique for its early depiction of a "suggested alliance between Mexicans and the African-American civil rights movement, which seldom again comes up so directly."[6] In what follows, I offer an account of this mural section's relation to a broader genre of art

objects, "the politicized [Chicano] murals of the 1970s," which centers this unique aspect of Bernal's work rather than the iconographic elements that it shares with those later murals. I do so by resituating both sections of the mural within what may have been their initial context of reception: the mural's dedication with a performance staged beside it by El Teatro for an audience of primarily Mexican-descent farmworkers in Del Rey on the evening of August 25, 1968.[7] Through his mural, Bernal may have intended to persuade those farmworkers to adopt a politicized Chicana/o identity as their own, but not necessarily because they recognized similarities between their personal experiences of social oppression and those of the figures in the mural whose ethnicity they shared, such as UFW leader Chávez. On the contrary, the interplay of the mural and El Teatro's performance may have brought into view a different basis for adopting that identity, one not dependent upon recognizing oneself as belonging to the same marginalized ethnic group as others. Namely, farmworkers could have recognized that their experiences were structurally similar, though not identical, to those of all the figures in the mural, whether Mexican-descent or not. As the two non-Mexican-descent figures in Bernal's mural, Malcolm X and Dr. King were central to his proposal for how the particular combination of iconographic elements that characterize Chicana/o murals as a genre should be interpreted in relation to the politics of a nascent Chicano movement.[8]

That Bernal's proposals about identity and art did not turn out to be widely adopted during the movement points to a risk in taking his mural to exemplify an entire genre of work. Beneath surface similarities of form, content, and conditions of display, shared across contexts, might lie underlying ideological disagreements between artists working in the same genre, including about what it means to do work in that genre. At the same time, the careful documentation of those similarities by prior generations of historians of Chicana/o art had to occur first; without it, the exceptional nature of Bernal's proposal cannot stand out in relief. I consider myself to be building on their example. Thus, in this essay's first section, I examine scholarship, exhibition history, and photographic reproduction of the Del Rey mural with the aim of establishing that attention to cross-contextual similarities underpins the discursive construction of Chicana/o murals as a genre, how these murals are beheld, and how they are documented. My aim is to inspire closer attention to contextual contiguity, that is, the relation between an object and its immediate contexts of production and reception, as a basis for thinking about genre. The second section then models a descriptive and explanatory practice attentive to contextual contiguity through my reading of Bernal's mural as in dialogue with a performance staged beside it.

Finally, in my concluding section, I briefly elaborate on the stakes of this competing account of genre for future art historical research on the Chicano movement, especially that focusing on artworks from early in the period. Bernal's proposal for what murals could accomplish may not have been widely adopted, but the value of researching art objects like his does not lie at the level of generality possible for retrospective accounts of the movement, like Goldman's. Instead, his mural demonstrates that artworks can function as arguments for how not yet programmatically articulated ideological positions, such as those in the period's manifestoes, should develop, rather than as a reflection of those positions. Through close attention to art like Bernal's, alternative paths for how the Chicano movement could have developed can be historicized.

The Discursive Construction of Chicana/o Murals as a Genre

Following scholarship by Goldman and Tomás Ybarra-Frausto, two pioneering historians of Chicana/o art, Bernal's mural has been widely regarded as the earliest known Chicano mural in California due to its convergence of pre-Columbian iconography, Mexican and Mexican American political figures, and civil rights icons, content that characterized subsequent murals produced mainly in the 1970s and early 1980s. During the 1980s and 1990s, this framing of the mural as an early example of Chicana/o muralism occurred in the context of efforts by Goldman, Ybarra-Frausto, and other early historians of Chicana/o art to establish Chicana/o murals as a coherent genre of politically engaged art practiced nationwide but with regional manifestations.

In "How, Why, Where, and When It All Happened: Chicano Murals of California" (1990), for example, Goldman justifies her discussion of Bernal's mural on the grounds that its sections "merit special attention not only for their early date, but for the example they present of iconography later prevalent in the politicized murals of the 1970s."9 Rhetorically, Goldman's choice to closely describe this mural is reinforced by its position as the first object she treats in depth within the body of the essay and by a reproduction of the right section that appears opposite the essay's opening page. Goldman concludes her discussion of the mural by noting that its iconography "encompasses the past events and personalities that most influenced the Chicano movement," a claim whose strength grows in proportion to the number of other objects that also exemplify this iconography and, through it, evince a relation to those "events and personalities."10

In the remainder of her essay, Goldman first presents a list of iconographic features categorized by theme and then describes other Chicano murals across California. Throughout, her discussion of the murals touches on "events and personalities" significant to the movement that are alluded to in Bernal's mural as well as in others. When one compares this list to her description and reproduction of Bernal's mural, the rhetorical role of the mural in her essay becomes clear. The framing of the mural as exemplary relies on its having predictive value as an antecedent to later murals and on its supporting cross-contextual comparisons to those murals based on shared iconography.

Goldman's framing supports her larger effort to document that there was a temporally and regionally extant practice of Chicano muralism, as does her framing of the mural in three other essays I will discuss. Nonetheless, the mural's predictive value and ability to support cross-contextual comparisons are insufficient criteria for considering it part of that genre, at least in the sense that Goldman and others seemingly intend it, that is, as having been politically engaged. Goldman recognized that the mural's surface features, such as its iconography, would also need to be explainable as causally connected to a set of ideological commitments held by Chicana/o muralists in response to a shared context:

> The mural movement resulted from an almost "spontaneous combustion," influenced directly or indirectly by the strikes and boycotts of the United Farm Workers Union, the militant Chicano Movement, and the spiritual and cultural concerns of writers and artists who were active in the movement. . . . Themes for murals were suggested to artists by contemporary events and the new philosophy of the Chicano movement.11

But she and Ybarra-Frausto too readily assume that Bernal and other muralists shared the *same* commitments. This is clear in their framing of both Bernal's mural and mural iconography more generally as restating portions

of the programmatic political and aesthetic ideology expressed in El Plan Espiritual de Aztlán (1969), an influential manifesto from the movement written a year after Bernal's mural was created. In the discussion below, it is important to keep in mind that Bernal and other muralists could have disagreed with each other and with the framers of El Plan, despite shared recourse to the same ideals and themes.

In 1985, Goldman and Ybarra-Frausto compiled Chicana/o art history's first comprehensive annotated bibliography, which included an introductory essay offering a historical overview of Chicano art. Within that discussion, the role of Bernal's mural in predicting and exemplifying an iconography extends even beyond California. In its iconography "are intertwined themes and allegiances that were later spelled out in thousands of Chicano murals across the country in multiple ways and combinations."[12] Prior to their description of the mural, the authors recount the importance of El Plan as a platform for developing an ideology for the Chicano movement. The mural and other art objects described in the section immediately following, "Issues and Images," are framed as reflections of the ideals and themes established in El Plan: "Thus, in a few pages of text, were established not only the ideals but also the themes of Chicano art."[13]

Five years later, in "The Iconography of Chicano Self-Determination: Race, Ethnicity, and Class," Goldman more expressly cast Bernal's mural as a restatement of the ideology elaborated in El Plan. She cites one of that document's more memorable lines, "We are a bronze people with a bronze culture," before proceeding to her description of the mural.[14] For Goldman, the mural effectively restates that line:

> Bernal applied the Maya style to modern as well as ancient personalities in order to establish a stylistic homogeneity. In what amounts

to an affirmation of racial pride, the Spanish (presumably white) lineage is deemphasized while the dark-skinned indigenous heritage is stressed.[15]

In context, her extensive description of the mural in this essay resembles that in her earlier and later writings. First, the mural "exemplif[ies] the iconography prevalent in the politicized murals of the 1970s," and so this iconography interpreted alongside the mural itself expresses the ideology outlined in El Plan.[16] The mural and El Plan itself are taken as standing in the same kind of relation to the shared set of structural conditions (anti-Mexican racism, colorism, economic exploitation, and so on) that motivated the writing of El Plan.

In "The Political and Social Contexts of Chicano Art" (1991), Goldman and Ybarra-Frausto finally imply a causal relationship between El Plan, iconography, Bernal's mural, and those structural conditions.[17] As in Goldman's previous essays, "Iconography" and ""How, Why, Where, and When," a reproduction of the mural's right section appears as the essay's first image. Yet, unlike in those essays, the image is accompanied not by a description of the mural but by a reading of El Plan that stresses its elaboration of an ideological program, framing the mural and its iconography as its visual restatement two pages before the description of the mural itself appears.[18] The closing line of their reading of El Plan nearly echoes that in their annotated bibliography, except that the document has been promoted from its previously passive role to a more active, causally efficacious one: "Thus a few pages of text *established* not only the ideals but also the themes of Chicano art and letters."[19] Whereas in Goldman and Ybarra-Frausto's annotated bibliography, the framers of El Plan had established the ideals it sets forth, here El Plan itself establishes those ideals; this attributes causal force to the document, linking it to objects made after it. But for

Bernal's mural, we can put aside the question of what causal force El Plan may have exerted, since he made the mural a year before the document appeared. We can then recognize that Goldman and Ybarra-Frausto leave us with a provocative reading of the relation between El Plan, iconography, Bernal's mural, and a shared set of structural conditions: that is, his mural anticipates the ideological program of El Plan and its recapitulation in later iconography, by virtue of all having been causally motivated by the same structural conditions.

Ybarra-Frausto's and Goldman's framing of Bernal's and later murals as restating portions of El Plan resonates with their statement on their methodology. They infer the causal motivation for an art object, which they refer to as "choice," in terms of similarity rather than contiguity:

> Any treatment of Chicano art history during the last fifteen years would have to take into consideration the conjunction of historical patterns attendant not only upon the emergence of the Chicano political movement, but of the ideological differences and conflicts within the realm of art history itself which affected aesthetic and conceptual formulations for hundreds of aspiring and maturing Chicano artists. In other words, choices had to be made by the artists. These concerned not only the needs of various political and social organizations which they served or organized, but the thematic emphasis, the style, and the artistic techniques which were to express a Chicano world view, a Chicano ethic, and a Chicano aesthetic, if such existed.[20]

For Ybarra-Frausto and Goldman, choice manifests primarily through the surface features of an object, its "thematic emphasis," "style," and "artistic techniques." Different choices can be distinguished from one another on the basis of similarities or dissimilarities between objects. On one hand, their conception of choice amply secures Chicano art as an internally diverse body of work, since artists did differ with respect to those features, and those differences could express divergent and sometimes competing ideological commitments, such as to internationalism, cultural nationalism, feminism, conceptualism, popular accessibility, and so on; as well, similarities along some dimension, such as shared thematic foci, help establish Chicano art as an internally coherent body of work distinct from other concurrent trends in art.[21] On the other hand, because their conception of choice depends on the identification of cross-contextual similarities or dissimilarities, Goldman and Ybarra-Frausto neglect to mention that the use of the same surface features need not imply similar or the same ideological commitments.

An alternative conception of choice might instead depend on the contiguity of that choice with what motivates it and how it will be received, both of which are context dependent. This conception would stress that Ybarra-Frausto's and Goldman's focus on cross-contextual similarities for discursively constructing Chicano murals as a genre was also contiguous with a particular set of motivations and context of reception, those related to the broader discursive construction of Chicano art as an internally diverse yet coherent body of work. That context mediates how Ybarra-Frausto and Goldman behold particular art objects, such as Bernal's mural. Closer attention to the role of contextual contiguity in beholding objects as belonging to a genre would suggest that different beholders can disagree on which cross-contextual similarities are relevant for them, and how, depending on what they deem characteristic about that genre. An exemplary disagreement about Chicana/o murals as a genre occurred at the first major retrospective exhibition of the Chicano movement, *Chicano Art: Resistance and Affirmation, 1965–1985*, known as *CARA*. This can be seen in the mismatch in reception between how Bernal's

mural was due to be exhibited and how Bernal himself claims his mural was first displayed, that is, as a stage prop for a performance.

In 1990 Bernal was contacted by Elizabeth Shepherd, the curator of the *CARA* exhibition. Shepherd requested reproductions of the mural's panels for inclusion in a slideshow of fifty-four murals produced between 1968 and 1983.[22] Though Bernal's mural ultimately did not appear in the slideshow,[23] grant documents from the exhibition attest that its organizers had strongly intended to include it,[24] under the impression that it anticipated iconographic elements more widely expressed after its creation: "Bernal's mural represents one of the earliest visual articulations of the pre-Columbian Mexican past on the left panel in relation to contemporary society on the right panel."[25] Bernal's response to the request, in contrast, attributes significance to his mural not in terms of cross-contextual similarities, but in terms of its contiguity with its context of reception. In his response, he writes that his mural "had no more significance [than] a stage prop, as it was used partly as a backdrop for the plays [of El Teatro]."[26] Bernal insists that the Del Rey mural was strictly intended for the farmworkers who attended El Teatro's plays, and he recalls that "the farmworkers who attended our plays received the murals well, and I remember they all lined up to shake hands and thank me for it."[27] In contrast, one prominent art critic critiqued the slideshow at *CARA* for its "diluted" representation of the "trademark form of Chicano art," namely "its powerful, raw murals"—a sentiment echoed by numerous exhibition attendees.[28] For Bernal and the *CARA* exhibition attendees alike, beholding a mural involves evaluating its surface features relative to that mural's contextual contiguity. If, as we will see, for Bernal this involves intending those features, for the attendees the judgment of a mural's reproduction as "diluted" points to

it being insufficiently contiguous with its context, unlike the actual "powerful, raw murals" some of them may have seen up close and in person.[29]

The contrast in reception illustrates how Chicana/o murals, as a genre, may be likened to the stage prop by some beholders if emphasis is placed on contextual contiguity rather than on cross-contextual similarities. The slideshow installation at *CARA* bears out this generalization. It consisted of the slideshow itself, with the beholder's line of sight focused on the mural plane as the murals were projected from a head-on perspective; a video loop of people driving or walking by the murals; and interviews with select muralists on their production processes.[30] In seeking to simulate what looking at a mural in person may have been like, the video loop effectively framed the distinction between the experience of a beholder in a mural's original environment and the experience of a beholder in a gallery as one of degree rather than kind. The reproduction of a mural differs from the mural itself in that the former ignores the importance of environment for interpretation of the latter. In this respect, at the slideshow, the importance of the beholder's presence before the mural could be said to have been neutralized. In contrast, when the mural is a stage prop, the beholder's presence in a shared situation with it allows the assignment of meaning to the object to occur progressively, relative to the beholder's comprehension of the scenario of a performance. Head-on projections at the installation also helped neutralize the presence of the beholder by diminishing each mural's sense of scale and its ability to be viewed from many vantage points. Yet for a stage prop, considerations of scale, the beholder's positioning, and the positioning of the prop are essential to its successful use. Moreover, the length of the artist interviews exceeded the time allotted to their respective murals in

the slideshow. This framed the murals as being more or less interchangeable: each mural's primary role, as well as the purpose of the artist interviews themselves, was to establish that the murals were similar to each other. A stage prop, however, cannot be important primarily in terms of its similarities to other props in other contexts; rather, it participates in the unfolding of a particular context as something whose meaning stems from being contiguous to it.

Chicana/o murals more generally could be conceived as stage prop–like in that their primary shared characteristic, as a genre, could be the importance of contextual contiguity for the assignment of meaning to their surface features, including their iconographic elements. This would mean that though the slideshow installation made cross-contextual comparisons of mural iconography possible, there could have been alternative approaches to doing so. One suggests itself in the difference between two photographic records of Bernal's mural. The first record depicts his mural as contiguous with a particular context, the façade of El Centro in Del Rey. In contrast, the second one anticipates that the mural's iconography will be most important for beholders in light of that iconography's cross-contextual recurrence. The records may depict one mural, but the documentation strategies themselves are generalizable, opening up into different accounts of genre, one emphasizing contiguity and the other not.

The first record hangs in a hallway at El Teatro's current headquarters in San Juan Bautista between photographs of El Teatro's previous headquarters in Delano and Fresno (all in California).[31] A black and white print by an unknown photographer, it must have been taken soon after Bernal completed the mural in 1968.[32] The photograph shows both mural sections and the entryway to El Centro

Campesino Cultural along with some of the two-story building's façade, the sidewalk, and a hint of the streets that form the intersection, Wildwood and Morro Avenue. Closest to the viewer, and dominating the image, is a telephone pole (see page 16). The entryway was photographed slightly off-center, with the post that supports the overhang visually rhyming with the pole. This composition draws the eye to the doorway of El Teatro's headquarters and, by association, to the organization itself. The mural sections recede on each side. The photograph, in short, situates the mural as part of the building.

The second reproduction comprises a pair of photographs that were made by Robert Sommer (plates 1, 2). They were taken in the 1970s, after El Teatro moved its headquarters to Fresno in 1969. The photograph of the right section was reproduced in the *CARA* catalog twice, in other writings by Goldman, in planning documents for the *CARA* exhibition, and in publications on Chicana/o art history as recently as a few years ago.[33] When Sommer's two images are juxtaposed, the mural sections appear head-on. In the photograph of the right section, the white paint of the wooden paneling to which the mural panels are affixed is nearly gone. In this section, the wooden grain behind the background layer of off-white paint peeps through, and tar-like splotches on the perimeter of the center panel indicate where creosote has leached through the wooden paneling.[34] Graffiti adorns El Centro's entryway, which is at the far left of the photo, having barely made it into the image.

The visual differences between the early photograph and Sommer's later ones register the passage of time. In the former, no graffiti adorns the entryway, the mural's paint looks freshly applied—King's suit is matte black—and the creosote stains have not appeared. Bernal recalls that El Teatro members covered

his mural with paper after he completed it, so that it could be unveiled to the farmworkers before El Teatro's performance on August 25, 1968. The covering surely also protected the mural; Bernal notes that Del Rey was "a notably arid and abandoned area" in 1968.[35] Turning once more to Sommer's particular record of the mural, my provisional explanation of its differences from El Teatro's image is that it was likely shaped by his expectation that his photograph's beholders would be most interested in the mural's iconography, not in the contiguity of that iconography with the mural's setting and time-bound use as a component of El Centro.

Presumably what needed to be intelligible to his image's anticipated beholders was that the mural was a pairing of sections, not components of a building facade. Had Sommer stood closer, his anticipated viewers would not have been able to assess the iconography within the compositional space of the sections. And had he stood farther away or not taken his images head-on, the iconography would have been harder to make out, as it is in El Teatro's image. Sommer's distance from the mural sections suggests that, for his anticipated beholders, the mural's iconography is to be interpreted through its potential for cross-contextual recurrence, not in light of the particular context in which it actually occurs.

The cross-contextual recurrence of the iconography that characterizes Chicana/o murals as a genre, however, can pose a barrier to recognizing how beholders can assign meaning to murals on the basis of their being contiguous with the works. Certainly, most of these iconographic elements, such as civil rights leaders, figures from the Mexican Revolution, and citations of pre-Columbian history, were in circulation in the broader US culture of the late 1960s prior to their inclusion in even the earliest Chicana/o murals, like Bernal's. That is, because these elements sometimes predate

Chicana/o murals and recur widely, beholders may have already known what those elements mean. This account can be only partly correct, however, as it neglects how every encounter between a mural and its beholders re-mediates iconography, potentially altering what it means.

Two recent methodologically astute entries in scholarship on Chicana/o murals account for the importance of context for re-mediating iconography, but the emphases that they place on contextual contiguity differ from my own. Specifically, neither of these entries claims that a mural itself proposes how the meaning of iconography should change for its original beholders. In Michael Cucher's recent readings of early Chicano murals "through conceptual frameworks that were not available in the 1960s and 1970s," re-mediation occurs due to the application of these frameworks, not the mural itself.[36] Moreover, while the recognition of the "additional usable pasts of activist women" that Cucher identifies in Bernal's mural does hinge on a relation of contextual contiguity, it is that of the mural's original beholders: "Contemporary viewers have options for learning about these feminist histories that were not available when Bernal's work first appeared."[37] In contrast, my methodological approach aims to recover a conceptual framework that could have been proposed by Bernal's mural in Del Rey in 1968. In taking this mural as proposing what its iconography should mean, my approach also differs from that exemplified in Cary Cordova's admirably thorough close readings of two murals in San Francisco's Mission District as "cultural texts," rather than "transparent propaganda."[38] Cordova demonstrates that, in their immediate contexts of reception, those murals "evoke special meaning for locals" but not always for "the general public."[39] While she demonstrates what prior knowledge of iconography some beholders could have brought to bear on murals, I show how murals

can revise that knowledge when they propose new interpretations of that iconography. If, like Cucher and Cordova, I attend to the meaning of a mural as being assigned due to its contextual contiguity with its beholders, my approach differs from theirs in asserting that contiguity can inform how beholders interpret elements of that mural that recur cross-contextually. In saying this, I mean to suggest that some murals deserve closer attention than others on the grounds that they propose how other works in their genre should be interpreted. As we will see, Bernal's mural is such a mural.

Proposals about Chicana/o Identity and Art Made through a Mural

I noted above that, through his mural, Bernal intended to persuade Mexican-descent farmworkers to adopt a politicized Chicana/o identity on the basis of similarities between their experiences of oppression and those of differently oppressed, that is, nonidentical, social groups. In this section I will demonstrate that this proposal about identity and his proposal about genre are analogous with respect to how personal experiences and the features of murals come to be interpreted as meaningful. For both proposals, a relation of contiguity, between a farmworker and other farmworkers as well as between a beholder and Bernal's mural, provides the basis on which cross-contextual similarities can be identified. Below, I refer to the mode of cross-contextual interpretation where relations of similarity follow upon those of contiguity as homologous. In a homology, two superficially dissimilar homologues can be recognized as similar if they are both contiguous to the same thing, such as if they share a cause. In Bernal's proposal about identity, the superficially dissimilar experiences of differently oppressed people can be recognized

as homologous because all of them are causally motivated by the class structure. The adoption of Chicana/o identity by the farmworkers would name their recognition of this.

Bernal's proposal about genre builds on homologous interpretation. The beholders of his mural would have been able to interpret the broad cross-contextual recurrence of Chicana/o mural iconography as being only secondarily about Mexican Americans, the particular forms of social oppression they have endured, and the Chicano political movement that arose in response. That iconography would be seen as primarily motivated by a desire to contest existing social arrangements in a class society broadly, a desire shared with other oppressed social groups. Taken together, Bernal's proposals are rejoinders to the movement-era ethnic nationalism of manifestoes like El Plan in that he conceives of Chicana/o identity and art alike as being meaningful expressions of one's intention to be in coalition with homologous others, Mexican-descent or not.

In order to support my reading of Bernal's mural as having made two proposals to farmworkers in Del Rey, I must account for how they understood their personal experiences prior to beholding the mural as used in performance and then afterward. Likewise, to attribute these proposals to Bernal and his mural, rather than to the members of El Teatro Campesino and their performances, I must describe what Bernal and El Teatro understood by the adoption of a politicized Chicana/o identity.

I'll begin with El Teatro's decision to move to Del Rey and establish a cultural center there in late 1967.[40] When El Teatro was founded in Delano in 1965, it was the "cultural and propagandistic arm" of the UFW.[41] The move to Del Rey came after the completion of El Teatro's first national tour and in response to director Luis Valdez's expressed desire to break away from the UFW in order to grow his company.

This decision would be perplexing had Valdez not envisioned El Teatro as a people's theater.[42] At the time, Del Rey had a population that doubled to 2,000 during the harvest season, suggesting that migrant farmworker labor fueled the town's economy during the summer.[43] Given that the UFW would not convince California growers to sign a union contract until 1970, farmworkers in Del Rey would have had long working days and substandard pay. They would have had neither the means nor the time to pursue theater as a leisure activity.[44] El Teatro moved to Del Rey because its members were concerned with the cultural and economic oppression of the town's largely Mexican migrant and Mexican American farmworker population.[45] As early as October 1967, El Teatro had a prospectus that set forth a goal of providing Mexican migrant and Mexican American farmworkers their long-denied "tools of cultural expression" through activities at El Centro and El Teatro's performances.[46] This goal persisted throughout El Teatro's tenure there. After El Centro officially opened on January 16, 1968, Valdez affirmed that El Teatro grew through "a recognition of the significance of the use of culture, music, and folk arts as a way of maintaining the spirit and militancy of a people."[47] For Valdez and El Teatro, the move to Del Rey was undergirded by a social and political vision of consciousness raising. He continued to voice the hope that El Centro would be a center for Mexican migrants and Mexican Americans throughout the Southwest up to the moment of El Teatro's departure for Fresno in early 1969.[48]

Beginning with the opening of El Centro, the company's educational "History Happenings" reflected that vision. These were biweekly events consisting of one-act plays, or *actos*, puppet shows, and music that focused on "successive chapters of Mexican and American history."[49] The History Happenings suggest that El Teatro presumed that farmworkers had not previously had access to that history, and these events also helped shift the group's thematic focus after it ended its close association with the UFW. El Teatro's theatrical corpus expanded from a focus on farmworkers to cover a variety of contemporary, synchronic issues faced by Mexican Americans across the country, such as educational reform and the Vietnam War, as well as contemporized, diachronic accounts linking pre-Columbian America to present-day Mexican Americans.[50] This thematic expansion coincided with the participation of Valdez and other El Teatro members in the burgeoning Chicano movement and appears to reflect their own nascent, self-reflexive adoption of a politicized Chicana/o identity (fig. 1).[51] In this sense, it also departed from a key principle underlying the farmworker actos from their Delano period. El Teatro's members could no longer assume that their knowledge of the scenarios referenced in the plays matched that of their core audience of farmworkers.[52] In an additional departure from the earlier farmworker actos that were usually staged on or near the UFW strike lines, the actos in Del Rey—including performances of the farmworker actos—did not lend themselves to spurring immediate political action such as joining a union.[53] These new actos and reprisals of old actos were instead directed at symbolic action. As Valdez would write in the 1971 collection containing actos from the Delano and Del Rey periods and afterward, "Chicano theater," as opposed to merely farmworkers' theater, must "educate the pueblo toward an appreciation of *social change*, on and off the stage."[54] Indeed, in September 1968, Valdez specifically cited the History Happenings as evidence that El Teatro wished to concern itself with "the cultural as well as the economic oppression of [the Chicano] people, whose consciousness as well as their land [has] been invaded by the

Figure 1. Guadalupe Saavedra with Luis Valdez and Agustín Lira at a rally to free the LA 13 at La Placita, Los Angeles, 1968. Lira was a member of El Teatro Campesino and Saavedra was the founder of El Teatro Chicano. The LA 13 were activists who were indicted on conspiracy charges for their role in organizing the East Los Angeles blowouts, when Mexican American students walked out of classes to protest systemic educational inequality. Photography by *La Raza* staff. Image courtesy of UCLA Chicano Studies Research Center.

Anglo."[55] As events that offered actos from the Del Rey and Delano corpora in addition to other activities at El Centro, History Happenings manifested Valdez's and El Teatro's desire to spur the farmworkers' adoption of a politicized Chicana/o identity by educating them on the aforementioned social issues.

The History Happenings were likely key to provoking the shift in understanding of one's personal experiences required for the adoption of that identity. Valdez recalls finding inspiration for the History Happenings while he was a member of the San Francisco Mime Troupe, an experimental Marxist theater group. He suggests that the History Happening, in name and in its formal elements, may have been meant to evoke the Happening, a form of performance

art developed in the late 1950s.[56] In a Happening, performers did not portray fictionalized characters in a set time and place; rather, they portrayed themselves.[57] El Teatro had around eight members at this time who performed different parts in successive actos. In the History Happenings they framed their bodies as allegorizing something outside of any particular acto: the shared structural position of being Chicana/o.[58] The influence of the Happenings' compartmentalization of performance into simultaneous or successive nonnarrative scenes can also be seen in the History Happenings' reconfiguration of spatially and temporally dispersed events represented across the actos as interchangeable components in a shared history.[59] This interchangeability of event for event

may have been a strategy for convincing farmworkers to recognize that their situation was homologous to that of others. The laughs and excitement elicited through constant slapstick and the satirical quality of many of El Teatro's actos may have helped farmworkers perceive that their shared embodied reaction to each play was due to its genre as a homologous scenario of Chicana/o oppression.

The farmworker plays from the Delano period were crucial to the success of the History Happenings as catalysts for that shift in understanding of personal experiences as homologous to those of others, but they could not, by themselves, be the catalysts. In these actos, the same embodied reactions to the other actos were likely experienced as shared among audience members due to an identification between the farmworkers in the audience and the farmworkers depicted in the plays. Farmworkers were likely aware that what they were reacting to in these actos was a shared experience that arose from their shared structural position as farmworkers. For these actos, important interpretive questions arise. Were the farmworkers in Del Rey able to acquire a politicized Chicana/o identity on the basis of a shared ethnic group experience, one we retrospectively recognize as held in common with other self-identified Chicana/os, or on the basis of a shared position within the class structure? Which basis was prior in importance for the adoption of Chicana/o identity among the farmworkers? How does the order of priority align the adoption of that identity among the farmworkers in Del Rey with that elsewhere, at other times, and among other historical subjects during the Chicano movement? The farmworker actos, the other actos that made up the History Happenings, and—crucially—Bernal's mural were primarily directed toward a grasp of the farmworkers' positioning in the class structure. Once farmworkers

recognized that the characters in the plays were oppressed because they were farmworkers, they could view the Mexican migrant and Mexican American protagonists of the other actos as oppressed not on the basis of a shared ethnic group experience, but on account of a positioning in the class structure homologous to that of differently racialized others.

Turning now to the mural as used in performance, Bernal remembers painting his mural as a backdrop to the "plays about the grape strike," the farmworker actos developed by El Teatro during its Delano period.[60] It is not possible to determine exactly which acto was performed in front of the mural, or whether more than one acto was presented.[61] Nonetheless, Bernal's depiction in his mural of a César Chávez figure holding a pair of pruning shears suggests that it may have been *Las dos caras del patroncito* (1965). One of two published actos to mention Chávez, *Dos caras* also stars a farmworker protagonist employed to prune grape vines. *Dos caras*, which was frequently staged on the bed of a flatbed truck with a minimal set, had only three roles, a small number of props (signs, pruning shears, and a yellow pig mask), and infrequent stage exits and entrances.[62] The play was highly portable and therefore a suitable candidate for El Teatro's first performance with an outdoor mural as a backdrop. Indeed, Valdez recalls El Teatro members performing on top of a flatbed truck parked outside of El Centro on the night of the mural's unveiling.[63] The truck may have been parked in front of El Centro, so that the two sections of Bernal's mural would flank this makeshift stage and recede backward at diagonals from it. I presume that *Dos caras* was staged beside the mural sections, but I also ground my reasoning about that acto's formal features in readings of scenes that have parallels in the other published farmworker acto, *Quinta temporada* (1966), as well as in actos developed during

El Teatro's Del Rey period, such as *Los vendidos* (1967).[64] Within the context of the History Happenings, the staging of acto after acto may have drawn attention to these similarities, which distinguished the performance of the farmworker actos in Del Rey from those in Delano. Rather than promoting the infrastructural intervention of joining the union, the staging of a farmworker acto in Del Rey would have encouraged audience members to identify as Chicana/os.

Dos caras has previously been read as bestowing onto farmworkers the recognition that their circumstances were oppressive. Such recognition, though a necessary step toward grasping those circumstances as homologous to others, is still insufficient. A basis for the attribution of meaning as local instances of broader patterns, the effects of shared structural conditions, is also needed. As the divergence between theater historian Jorge Huerta's readings of *Dos caras* and my own will clarify, El Teatro's plays up to the Del Rey period have not yet been read as being capable of providing such a basis. For Huerta, who reads the acto as if it were staged on the strike lines, *Dos caras* is "an allegorical situation . . . [in which] the exposition needed to demonstrate the conditions suffered by the worker simultaneously enlightens the audience." The acto realizes this function from its first lines, which present "a great deal of information to the audience."[65]

> FARMWORKER: (*To audience.*) ¡Buenos días! This is the ranch of my patroncito, and I come here to prune grape vines. My patrón bring me all the way from Mexico here to California, the land of sun and money! More sun than money. But I better get to jalar now because my patroncito he don't like to see me talking to strangers.[66]

With the farmworker's monologue, the play breaks away from "any pretense at theatrical realism" because this character directly addresses the audience.[67] *Quinta temporada* also opens with a direct address, leading Huerta to note that "again, direct communication with the audience sets the time and place and establishes the objective . . . both characters [a farmworker and a farm-labor contractor] wear signs identifying their social roles."[68] Huerta and I agree that El Teatro's farmworker actos are indebted to and rework Bertolt Brecht's epic-theater tradition.[69] In that tradition, the determinants of the play scenario are not the characters themselves but the underlying structural forces motivating their actions. Correspondingly, the audience would come to see their own lives as included within that social totality to which the play alludes.[70] In Del Rey, however, the Brechtian influence on *Dos caras* and *Quinta temporada*—an influence to which Valdez has repeatedly attested— meant that those plays would have moved past informing the farmworkers of their conditions and suggesting the union as a potential "solution" to those conditions; instead, the actos would have sought to radically affect the farmworkers' attribution of a structural cause to those conditions, beyond the proximate causes that Huerta identifies.[71]

In Del Rey, features that used to be central to communicating information become marginal for modeling a method of meaning attribution, and vice versa. With respect to *Dos caras*, Huerta infers that the "strangers" the farmworker character does not wish to be seen talking to include the striking farmworkers who were among the members of El Teatro's audience, but this inference fails to find support when the acto is imagined as staged outside of El Centro at a remove from the strike lines.[72] In the Delano performances of *Dos caras*, the signs worn around the farmworker and patrón characters' necks, the farmworker's pruning shears, the patrón's pig mask, the farmworker's pantomime of pruning vines, and the

patrón's comically exaggerated entry into the scene helped the audience quickly identify the characters' roles. In Del Rey the use of such features would have been redundant. Unlike in the strike fields, where "the neophyte Teatro members often had to compete with blaring radios or honking cars" by emphasizing the visual and gestural over the verbal, in Del Rey the dialogue would have likely been sufficient to convey the details of the play's scenario and setting.[73] Props and gestures may have been more significant for framing the acto's characters as important, not as identifiable roles within the acto's scenario but as elements of the social totality to which the acto alludes. The staging of *Dos caras* in Del Rey would have offered a way of attributing meaning to others that viewed them in terms of character types—theatrical representations of structural positions—considered in light of social origins and trajectories.

As the scenario progresses, the farmworker character shifts from introducing a way of reading an underlying structural cause in character types, elements of setting, and motivations to suggesting how it occasions a self-reflexive awareness of one's position within the class structure. The farmworker "can play the 'dumb Mexican' only as long as he is not threatened. . . . His entire opening monologue is given in English, but once the boss enters he assumes the passive, lowly worker role. . . . And his physical gestures are all calculated to demonstrate his subservient position."[74] The farmworker character knows that he is not reducible to his role but that expectations for his role require him to strategically perform it in service of his self-preservation. For Huerta, there is no parallel experiential basis for such knowledge on the part of the patrón. Instead, the patrón holds "a false and myopic view of what it is like to be one of his workers," right up until he switches props with the farmworker

and, in doing so, switches structural positions.[75] Once the farmworker-turned-patrón offers to pay the patrón less than he was being paid, the realization of class oppression, and a partial solution for it, dawns on the boss:

> PATRONCITO: Oh no, this is too much. You've gone too far, boy. I think you better give me back my things. (*He takes off* FARM-WORKER'*s sign and hat, throws down shears and tells the audience.*) You know that damn Cesar Chávez is right? You can't do this work for less than two dollars an hour. No, boy, I think we've played enough. Give me back . . .[76]

In Delano, this imaginative transposition of two different class roles did not aim for systemic change but rather for the narrower, though contextually important, act of divulging information and offering a solution in the form of the union metonymically represented by Chávez.[77]

A shift in context at Del Rey foregrounds the realization of a nonidentical relationship to one's position in the class structure as a constitutive element of a self-reflexive awareness of structure. In *Dos caras*, the patrón acknowledges that the intensely imagistic description of agricultural work he has just finished recounting to the farmworker is not a report of the patrón's own experience. This suggests a basis for a grasp of that nonidentical relationship other than lived experience and, by extension, shared ethnic group experience:

> PATRONCITO: [. . .] Those commie bastards say I don't know what hard work is, that I exploit my workers. But look at all them vines, boy! (*Waves an arm toward the audience.*) Who the hell do they think planted all them vines with his own bare hands? Working from sun up to sunset! Shoving vine shoots into the ground! With blood pouring out of his fingernails. Working in the heat, the frost, the fog, the sleet! (FARMWORKER *has been jumping up and down trying to answer him.*)
>
> FARMWORKER: You, patrón, you!

PATRONCITO: (*Matter of factly.*) Naw, my grandfather, he worked his ass off out here. But, I inherited it, and it's all mine![78]

Indeed, the patrón character anticipates one critique of a shared experiential basis for adopting an identity: the possibility of false consciousness. An objection grounding knowledge of structure in experience may be that people can mistake a proximal cause for a structural one. The farmworker has been taken in by a representation of an experience, only to be disillusioned when the patrón accounts for his knowledge of experience on the basis of its social origin and trajectory. In later actos, similar ploys by characters standing in for dominant positions in the class structure are rejected by the characters who represent the working class. In *Quinta temporada*, the farmworker refuses to accept that the farm-labor contractor is his friend solely on the basis of a shared ethnic subject position:

COYOTE: No! No, I'm your friend.

WORKER: Ni madre! You're a thief!

COYOTE: No, soy tu amigo. ¡Somos de la misma raza!

WORKER: ¡Simón, eres rata![79]

Los vendidos explicitly thematizes the possibility of a nonidentical relationship to one's social role conditioning a self-reflexive awareness of one's position in the class structure. In this acto, set in a lot selling "used Mexicans," an assimilationist Mexican American woman is duped by various caricatures of Mexicans and Mexican Americans into "purchasing" her double, another assimilated Mexican American, whereupon he and the other caricatures turn on her and chase her out of the lot.[80] The proprietor of the lot, a labor contractor turned salesman, however, announces this lesson of non-identity early on. His greeting to the assimilated woman, "Ah, una chicana!," should

not be understood as precipitating the failed interpellation of the woman into Chicana/o culture, as Huerta claims.[81] Far more radically, it points to the need for an emergent understanding of one's identity that moves past superficial similarities and instead recognizes identity as the effect of structural causes, causes that could impinge differently on differently oppressed people. *Dos caras* and other actos that might have been staged in Del Rey do not offer a positive account of this emergent understanding, even though they register nonidentity as a problem.

In his mural, Bernal revaluates this problem as a basis for adopting a Chicana/o identity. The mural posits that self-identified Chicana/os understand themselves as such through nonidentical homologous identifications with others. We can begin by accounting for these acts of identification through the Chávez figure. A farmworker's attention would likely be drawn first to this figure, early on in the duration of *Dos caras*, because it holds a flag emblazoned with the UFW thunderbird and represents a figure well known among farmworker communities in the San Joaquin Valley. The figure's flag leads the eye along the slant of the thin black pole toward the figure's body and the pruning shears he holds in the opposite hand. Depicted in a three-quarters pose with his left leg slightly bent at the knee, Chávez appears poised to march with a flag in one hand and shears in the other. His depiction likely inspired the farmworkers' identification with Chávez. This is reinforced by Bernal's choice to clothe the figure in a nondescript red plaid shirt and by El Teatro's choice to identify their acto's farmworker character through a pair of shears. That is, though the "real" Chávez's political acumen as a labor organizer distinguished him as the leader of the UFW, his depiction here plays a different role. The figure's clothing and the objects

it holds, as well as its similarity to the physical mien of the farmworker in *Dos caras*, frame Chávez as an exceptional everyman. Indeed, the figure's visual similarity to a rank-and-file striker, someone who we can imagine would not have had time to put away his shears before joining a UFW march, prefigures the patrón character's call for a strike at the conclusion of the acto. Bernal's mural sought to trigger an identification between Chávez, the farmworker character, the patrón-turned-farmworker, and farmworkers in the audience.

In a context in which joining the union, the solution offered in *Dos caras*, may have seemed the less immediate option given the distance between Delano and Del Rey, Bernal also provides a visual argument for how non-identity could become the basis for realizing a coalitional politics. In this instance, the symbolic form of this politics—a mass identification between the farmworkers and homologous others—would arise from the encounter with the mural. Like the Chávez figure, the Tijerina figure in the mural premises an identification between Tijerina and the farmworkers. This identification could be glossed as being between the land grant movement in New Mexico and farmworker organizing in California and thus as representing the struggles of different groups of Mexican-descent people. Bernal's depiction of Tijerina, though, undercuts such an identification on the basis of intragroup solidarity. His Tijerina clasps a document that reads "TRATADO de GUADALUPE HIDALGO," enabling farmworkers who are literate in Spanish but not English to identify it as the treaty marking the end of the Mexican-American War in 1848. This treaty stipulated that Mexican nationals residing in the US Southwest would have their land claims upheld by the United States government. Despite this stipulation, their descendants were dispossessed of their lands over the next century and into the

1960s. Aside from leading Tijerina to agitate for land grants to be respected, the treaty distinguishes ethnic Mexicans who can trace their descent to people living in the United States prior to 1848 from all other ethnic Mexicans, including most Mexican migrant farmworkers as well as a significant portion of Mexican American farmworkers. Tijerina's advocacy for land grants could not have encompassed these farmworkers. For Bernal, the farmworkers' identification with Tijerina, and with the Mexican Americans Tijerina metonymically represents, existed on a basis other than intragroup solidarity, as implied by the similarity between Tijerina's nondescript white shirt and Chávez's red shirt. The visual rhyme suggests that Bernal intended his farmworker audience to identify with the figure of Tijerina as well as with the figure of Chávez.

Reading the Chávez-Tijerina figural pairing alongside the Malcolm X figure to its left clarifies how this act of identification is a nonidentical homologous identification. The figure that Bernal has identified as a portrait of Malcolm X wears a vertically striped blue and black dashiki and a Panther-emblazoned white tee and holds a machine gun at his side, which visually associates him with the Black Panthers.[82] The black-framed glasses, the ambiguous play of shadow and black hair-like patches on the chin, and the unsaturated dark-brown curls fading into the scalp more clearly identify the figure as Malcolm X. Read as a composite figure, it offers a jarring articulation of the politics of Malcolm X and the Panthers. Bernal sees no irresolvable tension in the figure. While discussing a separate work, he recalled that "Malcolm was assassinated in 1966, and the Panthers were around in 1966. Back in LA, I remember asking a Panther if they would object to my painting him with a panther and a dashiki, and they said no."[83] In his mural, the figuring of mainstream civil rights figures such

as King and Black radicals like Malcolm X and the Panthers as similar grounds an identification of the pairing as fellow radicals.

Despite their political differences, then, nonidentical, homologous identification makes coalitional politics imaginable in and through the Malcolm X–Black Panther figure. The tension between Chávez's and Tijerina's politics with regard to which group was targeted by their advocacy efforts may be similarly resolved by identifying Tijerina with Chávez. The Malcolm X–Black Panther figure nestles his fingers softly over the Tijerina figure's shoulder, visually joining the two figures despite the lack of a direct historical connection between Black radical politics and Tijerina's land grant movement. The mural, however, encrypts the connection through the sequential repetition of three-quarter poses, the objects clutched in the figures' hands, and the use of clothes as costumes, signifying a role that can be imaginatively adopted as one's own. Admittedly, though, the farmworkers in Del Rey would have been unlikely to perform such a reading of the mural absent some form of model, or the activation of a model that had previously been only latent. Bernal's mural may have activated the History Happenings generally and actos such as *Dos caras* in particular as formal models for meaning attribution.

In activating these performances as formal models for meaning attribution, Bernal's mural directly affected how its beholders would attribute meaning to other objects cross-contextually. At the same time, the mural provides for the emergent understanding of oneself as Chicana/o that Bernal proposes its beholders adopt. Beginning with Chávez as the most immediate locus of identification for a farmworker, Bernal's argument for that understanding radiates outward in two directions. Moving toward the left of the composition, the eye traces horizontally and upward into the past, across a sequence of increasingly mythicized figures extending into the pre-Columbian procession in the mural's other section. This is the diachronic axis of narrative construction where the past is infused into the meaning of the present with the stability of myth. Structurally oppressed Chicana/os, such as the farmworkers, become the inheritors of a monumental legacy investing their present actions with the effectiveness of knowing that their ancestors, whether proximal and material like the revolutionary war heroes and Murieta or distant and imagined like the members of the pre-Columbian procession, achieved greatness and mightily resisted their historical antagonists. Moving toward the right of the composition, the eye does not shift vertically. This is the synchronic axis of historical narrative construction whereby contemporary struggles elsewhere and by other people not only analogize to one's own struggle but transfigure it from a local occurrence into an instance of a globalized phenomenon. The common movement-era refrain, "Chicano Power," carried the semantic load of invigorating the Mexican American past as a source of self-affirmation, but it did so through its similarity to the rallying call of the Black Power movement. If the mural insists on drawing tenuous connections between pre-Columbian cultures and contemporary Mexicans and Mexican Americans, it equally invigorates this strategic marshalling of the past as a resource for the present that is nonexperiential in nature. This resource is as unequally derived from experience as the connections to other differently racialized yet similarly positioned historical and contemporary others. Through his mural, Bernal urges that experience be grasped as contiguously related to underlying structural conditions. In being graspable as contiguous, the experience of a beholder can be related to that of others. It can

then be marshalled as a basis for an identification whose true conditions are structural in nature. These conditions are as encapsulating of others as they are pervasive.

A Chicano Movement that Was Not to Come

For the farmworkers who beheld Bernal's mural in Del Rey, its depiction of the Black Panthers, Malcolm X, and Dr. King did not supplement a prior recognition of themselves as Chicana/os. Rather, identification with these figures made it possible for these beholders to begin identifying as Chicana/os and, in turn, to interpret features of other murals as pointing toward coalition building with others as the basis for being able to think of oneself as Chicana/o at all. In contrast to what could have, in 1968, been legible as one artist's proposals for what Chicana/o art and identity might be conceptualized to mean for a still nascent political movement, in 2021 Bernal and his mural stand out in relief as exceptional, given what we know about how movement politics and art actually developed. Bernal's own retrospective explanation of events that occurred more than a half century earlier also presumes an audience who, like him, already knows what actually became of the movement:

> This points to a very important issue in The Movement[:] Divide and Conquer. The ruling class will always tolerate Chicano Movements and Black Movements and whatever, as long as they don't hook up with each other, what is now called intersectionality. The proper word is SOLIDARITY. . . . Sticking to just a narrow part of a movement, and refusing to hook up with others, is completely reactionary and only helps the power structure to stay intact.[84]

Bernal's explanation is full of sorrow. Juxtaposed against my reading of his mural, his explanation suggests that he, as the movement-era historical actor who made the mural, did not expect or intend a future from which he, as a post-movement observer of his younger self, could retrospect on solidarity as having failed to widely materialize. Movement-era solidarity is clearly being mourned in his explanation; it is the stillborn product of his mural's proposal.

I have been unable to locate anything as definitive as a picture or other period account that would "prove" that Bernal's mural was used in performance. The question remains an open one. But if my historical reconstructions, close readings, and formal analyses have been at all convincing, the question of whether such a performance was possible has now been settled. As I have suggested here through an explanatory and descriptive practice attentive to what artworks propose to their beholders, attention to what could have happened, rather than what did happen, can aid in historicizing how actors in a political movement may have imagined its development. Turning back to my epigraph, Bernal and the farmworkers who beheld his mural in 1968 began, like Gloria Anzaldúa, "to get glimpses of what we might eventually become." His and their vision of the future is part of the history of the Chicano movement and its art despite not having been borne out.

Notes

1. I gratefully acknowledge Antonio Bernal and Luis Valdez for their generosity with their time. I would also like to thank Jorge Huerta for discussing my readings of El Teatro's actos with me; the staff of the UCLA Chicano Studies Research Center and the UCSB California Ethnic and Multicultural Archive for research assistance; and Louisa Munoz of El Teatro Campesino for help in securing permissions. A Stanford Undergraduate Advising and Research Major Grant and the Escobedo Fund at the Stanford Center for Comparative Studies in Race and Ethnicity provided financial support for archival research. I presented a preliminary version of my argument at the 2019 Latino Art Now! conference and am grateful to the conference committee and my audience. Finally, I am immensely grateful to Michele Elam, Karina Gutierrez,

Marci Kwon, Jonathan Leal, and Ramón Saldívar for their guidance and advice during the earliest stages of this project.

2. Jorge A. Huerta, *Chicano Theater: Themes and Forms* (Ypsilanti, MI: Bilingual Press, 1982), 64. El Centro, though, did not officially open to the public until January 1968. Robert Francis Jenkins, "A Description of Working Principles and Procedures Employed by Selected Peoples' Theater Groups in the United States" (PhD diss., Florida State University School of Theater, 1980), 171.

3. For a discussion of the left section of the Del Rey mural, see the essay by Gabriela Rodriguez-Gomez in this volume.

4. Shifra M. Goldman, "The Iconography of Chicano Self-Determination: Race, Ethnicity, and Class," *Art Journal* 49, no. 2 (1990): 167.

5. Ibid.

6. Ibid., 168.

7. "Del Rey Center Murals Will Be Unveiled Today," *Fresno Bee*, August 25, 1968. I do not argue that the mural was *actually* used in performance, nor do I consider this essential; rather, I maintain that such a performance was *possible*. Formal analysis of the mural, close readings of El Teatro's Del Rey corpus, and a reconstruction of events based on primary sources from El Teatro's Del Rey period and on recollections from Bernal and from El Teatro's director together suggest it could have been so used.

8. A "proposal" refers to what can be discovered as having been in an artwork because the artist put it there. It contrasts with a "reading" of a work, in that readings need not presume intention. A proposal need not be obvious to everyone, or at first; rather, attentive and extended beholding can uncover what a work proposes. Likewise, attention can be directed toward a proposal so that what formerly seemed non-obvious can be recognized as having been ineluctably there in the object all along. In this essay, I intend to direct attention to Bernal's proposals, just as, in 1968, El Teatro's performances would have made them more obvious to the farmworkers who attended than they are to us, contemporary beholders of Bernal's mural, now. My usage of "proposal" is inspired by T. J. Clark, *The Sight of Death: An Experiment in Art Writing* (New Haven, CT: Yale University Press, 2008).

9. Shifra M. Goldman, "How, Why, Where, and When It All Happened: Chicano Murals of California," in *Signs from the Heart: California Chicano Murals*, ed. Eva Sperling Cockcroft and Holly Barnet-Sánchez (Albuquerque: University of New Mexico Press, 1993), 26.

10. Ibid.

11. Ibid., 28–29.

12. Shifra M. Goldman and Tomás Ybarra-Frausto, "Outline of a Theoretical Model for the Study of Chicano Art," in *Arte Chicano: A Comprehensive Annotated Bibliography of Chicano Art, 1965–1981* (Berkeley: Chicano Studies Library Publications Unit, University of California, 1985), 35.

13. Ibid., 32–33.

14. "El Plan Espiritual de Aztlán" (1969), reprinted in *Aztlán: An Anthology of Chicano Literature*, ed. Luis Valdez and Stan Steiner (New York: Knopf, 1972), 402.

15. Goldman, "Iconography," 167–68.

16. Ibid., 167.

17. Shifra M. Goldman and Tomás Ybarra-Frausto, "The Political and Social Contexts of Chicano Art," in *Chicano Art: Resistance and Affirmation, 1965–1985*, ed. Richard Griswold del Castillo, Teresa McKenna, and Yvonne Yarbro-Bejarano (Los Angeles: Wight Art Gallery, University of California, 1991), 84.

18. Ibid., 84, 86.

19. Ibid., 85. Emphasis mine.

20. Goldman and Ybarra-Frausto, "Outline," 14.

21. The organization of *Chicano Art: Resistance and Affirmation, 1965–1985* (CARA), the first major retrospective of the art of the Chicano movement, bears this point out, insofar as the exhibition layout was organized into thematic foci of artworks about Chicano movement politics, Mexican American cultural icons, and civil liberties. Within each focus, there was a diversity of style, content, and form, which could be taken to express a diversity of ideological commitments. For a discussion of the CARA exhibition, see Alicia Gaspar de Alba, *Chicano Art Inside/Outside the Master's House: Cultural Politics and the CARA Exhibition* (Austin: University of Texas Press, 1998). See also her "From CARA to CACA: The Multiple Anatomies of Chicano/a Art at the Turn of the Century," *Aztlán: A Journal of Chicano Studies* 26, no. 1 (2001): 203–31.

22. Antonio Bernal, letter to Elizabeth Shepherd, April 15, 1990, box 4a, folder 12, CARA (*Chicano Art: Resistance and Affirmation*) Records, Part I, UCLA Chicano Studies Research Center (hereafter cited as CARA Records).

23. Griswold del Castillo, McKenna, and Yarbro-Bejarano, *Chicano Art*, 274–83.

24. NEH Implementation Papers, 1990, box 28, folder 4, CARA Records.

25. NEH Implementation Grant, 1990, box 30, folder 9, CARA Records, 26.

26. Bernal, letter to Elizabeth Shepherd, 1.

27. Ibid.

28. William Wilson, "Chicano Show Mixes Advocacy, Aesthetics," *Los Angeles Times*, September 12, 1990, 1. For

comments from exhibition attendees, see Gaspar de Alba, *Chicano Art Inside/Outside the Master's House.*

29. CARA opened in Los Angeles and traveled to other epicenters of the mural movement, such as San Francisco and Fresno, California, and El Paso and San Antonio, Texas. Surely some exhibition attendees in these cities would have been able to contrast seeing Chicana/o murals in person to seeing them at CARA.

30. NEH Implementation Grant, 25–26.

31. I viewed this photograph on March 25, 2019. It is also reproduced in a video by Pedro Pablo Celedón, "Luis Valdez—Founder 'El Teatro Campesino,'" with commentary by Luis Valdez, posted on YouTube on October 21, 2011. The image is at 1:31.

32. The August 1, 1968, issue of *El Malcriado*, the newspaper of the UFW, features a poster with an image of Zapata similar to the one Bernal uses in his mural. This does not, however, provide a definitive dating, since the poster could have been in circulation earlier. An article on Del Rey suggests that *El Malcriado* had a readership there. United Farm Workers Organizing Committee, *El Malcriado: The Voice of the Farm Worker* 11, no. 11 (1968): 14–15.

33. See Goldman and Ybarra-Frausto, "Political and Social Contexts," 83–95; and Victor Sorell, "Articulate Signs of Resistance and Affirmation in Chicano Public Art," in Griswold del Castillo, McKenna, and Yarbro-Bejarano, *Chicano Art*, 141–54. The NEH Implementation Grant reproduces the section on page 25. Two more-recent publications that include the mural section are Michael Cucher, "Concrete Utopias from the Central Valley to Southern California: Repurposing Images of Emiliano Zapata in Chicana/o Murals," *Aztlán: A Journal of Chicano Studies* 43, no. 1 (2018): 25–29; and Dylan A. T. Miner, *Creating Aztlán: Chicano Art, Indigenous Sovereignty, and Lowriding across Turtle Island* (Tucson: University of Arizona Press, 2017), 102.

34. Luis Valdez recalls that before Bernal affixed the mural sections to the wall, he coated their backs with creosote. Valdez, unpublished interview by author, February 19, 2020.

35. Antonio Bernal, email to author, January 6, 2019. Valdez corroborated this in his February 19, 2020, interview with the author.

36. Cucher, "Concrete Utopias," 31.

37. Ibid., 40–41.

38. Cary Cordova, *The Heart of the Mission: Latino Art and Politics in San Francisco* (Philadelphia: University of Pennsylvania Press, 2017), 150.

39. Ibid., 136.

40. Eli Setencich, "Through a Glass Lightly," *Fresno Bee*, November 5, 1967.

41. "El Teatro Campesino: Organizational History," no date, El Teatro Campesino Archives, California Ethnic and Multicultural Archive (CEMA), Special Research Collections Department, University Library, University of California, Santa Barbara, https://www.library.ucsb.edu/special-collections/cema/etc.

42. Jenkins, "Description of Working Principles," 167–68.

43. Luis Valdez, "El Teatro Campesino," in *La Raza: Yearbook* (Los Angeles: El Barrio Communications Project, 1968), 55.

44. Yolanda Broyles-Gonzalez, *El Teatro Campesino: Theater in the Chicano Movement* (Austin: University of Texas Press, 1994), 242.

45. Valdez, "El Teatro Campesino," 55.

46. Bobbi Cieciorka, "Teatro Campesino Alive in Del Rey," *The Movement*, October 1967.

47. Sam Kushner, "Comment: Campesino Culture," *People's World*, May 4, 1968.

48. Stan Steiner, "Cultural Schizophrenia of Luis Valdez," *Vogue*, March 15, 1969.

49. Valdez, "El Teatro Campesino," 55.

50. Broyles-Gonzalez, *El Teatro Campesino*, 242.

51. Valdez, interview by author, February 19, 2020.

52. Jan Cohen-Cruz, *Local Acts: Community-based Performance in the United States* (New Brunswick, NJ: Rutgers University Press, 2005), 83.

53. Huerta, *Chicano Theater*, 16.

54. Luis Valdez, "Notes on Chicano Theater," in *Luis Valdez—Early Works: Actos, Bernabé and Pensamiento Serpentino* (1971; reprint, Houston: Arte Público, 1990), 8. Emphasis in original.

55. Valdez, "El Teatro Campesino," 55.

56. Valdez, personal communication with author, May 15, 2019. Valdez was a member of the Mime Troupe from 1964 to 1965, and many of the theatrical techniques employed by El Teatro and discussed in this essay were in use by the Mime Troupe during his tenure. Like that of El Teatro, the Mime Troupe's praxis was Brechtian. Susan Vaneta Mason, ed., *The San Francisco Mime Troupe Reader* (Ann Arbor: University of Michigan Press, 2013).

57. Michael Kirby, "Happenings: An Introduction," in *Happenings and Other Acts*, ed. Mariellen R. Sandford (New York: Routledge, 1995).

58. Setencich, "Through a Glass Lightly."

59. Kirby, "Happenings," 5.

60. Bernal, email to author, January 6, 2019. The Agricultural Workers Organizing Committee and the National Farm Workers Association organized a strike against Delano-area table and wine grape growers beginning in 1965. The two unions later merged in 1966 to form the United Farm Workers, which was led by César Chávez. The strike continued until table grape growers signed union contracts in 1970. Inga Kim, "The 1965–1970 Delano Grape Strike and Boycott," March 17, 2017, available on the UFW website.

61. Neither Bernal nor Valdez recalls exactly what was performed. Valdez, interview by author, February 19, 2020; Bernal, email to author, January 6, 2019.

62. Huerta, *Chicano Theater*, 18–19.

63. Valdez, interview by author, February 19, 2020.

64. *Las dos caras del patroncito*, *Quinta temporada*, and *Los vendidos* have been published in *Luis Valdez—Early Works*. Subsequent citations of these plays refer to the editions in that collection.

65. Huerta, *Chicano Theater*, 19.

66. *Dos caras*, 18.

67. Huerta, *Chicano Theater*, 20.

68. Ibid., 24.

69. Ibid., 17.

70. For an analysis of the impact of the Brechtian epic-theatrical tradition on El Teatro plays produced between 1965 and 1970, see Arturo Conrado Flores, "El Teatro Campesino de Luis Valdez, 1965–1980" (PhD diss., University of Arizona, 1986), 47–60.

71. Yolanda Julia Broyles, "Brecht: The Intellectual Tramp: An Interview with Luis Valdez," *Communications from the International Brecht Society* 12, no. 2 (1983): 37–40; Luis Valdez, "Felipe Cantú, Original Teatro Member, Dies April 26, 1989," *El Teatro: El Teatro Campesino Newsletter*, May 15, 1989; Luis Valdez, "Theater: El Teatro Campesino," *Ramparts*, July 1966, 55.

72. Huerta, *Chicano Theater*, 19.

73. Ibid.

74. Ibid., 21.

75. Ibid.

76. *Dos caras*, 26.

77. Huerta, *Chicano Theater*, 22.

78. *Dos caras*, 22.

79. *Quinta temporada*, 36.

80. *Los vendidos*, 41.

81. Huerta, *Chicano Theater*, 62.

82. Bernal indentified this figure as Malcolm X in an interview with Charlene Villaseñor Black and Gaby Rodriguez-Gomez on July 23, 2018; see the essay by Rodriguez-Gomez in this volume.

83. Bernal, email to author, January 6, 2019.

84. Ibid.

The Eventfulness of Antonio Bernal's *Breaking the Silence*

Miguel Samano

Antonio Bernal's *Breaking the Silence: A Novel of the Twentieth Century* narrativizes the lives of three generations of the Durán family from the beginning of the century until its close.[1] The plot follows the Duráns from the decade-long run-up to the Mexican Revolution until the immediate post-Soviet era and loosely draws inspiration from the lives of Bernal and the two preceding generations of his family, whose stories unfolded across the Americas.[2] As he relates these histories, Bernal interrogates the failures of various reformist and revolutionary political actors to effect lasting and significant change to the political systems that shape the lives of his characters. Among others, these actors include participants in the Mexican Revolution and in post-Revolutionary socialist organizing, the United Farm Workers' Strike and other labor strikes, popular elections of Leftist candidates in Latin American countries, and the Chicano civil rights movement. Bernal's novel could be categorized as a historical novel due to its fictional representation of real historical events and personalities; but, if Bernal has written a historical novel, he has done so with a difference. In its generic form, the novel bleaches out the contingency and open-endedness of lived experience. Bernal, however, gradually proposes to readers that the novel, as a form, can furnish an experience of time like that of life itself. He seeks to restore to it some of life's eventfulness. He seeks to eventilize the novel.

Resisting the Novelization of Time

"What, in fact, is a novel but a universe in which action is endowed with form, where final words are pronounced, where people possess one another completely, and where life assumes the aspect of destiny?"[3] The novel, as Camus's question implies, is a formal literary homologue to retrospection, a mode of relating to time in which the inevitability of a plot line can be read onto a sequence of past events. Retrospection novelizes time. A retrospective observer of a sequence of past events resembles a novel's reader because that reader usually presumes that events within a novel constitute part of a formed whole—a complete narrative whose interrelations and unity of action can be retroactively experienced synchronically, as is most obvious when re-reading. In contrast, a fictional character usually experiences that same sequence of events diachronically, as in process, with future events not yet determined by past ones. As Bernal's novel progresses, some members of the Durán family come to relate to the past events of their lives like readers do. These events become constituents of the novel as an artistically formed whole, one in which future events are predetermined by

past events, and vice versa. Bernal's placement of those events into a narrative structure all the while mitigates against the novelization of time. In a reversal of the critical commonplace that plot imposes a closed form onto the open-endedness of story, Bernal leverages narrative techniques at the level of plot to undo the novelization of time effected by some of his characters at the level of story.

The actions of Raquel Durán, the character who occupies the most narrative space in the novel, exemplifies the novelization of time. By the time she reaches early middle age, she has become an internationally renowned Spanish-language musical theater performer, and she is almost always away from her husband, Richard, and son, Lauro. While in transit between venues, she admits that "she felt that she was helpless, that circumstances (was it fate?) took hold and she had no choice but to go along." But this does not occasion regret. Instead, she concludes that she became a performer "because she could not do otherwise. She hadn't chosen her life; it had chosen her" (114). This novelizing attitude on the present, as merely a moment of transition between events that have already happened and events to come, vitiates the concept of choice. It denies the attitude toward the present that is held by Raquel's parents, Don Rufino and Eduwiges, who are among Mexico's landed elite. Unlike Raquel, her parents conceive of the trajectory of their lives primarily by reference to the firmly established customs that have structured life in and around Hermosillo, Mexico, for generations. Don Rufino and Eduwiges believe that their customs can be relied on to direct the lives of their children as well—but this does not mean that the future is fated. On the contrary, even if a projected outcome can be more or less guaranteed through abiding by custom, the anticipated future of its realization still needs to be deliberately brought about. For Don Rufino and Eduwiges,

the present is genuinely an event, not merely a point of transition between past and future. It comprises a space for reflection, a space where knowledge of what has already happened combines with a forecast of what could possibly happen to yield informed and intentional, and therefore freely chosen, action.

The novel stages this anticipation, but not overdetermination, of the future by employing backshadowing to allude to unnarrated events—events that are merely described. As opposed to foreshadowing, the provisioning of an earlier event as grounds for a reader to anticipate a later event, backshadowing provides the later event as grounds for the retrospective judgement that this event was anticipated in the earlier event. Both devices typically imply the inevitability of events; however, when the earlier event is described rather than narrated, backshadowing can sometimes convey that a character is positioned to anticipate an event, whereas a reader is not, on the basis of their knowledge of the past.[4] Through backshadowing, Bernal conveys a sense of the present as a space for reflection. For example, the first nine paragraphs of the novel depict Don Rufino reflecting on the broader historical circumstances informing the moment of Raquel's birth while he waits for her to be delivered. These paragraphs describe, but do not narrate, historical events that Don Rufino reflects upon while perusing a newspaper. Among other things, he considers the exploitation of the poor in Porfirio Díaz's Mexico; the reforms that aided landowners in dispossessing Indigenous Mexicans of their communal lands; the role of the landed elite who facilitated the execution of these reforms by consolidating their power; and his own fair treatment of local Indigenous communities (2–4). These paragraphs do not indicate how long Don Rufino reflects. Instead, the slow pacing and the failure to move the plot

forward simulate his sense of the present as requiring reflection.

These, plus other events that are unnarrated but described and focalized through Don Rufino's and Eduwiges's perspectives, collectively build out the world in which Raquel comes of age. Indeed, the remainder of the novel's first part, the only one in which the parents' plot lines develop, stages Eduwiges's relationship to her daughter as based on the mother's concerted attempt to bring up Raquel as a young woman who will choose to be respectable, as she herself did, and one day marry into one of the region's other respectable families. Eduwiges's expectations for Raquel assume a horizon of possible futures that is similar to that of her younger self. Eduwiges would have no grounds for her assumption, and no grounds for preparing her daughter to choose to accept it, if she did not believe the future could be simultaneously anticipated and made contingent on Raquel's actions.

Unfortunately, when Raquel reaches young adulthood, her accumulated knowledge of the past does not permit her to anticipate the future. Instead, the constant pace of unanticipated change she encounters in the second and third parts of the novel—covering, respectively, her marriage and the time she spends establishing her career in Los Angeles and her time touring internationally—means that new experiences continually eclipse any expectations that she may have developed at a past moment. If this set of circumstances appears to be incapable of sustaining the present as a space for reflection, that of her sister, María Elena, provides a ready foil. María Elena lives a turbulent life in Mexico City among the artists, activists, and intellectuals who are caught up in the post-revolutionary Mexican avant-garde of the 1920s and early 1930s.[5] María Elena's plot line begins after Raquel is married but before Lauro's birth. Like Raquel's plot line—which continues with

her move from performing dinner theater on Olvera Street to acting as a film extra, her big break as the star of a Latin revue at a serious venue, and, eventually, the neglect of her son and husband after she dedicates her life to an international career in musical theater—María Elena's also narrates the thrill of her liberation from the received culture of her parents. Unlike Raquel's plot line, which reaches its apex in part two of the novel, María Elena's culminates in part three as her son, Marcos, whom she has raised while working at a dry cleaner, reaches adulthood. The contrast between Raquel's and María Elena's stories suggest that any one of their constituent events could have turned out differently, changing the outcome for either of the two characters.

Put another way, the two plot lines "sideshadow" each other. In his elaboration of the term, literary theorist Gary Saul Morson conveys how a novelist can present alternative versions of the same event. The event is regarded as having a horizon of unactualized possibilities—possible outcomes. Only one will be actualized, but the novelist will have shown that it could have been different.[6] As my other contribution to this volume readily suggests, I am in agreement with Morson on the character of an event. But I would extend his usage of the term to cover events that are fungible because they present comparable sets of possibilities, even if the events themselves are not identical. This extension provides sideshadowing as a technique effected at the level of plot but having a clear analogue at the level of story: namely, the capacity of characters to compare a present event with events similar to it in the past.

As María Elena grasps but Raquel does not, the inability to forecast the future does not defeat the potential for reflection in the present so long as there exists a past event comparable with the one presently in process. For María Elena, for example, the difference between

the conventional married life that her mother elected and the promise of radical equality between herself and her partner, Arnulfo, only *appears* to present a choice between "household slavery" and freedom. María Elena recognizes that Arnulfo's proposal for a democratically run family "did not seem very different from her own family, since everyone did as they liked, as long as they did not openly go against certain traditions" (74). Once María Elena recognizes that her present is interchangeable with Eduwiges's former present, in which her mother opted for a conventional marriage, María Elena is able to identify that, despite surface dissimilarities in their decisions, she and her mother both chose freedom. Raquel's self-assessment—that she has chosen to rebel against being forced into a conventional marriage, where she would have had to care for Richard and Lauro—can then be seen as self-serving. Raquel's decisions present her as someone who merely reacted to changing circumstances as they appeared: "She had no regrets, because she had no choice" (115). Occurring after María Elena's moment of reflection, it may represent a *decision* not to reflect; it may be an intentional denial of her own freedom, a self-made novelization of time made over and against her capacity to compare fungible events.

The Presence of the Concealed

In defense of Raquel, we can say that she was unaware of the similarities between her present situation and the one that presumably faced Eduwiges in the past. Because these similarities were concealed, they were not available for retrospection. She could not compare her situation with her mother's as María Elena had, and so she may have been unable to decide otherwise than how she did. More generally, this reading suggests that the horizon of an event's unactualized possibilities has a dimension not only

of meaning but also of presence: unactualized possibilities cannot be deduced solely through reflection. Instead, some interaction in the broader world of experience has to unconceal them. An interaction that unconceals a possibility would be one that enables that possible outcome to be available for reflection. In María Elena's case, her relationship with Arnulfo and with the progressive women who were part of the circle that formed around muralist Diego Rivera—women such as photographer and activist Tina Modotti, poet and educator Gabriela Mistral, and model and novelist Guadalupe Marín—enables her to identify the taboos that they and Eduwiges broke, whether publicly or covertly: "Now she found kindred spirits in their iconoclastic indifference to tradition, in fact, she rejoiced in breaking taboos she didn't even know existed" (74). Raquel has had no comparable interactions, so the possibility of seeing Eduwiges as a woman who pursued her freedom remains concealed. In full sincerity, Raquel, then in middle age, continues to think of conventional marriage along more or less the same lines as she did when she was a teenager. At her quinceañera, "she rebelled against being forced into a conventional marriage," the narration reports (114). It does not occur to Raquel that freedom need not exclude interdependence and that adherence to such an ideal is a banality of youthful rebellion.

The novel is replete with moments of unconcealment, but I cannot hope to discuss all of them here. One more example will have to suffice to drive home that the concealment of possibilities has effects on how an event is experienced. I count at least two effects. First, the presence of concealed possibilities for an event in progress means that the set of events fungible with it will vary with how many of the possibilities are concealed. And, second, possibilities concealed while an event is still in progress can often be unconcealed at some

future point through retrospection. María Elena and Raquel's retrospection on their older brother Ramiro's death exemplifies both of these effects. When the sisters participate in the event of his death (from afar, while hiding in a well), they think it senseless, a product of Ramiro's rash choice to attempt to single-handedly prevent a regiment of soldiers from commandeering the Durán family ranch during the Mexican Revolution. But upon meeting others who had also experienced death during the Revolution, María Elena retrospectively recognizes that Ramiro did not conceive of himself as acting brashly, but instead as defending his principles. This, in turn, allows the event of his death to be compared to the deaths of other Mexican patriots (67). Similarly, while looking up at a monumental statue of Simón Bolívar, Raquel begins to think of Ramiro's death as interchangeable with the deaths of anonymous others who, like him, recognized that backing down would have been a betrayal of their principles (116).

Of course, María Elena's and Raquel's moments of retrospection are also comparable with each other. More precisely, the dispersed plot structure of the novel, wherein similarities across causally unrelated plot lines can be readily identified by readers, provides for the retrospective recognition among readers that a past event and a future one can be compared. Because some of these comparisons occur to readers but not to the novel's characters, the novel's plot structure participates in the unconcealment of possibilities. As such, retrospection does not always perpetuate the novelization of time. As Bernal's handling of the plot brilliantly demonstrates, retrospection can sometimes undermine the novelization of time by unconcealing possibilities for readers that, had they been unconcealed for the characters, would have thwarted their belief that their future was fated. If Raquel really is

a victim of her circumstances, the narration of those circumstances allows us to imagine the conditions in which she could have recognized her freedom.

Making the Impossible Possible

As it turns out, the novelization of time does not merely describe the experience of someone, like Raquel, who conceives of their life as fated. It also describes a collective situation in which a future outcome appears inevitable—that is, a future whose actualization is not contingent on any action that anyone in the present can undertake. For these futures, any possibility aside from the one that will be actualized can be regarded as an impossibility. If, upon retrospection, however, it turns out that the future understood as inevitable was not actually inevitable, then what formerly was impossible is unconcealed as an unactualized possibility. Unconcealment makes the impossible possible.

In closing out my reading of Bernal's novel, I want to suggest, then, that the author shows us that the processes of unconcealment effected by the novel's plot, and expressed in the experiences of its characters, can make the impossible possible. Throughout the novel's narration of life in the twentieth century, lasting revolutionary change—Bernal's continuing concern—is never realized. Indeed, at the beginning of the post-Soviet era, Raquel, now in her nineties, reflects on the century from her deathbed, as the narrator relates: "She had come into the century in revolution and was leaving it in revolution. Outside student riots were gaining momentum all over the world. Cities in the U.S. were ablaze" (178). In the novel's postscript, Marcos, now in late middle age, and an intellectual and lifelong Marxist, considers the century's socialist movements. At the heart of his musings is an assumption that it was the fungibility of events that silenced the voices

of those who aligned themselves with social-ism's cause: "He realized once again that, as the twentieth century drew to a close, times had changed with accelerated speed and the old for-mulas were no longer relevant. The old guard had had only one answer—the solution was revolution" (181). Marcos's remedy for this past failure to conceive of genuine revolutionary change is to open a bookstore and café, where members of Mexico City's political left go to hash out their ideological disagreements. The possibility for revolutionary change can emerge only from their attempt to collaboratively effect the unconcealment of impossibilities as unac-tualized possibilities. Through unconcealment, they will be "breaking the silence."

Two aspects of that process stand out. First, it is fundamentally retrospective. Marcos states, when describing the discussions of the leftists, that "they have torn the ending into a beginning, until the broken silence has become a roar" (185). Second, retrospection can seed the recognition that the present also contains concealed possibilities and that these possibili-ties can be felt and can have material effects on action. The leftists "go into forbidden corners, so carefully hidden so as not to exist, but really existing all the more" (185). Both of Marcos's observations lead him to an epiphany, which furnishes the novel's closing words: "The rev-olution, he said aloud to no in particular, is the purest form of poetry" (185). If we think of poetry as that which unconceals, as that which brings about new possibilities by casting some-thing in a new light, then "the purest form of poetry" would be that which casts everything in that light. In other words, unconcealment seeks to put us in a different relationship to the world, one not provided for by the whole of our collective past experience. This seems to me an apt description of revolution.

Making the impossible possible, bringing about genuine revolution, entails imagining

and seeking to bring about the circumstances in which one is positioned to retrospectively recognize the impossible as possible. Or, as Bernal, paraphrasing political thinker Mar-tha Harnecker, writes in his blog, "left politics should consist in discovering the potential that exists in any concrete situation today to make possible tomorrow what now appears impossible."[7]

As I have sought to establish, in a context in which the future appears inevitable, as fated, the experience of the present resembles that of characters in a novel. As opposed to being a genuine event—a space of reflection open-ing up into several unactualized possibilities for the future, one of which will eventually be actualized—the present appears as a mere moment of transition connecting past and future. In such a context, a revolutionary pol-itics will try to grasp a novelized time, a time that no longer admits of events, as capable of being eventilized. In his skillful deployment of various plot techniques that cumulatively work to undermine the novelization of time among the characters in *Breaking the Silence*, Bernal models for his readers methods for de-novelizing their own experiences of time. The novel contradicts the notion that art should be thought of as a reduction of life, as bleach-ing out the contingency and open-endedness of real experience through representing it in a closed form. Bernal does not seek to eventilize the novel form in order to make it more lifelike. Rather, he seeks to teach us to eventilize our lives through the plot structure of his novel.

Notes

1. *Breaking the Silence: A Novel of the Twentieth Century* (2008) may be read on Antonio Bernal's blog, also titled *Breaking the Silence*: http://antonio-diferencia. blogspot.com/2018/04/. Although the text of the novel does not have page numbers, it is searchable. Page numbers cited here were determined by printing the text.

2. For a biography of Bernal and his parents, see Charlene Villaseñor Black, "Crossing Borders, Resisting Answers: The Life of Antonio Bernal, Witness to the Chicano Movement," in this volume.

3. Albert Camus, "Rebellion and the Novel," in *The Rebel: An Essay on Man in Revolt*, trans. Anthony Bower (New York: Vintage Books, 1991), 262.

4. Readers, but typically not characters, are positioned to grasp that an event foreshadows or backshadows another event. Readers typically experience events as inevitable, whereas characters usually experience the events as having outcomes that depend on their choices. *Breaking the Silence* is atypical in that one character (Raquel) experiences events like a reader would. Because foreshadowing and backshadowing, then, are devices that have to do with the reader's experience of time, and not the characters', foreshadowed events do not need to be in the future relative to the events that foreshadow them; they only need to appear later in the reading experience; likewise, backshadowed events do not need to be in the past. The narration/description distinction has been most influentially articulated in Georg Lukacs, "Narrate or Describe?," in his *Writer and Critic and Other Essays*, ed. Arthur Kahn, 110–48 (New York: The Merlin Press, 1970).

5. Of participants in this avant-garde, the members of the Mexican muralism movement, such as Diego Rivera, are the most well-known. But, during the same period, international photographers, such as Edward Weston and Tina Modotti, both of whom appear in Bernal's novel, writers, such as the members of the Estridentismo group, and other artists aside from muralists, also participated in the avant-garde. For a recent history of this avant-garde, see Tatiana Flores, *Revolutionary Mexican Avant-gardes: From Estridentismo to ¡30–30!* (New Haven: Yale University Press, 2013).

6. Gary Saul Morson, "Sideshadowing and Tempics," *New Literary History* 29, no. 4 (1998): 601–3. Morson and Michael André Bernstein introduced the term "sideshadowing," as well as "backshadowing," in their monographs from 1994. These were published separately, but were initially intended to be part of a jointly authored book. See, Morson, *Narrative and Freedom* and Michael André Bernstein, *Foregone Conclusions: Against Apocalyptic History* (Berkeley: University of California Press, 1994).

7. Antonio Bernal, "The People Govern, not the State (Harnecker)," *Breaking the Silence* (blog), April 11, 2008.

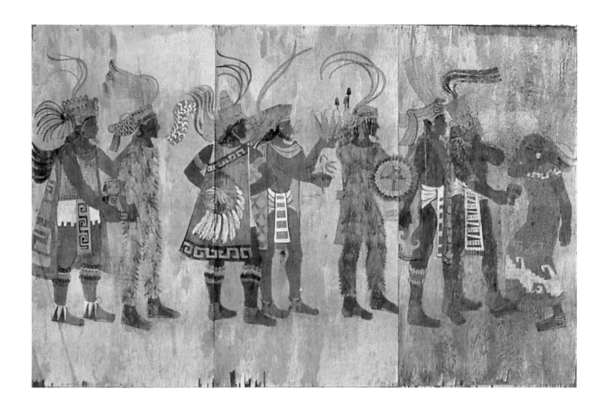

Plates 1, 2. Untitled mural in Del Rey, California, 1968. Enamel on plywood; two sections of three panels, each section approximately 6 × 15 feet. From photographs by taken by Robert Sommer in the 1970s. Image courtesy of Robert Sommer and *CARA* (*Chicano Art Resistance and Affirmation*) Records, part 1, collection 10, UCLA Chicano Studies Research Center.

Plate 3. *Autorretrato*, 1978. Oil on canvas, dimensions and location unknown.

Plate 4. *Ciudad de México,* 1976, oil on canvas, 20 × 16 inches.
Location unknown.

Plate 5. *Germany (Tübingen)*, 1984. Oil on canvas, 16 × 20 inches. Private collection.

Plate 6. *Eucalipto*, 1981. Oil on canvas, dimensions unknown. Location unknown, formerly at Galería Mer-Kup, Mexico City.

Plate 7. *Cementerio*, date unknown. Digital print, dimensions and location unknown. Derived from *Día de los Muertos* (page 112).

Plate 8. *Dos mujeres*, 1979. Oil on canvas, 24 × 36 inches. Location unknown.
Plate 9. *Elías*, date unknown. Oil on canvas, dimensions and location unknown.

Plate 10. *Xochipilli*, 1982. Oil on canvas, location unknown.
Plate 11. *Cuba: Fidel*, 1995. Oil on canvas, 24 × 36 inches. Location unknown.

Antonio Bernal's Writings
A Selection, 1973–2000

In addition to his artistic practice, Antonio Bernal also dedicated himself to writing, producing opinion pieces, educational essays, and even a novel. Some of his writings have been published and some appear on his blog, while others await publication. They all manifest his deeply held political convictions, his love of Mexico and Cuba, and his keen eye for the human condition. We reproduce here four writings by Bernal, written between 1973 and 2000. They have been lightly edited for publication.

"El Batallón de San Patricio" was written in 1973, while Bernal was an instructor of Chicana/o studies at California State University, Los Angeles. It tells the story of a group of Irish Catholic immigrants to the United States who, during the Mexican-American War of 1846-48, fought on the side of Mexico. Rich in historical detail, the essay sheds light on anti-Irish discrimination in the United States. *Barrio Maravilla* is a three-act play authored by Bernal and his advanced Spanish students at Garfield High School in the 1980s. Bernal based it on *Fuente Ovejuna*, Lope de Vega's classic comedia from the early 1600s, and worked with his students to condense, streamline, and modernize the original story. *Fuente Ovejuna* tells the tale of townspeople rising up against injustice, a plot line Bernal meaningfully transplanted to the East Los Angeles neighborhood of Barrio

Maravilla. In "Why Hispanic?" Bernal builds on an essay from 1990 that was published in the *Los Angeles Times* (page 8). In the essay that appears below, written in 2000, he expands his critique of the term *Hispanic*, advocating for *Latino* instead. The final writing in this section, "Cuba," is made up of a series of detailed reflections on the author's experiences on the island during the 1990s, the Período Especial. These entries track his annual summer trips to Cuba and reveal his deep investment in Fidel Castro's revolutionary ideals. Bernal's observations offer a rich portrayal of conditions on the island, the people he encountered, and his many adventures.

Bernal continues to write to this day, adding new posts to the blog that he began in 2006 (http://antonio-diferencia.blogspot.com/). These entries include political writings, commentary on Mexico's history and culture, thoughts on his travels around the world, and personal reflections, including a recent entry on his experience with Covid-19 (December 9, 2020). His novel, *Breaking the Silence: A Novel of the Twentieth Century* (2008), is also posted on the blog; written in 2008, it has not yet been commercially published. These texts complement the view of Bernal that is provided by his artwork. Both reveal his love of Mexico, deep knowledge of history, interest in world events, and dedication to social justice. In addition,

his writings bring into sharp focus his intellectual drive and his facility with political theory. Together, his artistic and literary works manifest his intense creative energy and love of life.

Charlene Villaseñor Black

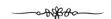

El Batallón de San Patricio (1973)

"El Batallón de San Patricio" is reprinted from the Fall 2020 issue of Aztlán: A Journal of Chicano Studies.

1840s

The Saint Patrick's Battalion was composed solely of foreign-born US Army deserters, mostly Catholic Irish immigrants, along with some German, English, French, and Polish ones. They formed a distinct unit in the Mexican army and fought with great distinction against their former comrades. Many were refugees from the potato famine in Ireland, which began in 1845 and lasted for seven years. In the United States they fared no better. Jobs were scarce and the pay was poor. Work offered to them was hard manual labor such as digging ditches or laying railroad ties. Many were forced to enlist in the US Army to escape dead-end jobs. When the United States invaded Mexico, the war was opposed by a small but vociferous minority. It was condemned by James Russell Lowell, Ralph Waldo Emerson, Frederick Douglass, and Henry David Thoreau, prompting the latter to write his manifesto on civil disobedience, in which he stated that the first duty of the individual is not to the State but to human society. The Irish immigrants found constant prejudice in the United States. They were badly treated in the military and had to contend with rumors that the objective of the war was to wipe out Catholicism in Mexico.

1846

Singing "Green Grow the Leaves on the Hawthorne Tree," they marched with Major General Zachary Taylor to the Río Bravo, where they had to wait for a war to begin. (This may be the origin of the word *gringo*.) They built Fort Brown on the north bank of the river (which gave its name to the city, Brownsville, that grew around it). There was little available water. The food was of poor quality and often filled with maggots. Firewood was scarce for cooking. Yellow fever and dysentery wasted the ranks. Politically appointed officers had little feeling for the enlisted men and mistreated them. General Pedro Ampudia saw an opportunity to demoralize the US Americans when his spies informed him of the miserable conditions of the foreign-born troops. Ampudia appealed to the Irish not to take arms against their religion, and he urged them to abandon their unholy cause and become peaceful Mexican citizens. When some of the US soldiers, quartered in a church, urinated on the altar to show their contempt of Mexicans and Catholicism, it was the last straw. A non-commissioned officer named Riley, with a Mexican leaflet in his pocket, crossed the river and presented himself to the Mexican officers, where he was commissioned a lieutenant. By May 11, when Congress declared war on Mexico, Riley had helped organize deserters into two companies of infantry known as the Batallón de San Patricio, which was ready and willing to fight for its adopted country. The Batallón proudly carried a banner of green, fashioned on one side with the figure of Saint Patrick, the harp of Erin, and a shamrock. The other side was emblazoned with the arms of Mexico. The Batallón got its first taste of combat in the defense of Monterrey, Nuevo León. When the city finally yielded after a last-ditch fight and the garrison marched out to join the Mexican army to the south, the deserters

were recognized by the US soldiers and jeered and spat upon.

1847

In the Battle of Buenavista in February, General Antonio López de Santa Anna and Taylor clashed in one of the major battles of the war. The San Patricios skillfully handled their batteries of heavy guns. Their 18- and 24-pounders raked General Taylor's forces with devastating effect. The San Patricios beat back the blue waves almost at will. At one point, the Battallón wiped out General Taylor's Light Battery D of the Fourth Artillery, completely outgunning the American battery and capturing two 6-pounders. Even so, the Battle of Buenavista was a rout for Santa Anna. As Taylor's infantry surged forward, the San Patricios not only covered Santa Anna's retreat and saved their own guns, they also carried off the two bronze 6-pounders, all that was left of Light Battery D. In March, General Winfield Scott landed in Veracruz, and by August he was camped on the continental divide near the Valley of Mexico. On the night of the August 19, in a heavy rainstorm, the Irish rolled their heavy guns into the fortifications at Churubusco's seventeenth-century monastery, which was south of Mexico City in the mid-nineteenth century. Mexican batteries sent a fierce flame of fire into the faces of the invaders. Then, for most of the afternoon, the Irish and the Mexican battalions defended their fortified position, putting up the most stubborn resistance of the entire war. Riley's gunners served their field pieces with reckless abandon and fury. For them, "Victory or Death" was not a slogan, but a fact. Their guns smashed back at the United States, assault after assault. The US Americans suffered heavy losses: some 177 were killed or missing, with some 879 wounded. The San Patricios took special satisfaction in spotting and picking off their former officers. By late afternoon the Mexicans were forced to yield their bridgehead at the Contreras River and retreat to the monastery, and the US infantry crossed the river to outflank them. The San Patricios fought with grim determination, and even when the Mexicans attempted to raise a white flag to stop a useless massacre, the San Patricios fiercely tore it down. At last, Riley and what was left of the Batallón were overpowered in hand-to-hand combat. When the US officers entered the monastery, they demanded, "Where is the ammunition?" General Anaya replied, "If I had any ammunition, you would not be here." General Scott issued an order by which he convened two courts-martial for the San Patricios who were captured as deserters. On August 26 in San Ángel, twenty-nine were convicted and sentenced to hang. General Scott pardoned two and commuted the sentences of seven of them. For the latter he ordered fifty lashes and the letter D branded on their cheeks. The Mexicans angrily termed the branding and the hangings an act of barbarism. Petitions for mercy were circulated by the archbishop, a number of foreign citizens, and the British ambassador, to no avail. Sixteen of the twenty-nine were hanged in September at San Ángel. Riley and the others who were spared were forced to dig the graves of their comrades. Four more were hanged in Mixcoac. The other lot, thirty-six in number, were tried and convicted in Tacubaya on August 23. Scott remitted the sentences of two and commuted four others to lashing and branding. Colonel W. S. Harney of the Second Dragoons mean-spiritedly put the thirty condemned men on a hanging scaffold, where he had them wait, fitted with nooses, so they could watch the last battle at Chapultepec. The fortress was heroically defended by the cadets of the Mexican Military College: Juan de la Barrera, Agustín Melgar, Juan Escutia, Fernando Montes de Oca, Vicente Suárez, and Francisco Márquez, who leapt to their deaths rather than

surrender to the gringos. Finally, the last sight these thirty San Patricios saw was the eagle-and-snake banner of the Mexican flag as it was lowered and the stars and stripes put in its place.

1848

Late in the spring, the US Army marched out of Mexico City and the remaining San Patricios were taken to New Orleans, stripped of their uniforms, and drummed out of the Army. The San Patricios went on to become national heroes for Mexico, and a monument to them was erected at the Museo Nacional de las Intervenciones, the war museum located in the former monastery in Churubusco.

Barrio Maravilla: Comedia en tres actos basada en *Fuente Ovejuna* de Lope de Vega (1980s)

Escrita por alumnos de español avanzado, Garfield High School.

Spanish playwright Lope de Vega wrote Fuente Ovejuna *probably between 1612 and 1616. The play dramatizes an uprising in 1476, in which the residents of the village of Fuenteovejuna, Spain, assassinated the* comendador *who ruled over them. In the play, the commander, a womanizer, demands submission from Laurencia, one of the young women of the village. She refuses, the townspeople defend her, and the commander responds with a series of abuses. The townspeople agree that he must be killed and that, when they are eventually interrogated, they will respond: "Fuente Ovejuna lo hizo." At the play's end, the villagers are pardoned for their murder of the villainous commander. The play was written with the collaboration of Bernal's students in his advanced Spanish class*

at Garfield High School. The East Los Angeles neighborhood of Maravilla is a few blocks from the school. The play published here is an adaptation of the original.

Acto Primero

Escena I

[Oficinas de Dirección de Proyectos Familiares. Llega el Comendador.]

Comendador	¿Sabe el Maestre que ya llegué, y quién soy?
Flores	Sí, sabe que está aquí, pero es joven, tiene poca experiencia, y no ha llegado a recibirlo.
Comendador	Es llave la cortesía, y si no aprende, se hará de enemigos.
Flores	(*Para sí.*) Esa cortesía no es más que apariencia.
Comendador	Ya se le quitará lo grosero cuando le apunte una pistola a la cabeza.

Escena II

[Sale el maestre.]

Maestre	¡Oh, perdón! No sabía que había llegado, Comendador.
Comendador	No me diga.
Maestre	Bienvenido. (*Se fija en las noticias en la televisión.*) ¿Se han peleado los cholos?
Comendador	Pues que ¿no lo sabes? Nada más te das cuenta cuando está la gente balaceada y los cholos tirados en el suelo.
Maestre	Bueno, disculpe. Siempre el trabajo y la política son atacantes. El alcalde ya ha señalado que van a poner más policías en el barrio.

Comendador	Mis allegados me defenderán. La gente de aquí no es tan violenta como dicen.
Maestre	Yo me encargo de la vigilancia, y me verá con más frecuencia.

Escena III
[Salen y ven a Laurencia y Pascuala platicando en la lavandería.]

Pascuala	¿Ya viste?
Laurencia	¡Ojalá que no vuelva!
Pascuala	Ya sabía que te iba a caer de la patada.
Laurencia	No quiero ni verlo.
Pascuala	Es el cuento de siempre. He visto a algunas que parecen bravas y luego luego azotan.
Laurencia	Sí. Pero ¿por qué las trae conmigo?
Pascuala	¡Anda ya! No digas nunca "de esta agua no he de beber."
Laurencia	¡Chispas! Lo digo y lo contradigo. Ya querrás casarme con él.
Pascuala	Ni de chiste.
Laurencia	Es un cabrón. Nada más porque alguna familia no puede pagar la renta, se mete con una de sus hijas. Dicen de hasta de 15 o 14 años.
Pascuala	Pues ya verá el modo para que no te le escapes.
Laurencia	Ya tiene un mes que anda oliéndome los pedos. Mandó a ese alcahuete de Flores que me diera una pulsera, y luego me mandó una ropa interior de esas.
Pascuala	(*Ríe.*) ¿Qué, de Fredericks?

	Te va a engañar, Laurencia.
Laurencia	¿A mí?
Pascuala	No, a mi abuela.
Laurencia	Mira, seré joven, pero voy a misa, y me defiendo como gato boca arriba. Prefiero ser pobre a tener un zángano como ese.
Pascuala	Tienes razón. Cuando anda tras de una, parecen gorrioncitos, con el sombrero en la mano, pero nada más logran sus propósitos, y empiezan a insultar, diciéndonos putas y huacaleras, cuando ellos tienen la culpa de todo.
Laurencia	¡No hay que fiarse de ninguno!

Escena IV
[En frente del 7-Eleven.]

Frondoso	Esta vez la regaste, Barrildo.
Barrildo	Ya verás. Aquí nos sacan de la duda.
Mengo	Órale, y si yo gano, me debes.
Barrildo	Y si pierdes, ¿qué me das?
Mengo	Lo que más te gusta, buey.
Frondoso	Hola, señoritas.
Laurencia	¿Y eso?
Frondoso	Queremos andar en la honda, hay que decir las cosas bien. Al bachiller, licenciado Al ciego, tuerto Al bisojo, bizco Resentido al cojo Y buen hombre al descuidado. Eso se llama "politically correct."

Laurencia	¡Qué nada! La realidad es otra. Hay que llamarle al pan pan y al vino vino. Al que es constante, villano Al que es cortés, lisonjero Hipócrita al limosnero Y pretendiente al cristiano.
Mengo	¡Eres un demonio! Parece que ya te echaron la sal.
Frondoso	Escucha, Laurencia, que te queremos hacer una pregunta.
Laurencia	Soy toda oídos. ¿Qué, han apostado?
Frondoso	Yo y Barrildo contra Mengo.
Laurencia	¿Y qué dice Mengo?
Barrildo	Que el amor no existe.
Laurencia	Uy, pues tienes razón.
Barrildo	Sin amor no se puede conservar el mundo.
Mengo	Yo no soy filósofo, ni sé leer. Me corrieron de la Garfield. Lo que sí sé es que todo está en discordia.
Barrildo	Pero Mengo, el mundo está en harmonía.
Mengo	No niego que hay amor. Si alguien me quiere pegar, me defenderé. Ese es amor propio. Nadie tiene amor más que de su misma persona. ¿Qué es el amor?
Laurencia	Es un deseo de hermosura.
Mengo	¿Y por qué lo quieren?
Laurencia	Para gozarlo.
Mengo	Allí está. Pues, ¿no es para lo mismo que dije?
Laurencia	Tienes razón. Dale gracias al cielo que a ti te hicieron sin amor.
Mengo	¿Amas tú?

Laurencia	Mi propio honor.
Barrildo	¿Quién ganó?
Frondoso	Pues nadie.

Escena V

Laurencia	¿Viene Don Fernando para acá?
Flores	Ya se está acabando el motín.
Frondoso	¿Cuál motín?
Flores	Cuatro policías le plantaron mota a un cholo y luego lo golpearon, y la gente del barrio se calentó. Pero el Comendador no se dejó amedrentar. Dio la orden de lanzar gases lacrimógenos y los mandó a todos a la cárcel. Ahora viene para acá, porque le hemos preparado una fiestecita.

Escena VI
[Música.]
[Se ve la fiesta en el Community Center. Laurencia y Pascuala están afuera.]

Comendador	¡Esperen!
Laurencia	¿Qu´hubo?
Comendador	Tú me despreciaste el otro día.
Laurencia	(*A Pascuala.*) ¿Habla conmigo?
Pascuala	Pues a mí, no.
Comendador	Contigo hablo, hermosa fiera, y con la otra chavala. ¿Vienen a la fiesta?
Pascuala	Sí, señor, pero no para lo que Ud. Cree.
Comendador	Pasen, pasen. No tengan miedo. ¡Flores! (*Se mete.*)
Flores	Mande Ud. Entren, pues.
Laurencia	No empujes.

Flores	Ándenle, que les quieren dar unos regalos.
Laurencia	¿Es que no le basta con las que ya tiene?
Flores	A ti es a quien quiere.
Laurencia	Vente, Pascuala. (*Se van afuera.*)

Escena VII
[En la lavandería. Es el día siguiente.]

Laurencia	¿Me está espiando?
Frondoso	Es que nunca sé cómo me vas a tratar.
Laurencia	Todos nos miran, y ya quieren casarnos. No niego que eres bien parecido, y vistes bien.
Frondoso	¡Laurencia! Si sabes que mi intención es de ser tu esposo. No bebo, duermo ni como pensando en ti. Tienes cara de ángel, pero eres dura. Quiero que estemos como dos palomitas, juntándonos los picos y arrullando.
Laurencia	Dile a mi tío Juan Rojo. Habla con él. (*Va caminando con la canasta de ropa.*)

[Frondoso va al 7-Eleven a comprar unos cigarros, y ve al Comendador caminar tras Laurencia.]

Escena VIII

Comendador	Iba a comer un pescado frito, pero me gusta más este chamorro.
Laurencia	Me tengo que ir—llevo la ropa.
Comendador	Ya me cansé de tus desprecios. ¿Es que te caigo mal? ¿No se rindió conmigo la Sebastiana, y eso que estaba casada?
Laurencia	La Sebastiana anda con cualquiera.
Comendador	Vas a ver, Laurencia. No podrás esquivarte siempre.

Escena IX
[En el callejón. Frondoso está escondido detrás de unas cajas.]

Comendador	No te defiendas, que vas a ser mía.
Laurencia	¡Dios mío, ayúdame!
Comendador	Estamos solos, no tengas miedo.
Frondoso	¡Déjala, cobarde! Antes de que haga algo de que me arrepienta.
Comendador	¿Qué haces aquí, perro?
Frondoso	Perro hay uno solo, y no soy yo. Córrele, Laurencia.
Laurencia	Ten cuidado, Frondoso. (*Se va.*)

Escena X
[Frondoso saca una pistola y le apunta.]

Comendador	¿Estás loco? ¿No sabes quién soy?
Frondoso	No me obligues a amartillar la pistola, porque si lo haces, eres carne muerta.
Comendador	Te vas a arrepentir. ¡Suelta la pistola, cabrón!
Frondoso	Estoy enamorado de Laurencia, y eso me hace sordo.
Comendador	Te crees muy hombrecito, ¿verdad? Entonces tira, maldito, y verás que tal te va.
Frondoso	Vivirás esta vez. No vales la pena. (*Se va.*)

Comendador	Hay peligro aquí. Pero no me voy a dejar. Cobraré venganza de este traidor. ¡Lo juro por el cielo! Esperaré el momento preciso.

Acto Segundo

Escena I
[En Tacos México.]

Abogado	No creas que te toque la demanda, porque ya se adelantaron muchos.
Barrildo	¿Cómo te fue en el tribunal?
Abogado	Es una larga historia.
Barrildo	Un Johnny Cochran has de ser.
Abogado	He procurado lo más importante.
Barrildo	Pues tú has leído todos esos libros de leyes.
Abogado	No por leer es uno sabio. Lo que lees en los periódicos son puras pendejadas. (*Alguien lee en otra mesa.*) Y mentiras. Luego escriben nada más para hacerse famosos, no importa si dicen mentiras o no. También algunas leyes son injustas.
Barrildo	No te creo.
Abogado	Es tu derecho. Es justo que el ignorante se vengue del letrado.
Barrildo	Bueno, no te enojes.
Abogado	Tenemos que buscar pruebas y testigos para la demanda contra el Comendador.
Barrildo	Está difícil. Es poderoso, y tiene allegados.
Abogado	Con el tiempo y un ganchito, hasta los de arriba caen.

Escena II
[Al pasar.]

Juan Rojo	No hay tiendas en este barrio para un buen vestido de novia.
Cholo 1	¿Y qué dice el Comendador?
Juan Rojo	¡Ay! Laurencia tiene la culpa por habernos metido en este aprieto.
Cholo 1	Pero fíjese bien, ese, que el Comendador es el que tiene la culpa. Él fue el quien la atacó. Alguien debería meterle un filero.

Escena III
[Oficina del Comendador.]

Comendador	Buenos días, señores. Siéntense.
Alcalde	Estamos bien de pie.
Comendador	¡Que se sienten, les digo!
Esteban	(*Para sí.*) Es bueno honrar a los honrados, pero ¿si no lo son?
Comendador	Siéntense. Quiero hablarte, Esteban. Una liebre se me escapa.
Esteban	¿Cuál?
Comendador	Tu hija es.
Esteban	¿Mi hija?
Comendador	Sí. Habla con ella. Ha consentido en verme, y luego me trata mal.
Esteban	Entonces hizo mal, pero Ud. tampoco debería hablar tan libremente.
Comendador	¿Cómo te atreves a contestarme?

Esteban	Ud. es el dueño, y queremos que Ud. esté aquí, pero la gente de Barrio Maravilla es honorable. No somos liebres para que nos cace.
Comendador	¿Qué tiene de malo en lo que digo?
Regidor	Ud. al hablar así nos quita nuestro honor.
Comendador	¡Qué honor van a tener, si son una chusma!
Esteban	Chusma hay, pero los que no son de sangre tan limpia.
Comendador	Y yo me ensucio la sangre juntándome con ella. A sus mujeres se les respeta.
Alonso	(*Para sí.*) ¡Qué desvergonzado y mentiroso!
Alcalde	Nunca hemos visto prueba de ello.
Comendador	¡Y ya me cansaron la paciencia! Para muchos es un honor que yo visite a sus mujeres.
Esteban	Y sin embargo nosotros las protegemos.
Comendador	¡Ya lárguense! ¡Que no quede ninguno aquí!
Esteban	Ya nos vamos.
Comendador	Nada más andan chismorreando a mis espaldas.

Escena IV

Comendador	¿Qué les parece tanta concha?
Ortuño	Debías haber escondido tus propósitos.
Comendador	Y dejar que me traten al tú por tú?
Flores	Eso no es igualarse.
Comendador	¿Y qué me dicen del villano de Frondoso? ¡Eso no se va a quedar así!
Flores	Anoche soñé que le rajaba la garganta de oreja a oreja a ese.
Comendador	¿Dónde está ahora? Que se atreva a amenazarme a mí y el mundo se acaba, Flores. Yo he disimulado, pero no descansaré hasta no cobrar venganza. ¿Qué hay de Pascuala?
Flores	Dicen que se quiere casar.
Comendador	¿Y la Olalla?
Ortuño	Su novio anda muy celoso tras de ella. Intercepta mis recados. Pero si se descuida, entrarás como primero.
Comendador	Esa voz me agrada. Pero hay que tener cuidado del villano del novio.
Ortuño	No se preocupe, mientras tenga precaución.
Comendador	¿Qué hay de Inés?
Flores	¿Cuál?
Comendador	La de Antón.
Flores	Esa está lista para todo. Háblale por la puerta de atrás, y te deja entrar.
Comendador	A las mujeres fáciles, las quiero bien y les pago mal. Si solo supieran valorarse, pero ¡son tontas!
Flores	Hay mujeres que apetecen de los hombres, y eso no es de asombrarse.
Comendador	Un hombre puede estar locamente enamorado, pero si se le rinden fácilmente, las tiene en poca estima, y aunque sea muy cumplido,

él fácilmente olvida lo poco que le costó.

Escena V

Policía	¿Está aquí tu jefe?
Ortuño	¿Que no lo ves?
Policía	El jefe de policía me mandó para invitarle a salir con nosotros y hablar con la población del Barrio Maravilla. Están enardecidos porque golpearon a sus cholos.
Comendador	Ahora voy. ¿Qué hay de seguridad?
Policía	Tendrá unos 50 efectivos de seguridad.
Comendador	Así, sí voy.

Escena VI

Jacinta	(*Toca a la puerta.*) ¡Ayúdenme!
Laurencia	Jacinta, ¿Qué te pasa?
Jacinta	El Comendador me mandó a sus achichicles para que me llevaran con él, pero me largué.
Flores	¡Con que te ibas a escapar!
Jacinta	¡Estoy perdida!
Mengo	Ten un poco de piedad.
Flores	¿Tú quién eres para defenderla? Si quiere el Comendador, la mete en la cárcel.
Mengo	Si tratas de llevártela, te costará caro, cabrón.
Flores	Ah, pues ahora vienes tú con nosotros. (*Pone las esposas.*)

Escena VII

Comendador	¿A qué se debe tanto barullo?
Flores	Este naco está buscando pleitos.
Mengo	Señor, tenga un poco de piedad con Jacinta, que quieren robársela, siendo ella de familia honrada.
Comendador	Tendré piedad de ti y no te mando matar. Órale, muchachos, ya saben qué hacer.

[Se llevan a Mengo al otro cuarto y se oyen los golpes.]

Comendador	Ahora ya sabe Barrio Maravilla quién soy yo. Y tú, villana, ¿a dónde vas?
Jacinta	A recobrar el honor que me han quitado.
Comendador	¿Nada más porque te di un piropo?
Jacinta	Sí. Yo soy de una familia decente. Mi padre no es rico, pero tiene más honor que tú.
Comendador	Tiene poca madre, dirás. ¡Entra en el despacho!
Jacinta	Tendrás que matarme primero.
Comendador	Eso se puede arreglar.
Jacinta	¡Piedad, señor!
Comendador	No hay piedad, ahora vas a pagar todo lo que me debes.
Jacinta	¡Dios te castigará!

Escena VIII

[En Tacos México.]

Laurencia	¿No tienes miedo de que te vean?
Frondoso	Desde que vi cómo se comporta Gómez, no tengo miedo, solo coraje. Yo lo único que quiero saber es si todavía me quieres. El Barrio nos tiene como

	pareja, y están esperando si sí o si no.
Laurencia	Pues dile al Barrio que sí nos casamos.
Frondoso	Tu respuesta me da nueva vida. (*Se besan.*)
Laurencia	Habla con mi papá, y seré tu mujer.

Escena IX
[En la peluquería.]

Alonso	Fue un alboroto de aquellas. Pobre de Jacinta.
Juan Rojo	Tenemos que avisarle al alcalde.
Alonso	¿Y dices que le golpearon a Mengo?
Juan Rojo	Está todo moreteado.
Esteban	No sigas, que me hierve la sangre.
Alonso	No es la primera vez. Él se siente con derechos de hacer lo que le dé la gana, pues nadie le pone el "hasta aquí." ¿Quién anda allí?
Frondoso	(*Sale del cuarto de atrás, donde se estaba escondiendo.*) Yo.
Juan Rojo	Vete a mi casa, Frondoso, que corres peligro. Yo te he criado como a un hijo, y te protegeré.
Frondoso	Necesito que me ayude, señor.
Esteban	También a ti te ha agraviado ese canalla?
Frondoso	No poco.
Esteban	Ya lo sabía.
Frondoso	Quieró hablarles de otra cosa. Quierá a Laurencia y me quiero casar con ella.
Esteban	Me alargas la vida. Casada, Laurencia tendrá quien la

proteja. Te lo agradezco, la limpieza de tu celo. La boda será cuanto antes. Y tengo un poco de dinero ahorrado, y voy a hablar con el cura.

Escena X
[En la fiesta.]

Músicos	¡Vivan los novios!
Mengo	Nos ha costado mucho esta alegría.
Barrildo	¿Tú sabes hacer un brindis?
Frondoso	Yo más bien entiendo de azotes.
Mengo	(*Toca un vaso con un tenedor.*) Vivan muchos años juntos Los novios, ruego a los cielos, Y por envidias ni celos, ¡Ni riñan ni anden en puntos!
Frondoso	Ay, no digas pendejadas.
Barrildo	¡Estuvo bien!
Mengo	¿Nunca has visto hacer buñuelos que con el aceite abrasa los pedazos de masa. Unos salen hinchados otros tuertos y malhechos ya zurdos, ya derechos ya fritos, ya quemados? Pues la gente no los aprecia Y el poeta es el único que sabe lo que valen.
Barrildo	Déjate de locuras. Deja a los novios hablar.
Esteban	Hijos míos, les doy la bendición.
Juan Rojo	Ahora son uno solo.

[Músicos tocan la Negra.]

Escena XI

Comendador	Quietos todos y que no se mueva nadie.
Juan Rojo	¿A que vienes, señor? ¿Quieres un lugar en la fiesta? Aquí no hay que andar con pleitos.
Frondoso	¡Me viene a matar!
Laurencia	Córrele y escóndete.
Comendador	Eso no. Agárrenlo. Quedas arrestado. Yo no agarro a los inocentes, solo a los culpables. Llévenlo a la cárcel, donde la culpa que tiene sea justamente pagada.
Pascuala	Señor, piedad, que se casa.
Comendador	¿A mí que me importa eso? ¿Acaso yo la obligué?
Pascuala	Si le ofendió, perdónele.
Comendador	Está fuera de mis manos. Es importante para el ejemplo, el castigo, si no otro día habrá alguien que haga cosas peores. Él me amenazó con una pistola— así muestran su lealtad.
Esteban	Tú pretendes quitarle a un esposo su mujer.
Comendador	¡Majadero! Yo nunca quise quitarle a su mujer, pues no lo era..
Esteban	¡Sí quisiste! Es una pesadilla tenerte aquí entre nosotros.
Comendador	Ya te enseñaré lo que es una pesadilla. (*Lo golpea con una vara.*)
Pascuala	¡A un viejo de palos das!
Laurencia	Si le das porque es mi padre. ¿Qué te ha hecho?

Comendador	Llévensela, y que no la dejen escapar. (*Se van.*)
Esteban	¡Pido justicia!
Pascuala	¡Se volvió en luto la boda!
Barrildo	No hay nadie que haga algo.
Mengo	Yo ya tengo mis azotes.
Juan Rojo	Hablemos todos.
Mengo	Aquí todo el mundo calla.

Acto Tercero

Escena I
[Se reúnen los vecinos.]

Esteban	¿Han venido a la junta? Más aprisa.
Barrildo	Ya están todos.
Esteban	Frondoso torcido, y Laurencia en aprietos. Que la piedad de Dios nos socorra.
Juan Rojo	(*Al oído.*) Esteban, mejor hay que tratar las cosas en secreto.
Esteban	Si no estoy diciendo nada. (*A los demás.*) Nuestro pueblo ha perdido la honra. ¿Qué va a pasar, si no hay gente entre nosotros que le haga frente a ese bárbaro? ¡Contesten! No hay nadie que no esté lastimado en honra y vida. ¿No hay nada que lamentar? Si todo está perdido, ¿qué les queda?
Juan Rojo	Hay que ir con el alcalde para pedir un remedio.
Mengo	Si el Comendador se entera de esta junta, nos mandará matar a todos.
Regidor	Ya se no acabó la paciencia. Le quitan la hija a un hombre honrado, y golpean

	a un inocente. Ni que fuéramos esclavos.
Juan Rojo	¿Qué quieres que hagamos?
Regidor	Matar o morir. Nosotros somos muchos y ellos pocos.
Esteban	Serán unos bárbaros e inhumanos, pero a fin de cuentas, solo hombres, no superhéroes. ¿Qué nos ha de costar?
Mengo	Sin embargo, hay que tener cuidado. Mientras más asediados, más peligrosos son.
Juan Rojo	Si nuestras desventuras se comparan, Para perder la vida ¿qué aguardamos? Las casas nos abrasan, tiranos son, ¡A la venganza vamos!

Escena II
[Sale Laurencia desmelenada.]

Laurencia	Déjenme entrar, tengo derecho. Yo también soy del Barrio. ¿Nada más porque soy mujer no tengo voz ni voto?
Esteban	Santo Cielo, es mi hija.
Laurencia	No me nombres tu hija.
Esteban	¿Por qué?
Laurencia	Porque dejas que me roben tiranos, sin cobrar venganza. Aún no era yo de Frondoso. La venganza aquí por tu cuenta corre. En la fiesta de la boda ni siquiera había llegado la noche y me llevaron a casa de Gómez. Dejaron la oveja al lobo, como cobardes. ¡Qué palabras, qué amenazas qué delitos atroces para rendir mi castidad a sus apetitos torpes! ¿No lo dicen mis cabellos? ¿No ven aquí los golpes, la sangre? ¿No se les rompen las entrañas de dolor al verme así? ¡Bola de ovejas! ¡Denme la pistola a mí, que yo soy más hombre que todos ustedes! Una tigresa a quien le roban el crío sigue a los cazadores y los mata. Pero ustedes son unas gallinas. A nosotras las mujeres nos toca recobrar la honra, y sacar sangre de esos tiranos. ¡Cobardes y maricones! A Frondoso el Comendador lo quiere mandar a la pena capital, y ustedes aquí, con las manos cruzadas.
Esteban	Yo no hija, permito que se hagan tantas injusticias. Iré aunque sea solo yo, aunque todos se pongan en mi contra.
Juan Rojo	Yo también iré.
Regidor	Vamos todos.
Barrildo	Que mueran los injustos.
Mengo	Vamos a matarlos entre todos. Junta a Barrio Maravilla en una sola voz, que todos estén conformes en que los tiranos mueran.
Esteban	Agarren sus armas, pistolas, piedras, palos, lo que tengan a la mano. ¡Mueran los tiranos y traidores!
Todos	¡Mueran! *(Se van.)*

Escena III

Laurencia	¡Mujeres de Maravilla! ¡Vengan todas! ¡Vamos a tener una junta!
Pascuala	¿Qué pasa? ¿Porque gritas?
Laurencia	Jacinta, porque a ti te agredieron, serás vengada por una escuadra de mujeres.
Jacinta	Tú también tienes tu dolor.
Laurencia	Pascuala, tú llevarás nuestra bandera.
Pascuala	Órale pues, vamos.

Escena IV

[*Frondoso está con las manos esposadas.*]

Comendador	Ahora vas a ver quién soy yo. (*Lo golpea.*) Flores, mátalo.
Flores	Un ruido suena.
Comendador	¿Qué ruido?

[*Se asoman a la ventana. La gente viene amotinada. Empiezan a tocar la puerta.*]

Comendador	Desátalo y déjalo ir.
Flores	(*A Gómez.*) Que no te encuentren aquí. Cuando la gente se altera, no se van hasta que no haya sangre.

[*La gente tumba la puerta.*]

Frondoso	¡Viva Barrio Maravilla!

Escena V

Comendador	¡Esperen!
Todos	Agravios nunca esperan.
Comendador	¡Yo soy la autoridad aquí!
Todos	Eras, desgraciado.

[*Lo van empujando, a golpes, cuando aparecen las mujeres frente a ellos.*]

Escena VI

Laurencia	No hay venganza como de la mujer ultrajada.
Pascuala	¡Atraviésalo con un cuchillo!
Esteban	¡Muere, traidor!
Comendador	Muero, tengan piedad de mí.

[*Barrildo corre tras Flores y lo atrapa.*]

Mengo	Dále también a ese. Por su culpa me torcieron.
Frondoso	Le voy a sacar el alma de su podrido cuerpo.
Laurencia	Pascuala, guarda la puerta.
Barrildo	(*Arrastrando a Flores, que balbucea.*) No me aplaco con lágrimas. ¿Te creías muy protegido? Ahora, ¿quién te protege, cabrón?
Flores	Piedad, que no soy yo el culpado.
Barrildo	No te dabas abasto.
Pascuala	Dánoslo a nosotras. Vengaré tus azotes.
Jacinta	¡Muere, traidor!
Todas	¡Muere!
Pascuala	¡Moriré matando!

Escena VII

[*En la cárcel.*]

Esteban	Vamos a ponernos de acuerdo en lo que vamos a decir.
Frondoso	¿Qué aconsejas?
Esteban	Morir diciendo ¡Barrio Maravilla!
Frondoso	Es el camino derecho—Barrio Maravilla lo ha hecho.
Esteban	¿Lo quieren hacer así?
Todos	¡Sí!
Esteban	Ahora dime, Mengo. ¿Quién mató al Comendador?
Mengo	¡Barrio Maravilla lo hizo!
Esteban	¿Y si te martirizo?
Mengo	Aunque me mates.
Esteban	¡Confiesa, ladrón!

Mengo	Confieso.
Esteban	Pues, ¿quién fue?
Mengo	¡Barrio Maravilla!

Escena VIII
[En el tribunal. El fiscal llama a todos uno por uno.]

Fiscal	¿Quién mató a Fernando?
Esteban	Barrio Maravilla lo hizo.
Laurencia	Tu nombre, padre eternizo.
Fiscal	Llamo al niño Quintanilla. ¿De quién fue?
Niño	Barrio Maravilla.
Laurencia	¡Bravo, pueblo!
Juez	Vuelven a gritar así y los voy a sacar a todos.

[Pascuala en el banquillo.]

Fiscal	¿Quién mató al Comendador?
Pascuala	Barrio Maravilla, señor.

[Mengo en el banquillo.]

Fiscal	Está usted bajo juramento. Si miente, los cargos serán contra usted.
Mengo	Yo lo diré, señor.
Fiscal	¿Quién lo mató?
Mengo	¡Barrio Maravilla! (*Todos aplauden.*)

Escena IX
[En la panadería.]

Mujer 1	¿Quién mató al Comendador?
Panadero	¡Barrio Maravilla!

Escena X
[En el mercado.]

Marchante 1	¿Quién mató al Comendador?
Marchante 2	¡Barrio Maravilla!

Escena XI
[Cholo manejando y escuchando el radio.]

Locutor	Ahora tenemos a Sergio Martínez, defensor del caso. Señor Martínez, la gente anda diciendo que nadie es culpable porque no hay prueba contra algún asesino en particular. En cambio, el fiscal, Mr. Quackenbush, quiere meter a todo Barrio Maravilla en la cárcel. ¿Qué opina usted?
Martínez	No se puede meter a todo un barrio en la cárcel. Si no hay culpable, no hay delito.
Locutor	Allí lo tiene, amables radioescuchas, las últimas noticias de radio Chipotle, el programa con sabor a México. Sintonicen con radio chipotle para las noticias más picantes del día.

[Música.]

Escena XII
[En el tribunal.]

Juez	Señores y señoras del Jurado, están prestos para dar el veredicto.
Jurado	Así es, su señoría.
Juez	¿Cuál es su dictamen en este caso?
Jurado	Encontramos a Barrio Maravilla no culpable.
Todos	Risas, aplausos, música.

Fin

Why Hispanic? (2000)

"Why Hispanic" is reprinted from the Fall 2020 issue of Aztlán: A Journal of Chicano Studies.

In the sixteenth century, Spain colonized the American mainland, Guam, Puerto Rico, Cuba, and the Philippines. The Caribbean colonies developed a rich African-Spanish mixture, the Pacific Island colonies developed a rich Asian-Spanish mixture, and the mainland Americans developed a rich Indigenous-Spanish mixture. This *mestizaje* was racial and cultural. The actual Spanish population was always in the minority. In Mexico, as in other places, Spaniards intermarried with the Native Americans to the extent that after independence they ceased to exist as an ethnic group. The *criollos* that remained considered themselves Mexicans, not the loathed Spaniards. While Spanish became widely spoken, in spite of genocidal efforts the Native languages and customs did not disappear, and rather than the Natives becoming Hispanicized, the Spaniards became Americanized, developing a taste for Native food and customs, as well as Native partners in marriage.

It is hard to believe that people consider Mexicans Hispanic. One need only walk around the Aztec capital (*Mexico* is not a Spanish word) to see people today in the big city wearing Native clothes, braids, and huaraches as a matter of course. Those that do not have identical features to those who do. As far as a ruling elite, it is true that Mexican politicians and industrialists tend to be European-looking, but it also true that some of Mexico's presidents, such as Juárez and Díaz, were full-blooded indigenous people. How many African American or Mexican presidents has the United States had? Many Mexican intellectuals are indigenous (de la Cabada, Altamirano, Goitia). The same indigenous strength is obvious in Yucatán and Guatemala. People walk around speaking Maya in their daily activities. In other parts of the Republic there are more than one million Nahuatl speakers today. In Sonora and Sinaloa, where the indigenous people look more European—that is, they are tall and their skin is lighter—the fact that a man or woman is dressed in a suit or high heels does not prevent them from being Yaqui or Seri. Proof that "Hispanic" is strictly an Anglo concept is the attitude Anglos have about race mixing. To them, "half breed" is an attribute of contempt, while a Mexican will call himself "mestizo" with pride in his Native heritage. Any observant gringo, if he bothered to notice at all, would soon realize the dearth of Spanish symbols in Chicano, Mexican, or Central American iconography. There are no castanets, no mantillas, no paella, no flamenco. Instead we find the Aztec serpent and eagle on the Mexican flag, the feathered shield, the quetzal, the tamal, the coyotl. It seems the Native people are trying to tell us something.

To say Mexicans are Spanish is to show the most spectacular ignorance of history, but most important, they themselves would laugh in amazement at the idea. Only Mexicans who have gone through US public schools can say they are Hispanic with a straight face. The idea does not exist south of the Río Bravo.

Mexico City was founded by the Mexicas in 1325. The Mexican empire stretched all the way from today's state of Colorado to Panama. In 1978 a stone monolith with the likeness of the goddess Coyolxauhqui was discovered under priceless Spanish colonial buildings next to the Zócalo in Mexico City. A few people objected to tearing the colonial buildings down, but there was no contest; the Aztec buildings were more important. The buildings came down to reveal the ruins of an Aztec ceremonial center for the first time in almost 500 years.

How can Rigoberta Menchú, who has not a drop of Spanish blood and didn't even speak Spanish until she was ten, be called a Hispanic? If she can't, then why should Dolores del Río be called a Hispanic? Dolores, who wore furs and diamonds and stayed at the Plaza, and who made a perfectly convincing Otomi in *María Candelaria*. Aurora Bautista, a Spanish actress, contemporary of Dolores, could not have done it. Why should María Félix, who hobnobbed with Cocteau and Jean Gabin and had a grandfather who was a full-blooded Yaqui, and proud of it, be called Hispanic? Columba Domínguez's grandmother was also indigenous. El Indio Fernández speaks for himself. The list goes on ad infinitum. The fact is that Mexicans, whatever their color, are Native Americans, and if there is a small amount of Spanish blood in them, there is little Spanish culture other than language and a few token institutions, such as Catholicism, remaining. One must bear in mind that many Mexican presidents (notably Cárdenas) have waged open wars on the Church, confiscating their lands, turning the buildings into libraries, and forbidding their prelates to wear their habits in the street. Anti-Catholicism has a long tradition in México, precisely because Catholicism is considered a foreign ideology identified with the hated Spaniards and the conquest. In 1810, the people of Guanajuato rioted and broke into the Alhóndiga de Granaditas, took out 138 Spanish prisoners there and murdered them in cold blood. That scene was repeated thousands of times throughout Mexico's colonial history. Don't Anglos realize that September 16, the famous Mexican holiday with parades, food, and dancing, is celebrating the death of the *gachupines*? Apparently not. Although mistrusting Catholicism, they have always supported the missions, which were indeed Spanish, as key to the central infrastructure. The anti-indigenous bias is obvious.

It is not even a question of Spanish blood. Mexicans are heavily intermarried with Germans, Jews, Arabs, and Africans. Some Mexican last names: Herzog, Betancourt, Leduc, Caen, Haro, Awad, Mansour, Eherenberg, Ripstein, von Bertab, Poniatowska, and Yampolska. There are millions of indigenous last names. In Yucatán we find, among many others, Pech, Balam, Canché, and Canek, and in other parts such names as Suboqui, Ocomol, Xaxni, Nucamendi, Equihua, Cuautle, Coyote, Chimal, Xiu (who count forty-six generations to date), Teopantitla, and Jolote are common. The Moctezumas are direct descendants of the emperor, with papers to prove it. Not a Hispanic in the lot.

If the foregoing is true, why the rabid insistence that Mexicans are Spaniards? US Americans do not wish to be called "British." Filipinos are considered Asian, not "Hispanic," yet they were colonized by Spain and speak Spanish. (Many even have Spanish last names, such as Monteverde, Romero, and Silvestre.) Why are Mexicans, who were colonized by Spain (as were the Filipinos) and speak Spanish as they do, clamorously singled out for the "honor" of being called Spanish? The answer can only be political.

The term *Hispanic* came from the fevered mind of a Washington bureaucrat, not from contemporary reality or history. The Protestant English people on the East Coast of the United States, who only recognize the colonizers, not the colonized, have been fighting the wars with Spain and Catholicism since the time of Queen Elizabeth the First. They took American lands from Spain and never bothered to find out that the people on these lands are not Spanish. Refusing to intermarry, for years they have been harping that there were no more "Indians" (*The Last of the Mohicans*, *The End of the Trail*, *Ishi: The Last of His Tribe*, etc.) They have also been harping that there were no more Mexicans, whose Spanish masters (Californio

aristocrats, not Mexicans, according to the scenario) played guitars to their dark-eyed señoritas. All gone. Their descendants have assimilated and salute the US flag. Good citizens of Spanish descent, like Rita Hayworth.

The gauche Anglo mantra goes like this: First there were Indians, who were cruelly conquered by the Spanish. (According to the narrative, Spanish cruelty was much worse than Anglo cruelty—the North Americans are always the good guys.) Then the Indians all magically disappeared from the Midwest and left the land empty for the pioneers. There were no Mexicans in the United States. Mexicans were in Mexico, Spain. They picked a war with the peace-loving United States, but then it was over, and the Southwest was empty to make room for the pioneers. Brown-skinned people in the United States have a "Hispanic" ancestry, which means they are foreigners from Europe. If they don't come into the country with permission from immigration, as the Anglos did through Ellis Island, then they are illegal and should be sent back.

The facts are otherwise. Mexicans are Aztec, Otomi, Maya, Huichol, and Yaqui (the list goes on) who intermarried with Spaniards, Jews, Arabs, Germans, and Africans, as well as with Chumash, Gabrielino, Comanche, Apache, and Pueblo. Mexicans are Native Americans who did not come from Europe. Should there be any doubt, the biological evidence is irrefutable. Most Mexicans are born with the Mongolian birthmark, a dark stain at the base of the spine that lightens as the child grows older. This characteristic is totally absent among Europeans, but present in indigenous people, whether North, Central, or South American. The only foreigners in the picture are the European Americans themselves.

Cuba (1991–98)

1991: El Periodo Especial

"Police authorities frequently employ undercover agents. . . . Cuban authorities restrict photography. . . . [You] should not photograph military or police installations or personnel, or harbor, rail and airport facilities. . . . [You] should be careful about what you say and do in Cuba. . . . [Your] comments are likely to be reported to authorities. . . . This is punishable by law."

As if this were not enough to have you running, screaming, from the place, a gusana in Miami attached herself to our line of United Teachers Los Angeles (UTLA) delegates and spoke to them, uninvited, about the horrors of Castro's Cuba. "People are afraid to talk openly," she said. "Of course, as tourists, you will have a good time, but the people are suffering. They are tortured if they are caught talking to strangers." She admitted that she had not been in Cuba since she was five years old. Her family was persona non grata.

By this time, some of the teachers in our UTLA (union) delegation had become thoroughly paranoid. Since they did not speak Spanish, they had no way of proving the truth of the assertions. Every airline hostess, every cab driver, was a sinister figure waiting to turn them in at the slightest provocation. They were not enjoying themselves.

We were hustled through José Martí airport ahead of individual Cubans who were visiting relatives. Our bags were not even opened, and we thankfully sank into the cushions of a Cuban-built, air-conditioned tour bus. Delegates were snapping pictures of the forbidden airport right and left, but strangely, nobody tried to stop them. As we sped along to the hotel, I recognized it. *Latin America!* Here was Cozumel, Veracruz, Maracaibo. Also Dakar

and Conakry. Hot. Underdeveloped. Colonial. Fabulous. *My place.*

"Socialismo o Muerte" screamed a sign as we sped along. Nobody fainted.

We arrived at the hotel, which was air conditioned, had plenty of hot water (water can be drunk from the tap), color cable TV, and marvelous buffets. Then a tour of La Habana Vieja, El Castillo de la Real Fuerza, La Rampa, and back. Delegates were busy snapping pictures of the ships in the forbidden harbor, about a block from a police station, but the bored officers standing around seemed more interested in getting a cold drink than chasing after yet another bunch of tourists. (La Habana is full of Europeans and Latin Americans.) Teresa, our guide, mentioned that there was little paint in Cuba because of the blockade, and, indeed, the buildings were badly in need of some paint, giving what were lovely stone structures a distinctly shabby air. She also explained that the US blockade made it impossible for Cuba to trade with many countries and also difficult to get hard currency (convertible outside of Cuba), so that the government had to choose between paint and, say, food for the schoolchildren. So they did without paint.

The colleagues, bless them, did not adjust quickly to the changes. One vegetarian felt that Cuba's problems could be solved if everybody grew alfalfa sprouts for food. Later in the week some feminists engaged a representative of the Federación de Mujeres Cubanas in a discussion on condom etiquette (who puts it on and who takes it off); one teacher wanted to know if that was the Bay of Mexico; and almost all were interested in how Cuban teachers could make more money—that is, how they could appropriate the surplus value of the workers better. The Ministry of Education rep tried to explain that a teacher could make more money by going to the countryside or working odd hours in order to adapt to the needs of the students, but many delegates failed to make the connection between working harder and making more.

The talks were illuminating, but were only one side of the picture. I had been told that it was illegal for a foreigner to take a private car, as opposed to an INTUR (Instituto Nacional de Turismo) car, on a sightseeing tour. I decided to test the system and see if I could get arrested. I ran into a retired driver and went to Varadero with him. As the trip lasted two hours each way, there was plenty opportunity to dish the dirt.

There are three main problems that Cubans have to solve before further progress can be made. 1) Mistakes made by the Communist Party (Partido Comunista de Cuba, or PCC), which may include favoritism for members over nonmembers. 2) The dismantling of the system in Eastern Europe. Cuba has relied heavily on help from other socialist countries. Contracts have been signed and reneged upon. For example, Czechoslovakia had agreed to supply Cuba with goods while Cuba paid back in kind (e.g., sugar), but now the Czechs want dollars, which Cuba doesn't have. Thus the surge in tourism. Every tourist is to bring dollars into Cuba so that the government can meet its trade obligations. Thus the illegality of changing dollars on the street. Dollars are to be spent only at INTUR establishments, so that they can go directly to the government without being devalued first on the black market. Makes sense, actually. 3) The US blockade. Never mentioned by Miami Cubans, this is at the root of much of Cuba's poverty. It is not simply that the United States will not trade with Cuba, it forces other countries to not trade or limit trade with Cuba. There was even talk that Bush told Gorbachev that he would help Moscow if the USSR stopped all trade with Cuba. A nasty business, and one which caused great bitterness among ordinary Cubans. The blockade makes it difficult or impossible for Cuba to

import goods. Cuba is a no-frills society. If it is not produced on the island, it doesn't exist. Thus there is no shampoo, no Band-Aids, no chewing gum. Ballpoint pens fall apart. Cuba, after all, is a Third World country and cannot be compared to a high-tech, industrialized one.

So, what have we got? 1) The best medical care in Latin America, absolutely free for everyone. My driver had an operation in the same hospital attended by Fidel, where open heart surgery and organ transplants are made. In his sixties, he was certainly healthy. In 1974 the rate of doctors graduated was one for every thousand in the population, and as the rate increased and there was less need for doctors, they were simply given opportunities to practice abroad. 2) The highest educational level in Latin America, absolutely free through university, with two meals a day and a stipend guaranteed to those on scholarship. No mean feat, this, in a country with a literacy rate of over 97 percent. There is one teacher for every twenty-five citizens (not every twenty-five students). 3) Guaranteed jobs, with one month paid vacation. Just about everybody over a certain age has been in Eastern Europe. A student who goes through the system and gets good grades will have an adequate standard of living, with about four hundred pesos a month. The highest salary is six hundred pesos, the lowest two hundred. A high school dropout will have a lousy sweeping-up job and will be likely to go to Miami, where he feels everything must be heavenly. He will also be likely to approach tourists, give them a bad impression of Cuba, try to change money illegally in an undertone, while peering around suspiciously, and get into trouble with the police. Thus the myth that Cubans are afraid to talk to strangers. In fact, they complain bitterly and loudly to anyone who will listen about the shortages. Two years ago there was no rationing; now, because of the shifting political situation, rationing is

in place. 4) Housing. Some housing is definitely substandard, but no one is homeless. After the Revolution, many houses of the rich remained empty, and people simply moved in. They are still there. New housing is everywhere, some of it right on the beach and totally inviting. In fact, some of the poorest people seem to have the choicest beachfront. Another form of construction is the sites of the Pan American games, hosted by Cuba, and a new five-star Meliá hotel going up to accommodate tourism. The builders of the Pan American housing get to keep the apartments after the games are over.

How are "free" services provided in a land where there are no taxes? The Junta Central de Planificación appropriates surplus value—that is, pays a worker a portion of his labor value and uses the rest to lower prices, raise salaries, and administrate social services, including culture. As long as people are working, the system can sustain itself. High school dropouts hurt the economy, and every effort is made to rehabilitate them.

Still, the problems remain. The government's refusal to allow a parallel economy (small business) makes it impossible for Cubans to get, except at limited locations on the street, cold drinks or food or tennis shoes or other things that tourists take for granted. They are not allowed in the INTUR stores, again, because they are not allowed to have dollars. Thus the few restaurants and stores that deal in Cuban pesos have long lines attending. (Coppelia, the ice cream parlor, has two hundred outlets, but a hundred people waiting at each outlet.) People can travel wherever they please in Cuba, but they cannot be guaranteed a hotel or restaurant and may have to take everything with them and sleep on the beach. The only solution, for Cubans, is a greater development of socialism, without trade restrictions, and greater prosperity so that everyone's standard of living is raised. The path is difficult. The Communist

Party has defiantly thrown down the gauntlet and has declared Cuba to be "un eterno Baraguá"—that is, it will never surrender.

My driver put it this way: "I know there are problems. I am not blind. But I would give my life for the Revolution. Before 1959, I had nothing. The Revolution sent me to Moscow for five years to study. I was in Angola. The Revolution educated my children. One is an engineer, the other a teacher. It gave me my house and my car. Cuba has the respect and admiration of the world. If it were not for the blockade, things would get better. Before the crisis, we had no rationing. Things will get better. Nothing stays the same."

After Varadero, I started out from the hotel at around 10:00 p.m. for a walk around La Habana. I wasn't sure where I was going and, still under State Department paranoia, I eyed a policeman warily on the street. On impulse, I asked him how I could walk to the Plaza de Armas from G Street. Young, athletic, he could only be described as charming. He took the map, squinted at it under the street lamp, couldn't believe that I would want to walk several miles without taking the guagua, and tried to show me the shortest route. I told him I had forgotten my passport (I had been instructed by the US tour guide to have it with me at all times) and asked him if I should walk back to the hotel to get it. He seemed puzzled by the question. He kept trying to show me how to get to Neptuno (closer) and I kept telling him "No, I want Salvador Allende" (farther away). He whistled at two passing girls, obviously from the neighborhood, and asked them how to get to Salvador Allende. "Oh," they said," that is too far." "I'm not in a wheelchair," I grumbled. "Nobody wants to walk around here." Finally, they showed me the way. The policeman shook hands, smiling broadly, and we parted.

La Habana at night is crowded with people. There is no danger. I met Teresa, one of the tour guides, on Salvador Allende. (It wasn't far at all.) She lives there. She cautioned me not to go into the "recovecos." I said, as long as I wasn't killed, I didn't care. I liked adventure. She laughed and said it had been five years since any violent crime had been committed in La Habana. The most that could happen is that I could get robbed.

Because of the heat, people were lying in open doorways looking at television inside. I finally reached Plaza de Armas, on the water, and started walking down the Malecón. The Malecón has been taken over by every teenager in town. The police patrol it, but there is an unwritten rule that they are not to interfere unless needed. Kids hang out far into the night, drinking, talking, even making love in the "recovecos." There are no drugs. It is impossible to walk more than a few yards without someone asking for a cigarette, a subterfuge to find out who the stranger is, where he is from, etc. By this time it was 2:00 a.m. David, my newfound friend, offered to get some pizzas, one for me, one for him, and one for his girlfriend, thus saving me from standing in line. The girlfriend, Concha, impudently stuck her pizza in my mouth and gave me a kiss. Another friend, Elías, offered to take me to a Santería mass. I walked along, enveloped by Cuban ghosts, the whispers of Martí and Maceo and Guillén, lapping on the shore. The socialist moon bathed the people in a glow punctuated by street lamps, turning their dark skins into shadows. In Cuba, el que no lo tiene de Congo, tiene de Carabalí—that is, everyone is African to one degree or another.

The talking, the laughter, the dancing in the tropical night were enough to send me back, and Cuba settled in my heart, irrevocably, like an arrow. Gone were the meanness and pettiness of life in Los Angeles. Here was life to be lived openly and naturally. "Quisiera ser pajarito para volar a dondequiera," said a girl

wistfully. Yeah, I thought, but you won't find it better than here. That night, on the Malecón, for a few hours, life was good.

Too soon it was time to return to Miami. Forty minutes and half a world away. Back to the antiseptic, cancerous world where people were only concerned with number one, went home to watch television, took pills to deaden the unease. Back to the memories of a country and a generous, loving people who struggle every day, but with a purpose and a sense of humor that makes the greatest sacrifice as inevitable and natural as breathing. Memories of the daughters of the Varadero maids, beauties by any standard, giggling in their adolescence at the beach. Memories of the mulattos at the beach, dancing, just for me, a bit of their Tropicana routine. Memories of Lariosi, an Arab from Western Sahara studying in the Isle of Youth, grateful for what Cuba had done for his education.

Struggle is not new to Cuba. The Cuban people have banded together time and again and overcome difficulties, from slavery to invasions. It is that spirit, of making do with whatever is at hand, of dancing at the beach, of hugging and kissing strangers, that will carry them through "el período especial." Cuba is and will be an eternal Baraguá.

1992: Cuba Update

Some of the frustration felt by Cubans, aside from the double blockade, has to do with geography. The sea, open and free, can also be a wall that surrounds the population at a time when money for travel is scarce. Someone on the street quoted to me "Los Muros de Agua," by José Revueltas. Professionals, however, have no problem attending functions in other countries. My friend at Empresa Cubana de Radio y Televisión (ECRT) has just gotten back from a film festival in Toronto.

Time and again, I was told by street people that no one goes to bed hungry. Few Cubans would think of leaving if the blockade were over and things could proceed normally, with an end to rationing. The blockade creates some bizarre situations. Another friend is a merchant marine, but there is little merchandise, so he is not working. He does, however, get his full salary and benefits, and he is on call whenever there is work.

The movies. A flock of screaming queens flew down La Rampa like flamingos to the Cine Yara, where the men are, ready to snap them up like fish in a shallow lake. Six or seven policemen standing around were totally indifferent to the proceedings. When the tickets were all sold, there were still large crowds outside the theater. The theater then projected the movie, with sound, on an opposite wall, across the street (*Cinema Paradiso* style) so that people who did not get a ticket could still watch. It's rather startling to watch intimate sex scenes thrown seventy-five feet across La Rampa.

Fidel, the ultimate tango dancer. An interview with Edmundo Daubar at the Casa del Tango yielded the following picture of Fidel. Carlos Gardel's photographer rescued the last picture of Gardel from the fire in which he died and, at age ninety-four, brought it to Cuba as a present for Fidel. Fidel said, "This should be part of the collection of the Casa del Tango," and personally presented it to Edmundo Daubar as a gift. This prompted Edmundo to give Fidel the highest compliment he could think of: "The greatest tanguero in the world."

The bus lines. After a day at the beach, as the sun was beginning to set, I decided to walk to the guagua, rather than try to find a taxi. Every young person from the beach was concentrated at the stop. They came in seemingly endless waves. Now was the time to find out what a Cuban line meant. The young people, inexhaustibly energetic, danced and sang and

gossiped with each other, so when the bus actually came, they were loathe to part. The wait was anything but tedious. First, a flatbed truck driver stopped, going home after working all day, and gave several dozen kids a ride. (Taxis will also customarily pick up passengers for free if they are going in the same direction as the paying customer.) Then two buses sped by, full. A third came by almost empty, and I got on and went into La Habana. Total waiting time, forty-five minutes, less than a comparable situation in Mexico City. Fare: twenty Cuban cents.

Attitudes. Almost without exception, everyone over forty is in favor of the Revolution, passionately so. Some young people—not members of the Unión de Jóvenes Comunistas (UJC) or Federación Estudiantil Universitaria (FEU), which together represent the vast majority of young people—feel left out of the capitalist world economy. They would like fancy, glittery things, they would like to travel. They can have fancy things and travel if they work for the government, but they don't want to do that. They want things without working for them.

Some people like the good things about socialism in the período especial and don't like the bad things occasioned by the double blockade. They like having free and universal medical care, housing, schools, no unemployment, a steady income. They don't like the discipline. They don't like to be watched when they are doing something illegal. They don't like to share equally in the scarcity of goods. They are not particularly rational, nor ready to sacrifice.

Hustlers. Much of the police action in the tourist areas has to do with officials trying to keep the hustlers away from the tourists. Tourists often get a skewed impression of Cuban society because all they talk to are the lumpens on the street. It's as if a visitor to Los Angeles went to 5th and Main and talked only to the homeless. Even then, that would be more accurate, because there is structural unemployment in Los Angeles. These are high school dropouts who don't want to follow a career path and would rather hustle and cadge money from tourists. They have learned to manipulate tourists by feeding their prejudices. They lie through their teeth in order to make tourists feel sorry for them. "I have no shoes," "I am constantly being watched," "would you like to change dollars for pesos?" are constant refrains. "Some (adulterated) rum, some (fake) cigars, some (bogus) pesos?" These potential capitalists dream of going to Miami and getting rich, little thinking that if they were to make it there, they would be washing dishes and feel lucky to have a job. In Miami, because of their color, they would know what persecution by the police really meant.

Food. When a tourist buys a meal, he says, "I feel guilty eating all this food when people outside are starving." First of all, the people outside are not starving (one need only look at gorgeous bodies on the beaches). Second, that ten-dollar meal actually costs the government much less. By buying that meal the tourist is actually subsidizing the Cuban vacationer, possibly that same couple at the next table.

The hotels are full of Cubans on vacation, lolling by the pool and scarfing up the buffet. Cubans are indeed allowed in the hotels, restaurants, and night clubs, if they are guests there. It is part of their paid vacation benefits, which are at least in part subsidized by the tourist dollar.

The policy of the United States is to starve Cuba to death, to foment discontent among the people until they rise up in revolt against the scarcity. Whenever mention is made of the lines in front of restaurants and grocery stores, lines for the guagua, scarcity resulting from the blockade, the United States must feel very satisfied. The fact is that the blockade is a failure.

Every day new arrangements are signed with countries unwilling to knuckle under to the US diktat. The lines here are no worse than anywhere else. Everyone in Cuba eats, everyone sees the movie, everyone gets to where he or she is going.

At 5:00 p.m. the most amazing smells permeate La Habana. Every housewife or househusband plops a bunch of garlic and butter or fat into a frying pan in preparation for dinner. While meat is not eaten every day, a meal might include any of the following: pork or ham with rice and black beans and fried plantains, chicken (a lot of people raise chickens on the back porch, even in apartments), seafood, bacalao, picadillo, estofado, bread, milk, beer, tomatoes, lettuce, cabbage, oranges, grapefruit, flan or cake. The starches, fruits, and vegetables are plentiful. Soya products help balance out the protein needs of the population.

Tourism. One price that Cuba has to pay for its independence is to be accused of pampering tourists at the expense of its own people, an accusation that completely ignores the point: tourist dollars are distributed to the Cuban people in the form of goods and services and keep the economy afloat (hence the US ban on its citizens traveling to Cuba). As a comparison, no one has ever said that tourist dollars have helped the Mexican people, other than possibly in tips. On the contrary, they are inflationary because they create a demand for expensive technology. If a simple whole chicken in a Mexican market costs two or three dollars, at Kentucky Fried Chicken on Reforma it costs tourists and Mexicans alike twelve dollars. In Cuba, the tourist dollar is controlled so that it is neither devalued on the black market (as much as possible) nor inflationary through the importation of nonessentials.

The socialist system has done something not found elsewhere. In the world crisis of capitalism, no cutbacks of essentials have been made.

Not one school has closed down, not one scholarship has gone unawarded, not one patient has been denied medical care. The Cuban economy is sound. Demanding discipline, it makes allowances for human frailty and desire for privilege as long as these don't interfere with the overall progress of socialism. That the Revolution has been able to withstand the double kick in the cojones by the US and the USSR and remain on its feet is proof enough of its staying power.

Rather than envy foreign products and expertise, Cuba offers pride in the rich and varied achievements (past and present) of its own people. It offers human contact. The kind of camaraderie inherent in a socialist society simply doesn't exist in competitive capitalism. In Cuba strangers become friends in a matter of minutes. This convivencia is within native Latin American tradition. The alienation and racism reflected in North America's cities, for Cubans, is a high price to pay for electronic gadgetry and consumerism.

Washington says that Latin America must have "freedom," but socialism isn't about freedom. It's about equality, a very different thing. Freedom has done little for the homeless in the United States. In Cuba, socialism means not only equality of opportunity, though it is surely that, but also equality of living standard. The great contribution that Cuba makes to world history is that everyone—young or old, smart, stupid, industrious, lazy, kind, mean, thin or fat—has a fundamental right to live like anyone else. A house, free medical care, a good school. This is real democracy. This affirmation of the basic unity and goodness of humankind is what differentiates socialism from every political and economic system that has gone before.

No hay mal que por bien no venga. When the blockade is over, as it surely will be, and the ex-USSR has definitely retired from the scene, Cuba will be truly independent, strong and

free, and the Revolution will take its destined giant step in the fulfillment of its promise.

1993: The Revolution Continues

People think that socialism is some magic wand that changes everything overnight. It does change some things quickly, but some things take more time, and some things never change. The idea that Cuba is a country with a small ruling elite and an oppressed mass population is as simplistic as it is vicious and mean-spirited. Cuban society, like any other, is complex. The lumpens have not disappeared. Marx said they would disappear as a class, but they are numerous enough in Cuba to cause real concern. The blockade has strengthened and intensified this element.

During the halcyon days of socialism, the lumpens had all but disappeared, but with the poverty caused by the double blockade, they have come out of the woodwork. Prostitutes, hustlers and thieves proliferate. This is what the United States wants for Cuba: people who put themselves first, who indulge in petty jealousies, who are hysterical because they think somebody else is going to get more than they, who traffic on the black market, who will do anything for a profit, who think the world owes them a living, who resent the Party because it demands sacrifice (in the special period) and selflessness always. The United States, the true evil empire, forces the Cuban government to choose between becoming more repressive to the lumpens, which creates more repression and discontent for everybody, or becoming more liberal and paving the way for a glasnost-like anarchy. Socialism will survive in Cuba in spite of the blockade, but it must find a way to neutralize the darlings of empire: the alcoholics, the male prostitute with the US flag tattooed on his shoulder, the man who married a tourist thinking he could go to New York to live with her, those who are ready to deal in drugs, if given a chance, and to commit murder. These are the people standing in the wings, hoping to create another perestroika. Rather than being repressive, as it is supposed abroad, the Party stands as a bulwark against these criminal elements. If it weren't for the civilizing forces of the Poder Popular, the FARC militia, and the Comités de Defensa de la Revolución (CDR), Cuba would revert to the jungle that is now Eastern Europe, run by the Russian mafia.

There are external and internal enemies in a symbiotic relationship, and the Party must find a way to deal with both while protecting the Revolution. The fact that it has rejected the siren call of perestroika means that the Revolution will survive.

The lumpens are victims who do the dirty work of Washington without even realizing it. They feel like victims, but instead of being victims of socialism, they are victims of the empire that manipulates them and that they so admire.

How the blockade hurts ordinary people. I spoke with Raúl, a taxi driver in his sixties. Before the Revolution, his parents were rich and he had uniformed nannies. He always noticed that the kids he played with did not know when or if they were going to eat. He would sneak food out from his home to them. He eventually became a lieutenant coronel in the rebel army, and during the 1960s and 1970s everything went well. The double blockade has forced him to take a job as a taxi driver in his old age. His friend, a university graduate, had to take a job as a taxi driver also, as jobs dried up for lack of resources. (There are too many university graduates to be easily accommodated by the economy.)

Cuba needs, primarily, petroleum to make the machines that transport people, that harvest the crops, that feed the cattle, that produce the milk, that provide shoes, that provide the meat, that provide the soap. The United States

killed more than 1,000,000 people in Iraq to make sure that the Iraqis and the Saudis controlled the world's distribution of petroleum. Other countries are not allowed to sell petroleum to Cuba. Cuba is looking for petroleum on the island. There is one country, however, that doesn't give a fig what the United States thinks. Iran is selling some petroleum in exchange for sugar.

Punishment. Cubans are not allowed in the hotel rooms because only prostitutes and their pimps would go. They would steal money, passports, jewelry. Is this a violation of their human rights? The incident with José showed me how Cubans violate human rights.

He was dying to come up to my room, strictly forbidden. He apparently had had a couple of drinks and came and knocked loudly on my door. Naturally, I let him in. He asked me to give him ten dollars, strictly forbidden, so he could buy a bottle of rum. I gave him five and the bottle appeared, miraculously none the worse for wear at the lower price. By this time he had brought his twenty-three-year-old nephew, who immediately turned on the radio full blast. Together they proceeded to finish the entire bottle and started asking for my things: a cigarette lighter, dark glasses, a bottle of shampoo. The nephew eyed my camcorder.

The party was getting loud when the acting manager knocked on my door and asked to see José. After a while he and the nephew left.

The next day the manager came up came up and wanted to know what happened. I apologized for the incident, but he explained that "the tourist is always right," that José knew the rules and he had been warned before. When I went down, José was nowhere to be seen. He had disappeared.

A couple of days later, I ran into José and his nephew on the beach. He was working at another hotel and happy as a clam. He was still drinking. He said a few choice words about the

manager and invited me to come and see him at his new location, about five blocks away.

The hotel. Since I did not go on a tour—that is, I took a taxi from the airport and went straight to a hotel of my own choosing—I was able to see how ordinary Cubans live. Tours take you to see the sights, no matter what country it is. The hotel is tiny, with only nine rooms, considered third class. After a few hours I felt right at home and went into the kitchen, the bar, and the office, where I sat at the manager's desk and noticed a memo: "The following people are to report to AIDS testing tomorrow," followed by a list of names. It was if I were in my own house. The rate was twenty dollars a day, not including meals. The tables in the restaurant had tablecloths and flowers on each. A typical menu was cream soup, rice and beans (the inevitable congrí), stew or chicken or steak with potatoes, salad, coffee, bread, butter, with beer optional for six dollars and fifty cents. The people working there did not fare so well. Their diet was a vegetarian's dream: heaping plates of green vegetables, beans, rice, and potatoes. Plentiful but boring.

I was there during International Women's Day (the airplane was full of female delegates). At the hotel the manager made a special meal for all the ladies, while the men served them. They closed the restaurant, and I was invited to film the event. The tables were pushed together to form one long table with a tablecloth and flowers. All the cooks and maids and female managers sat while they were given small presents, and they ate a meal that included chicken, beer, and cake made especially by one of the (male) cooks. The manager made a speech emphasizing togetherness and cooperation, referring to all as members of a family who should consider their workplace their home. The atmosphere was one of good fellowship and graciousness. I looked at the people around the table: black, white, maids, managers, all with

an easy familiarity and equality of purpose. One maid, "La Gordita," refused to come. She hated everything about socialism and wished she were in Miami. I wondered what her life would be like as a maid there. In Cuba most people work four days and have three days off.

Workers come from all over, work in the fields, live in worker's houses supplied by the government, and go back at the end of the season. One said to me, "Nosotros alimentamos al pueblo." (We feed the people.)

The town. Guanabo used to be a fishing village with neighboring Playas del Este, the place where the rich had their beachfront summer houses. Now Playas del Este has been turned over to the international tourist trade, while Guanabo has become a working-class community, still very much like a fishing village. Very, very peaceful.

At night I saw the stars for the first time in ten years. People who live in Los Angeles have no such privileges. I walked along a deserted beach after a spectacular sunset. I suddenly realized they were still there, that they had not gone forever. Was it the waves breaking on the shore, or was it my father's voice? I was ten years old again, and he was whispering in my ear. "See, there is Orion. The Little Dipper points toward the Big Dipper. Look, there are the Pleiades." My father loved the Greeks and the Mayas. He is up there somewhere, exploring Osa Mayor and Kukulcan. I am glad the stars are still there.

Later that night I realized the reason for the sunset. Like a great angry Yoruba goddess, the wind came screaming down the ocean side, tearing everything in its path. Winds of 150 km and torrential rain hit La Habana, the worst in a hundred years. By 7:00 a.m. Oyá had died down somewhat. By 8:00 a.m. the volunteer brigades were out in force, clearing the debris from the highways, so that by 9:00 a.m. it was hard to tell, except for some electric posts that had fallen and been pulled over to the side, that anything had happened. Morning traffic proceeded normally. No money was exchanged, no orders were given. This is probably the best example of socialism in action.

Somewhere in all this is the reason why the United States is determined to make Cuba fail. People are civilized. They are basically happy and friendly, in spite of the shortages. They are willing to go out and work for free, because they can see how their lives are better if they do so. Even the malcontents are part of the system, the dark without which the light could not be seen. Thousands of young people, students from the city, volunteer to work in the fields and bring the crops in. The storm caused a billion dollars worth of damage (there was no mention of it in the US press), much of it to crops, but the Cubans didn't bat an eye. They picked themselves up and went out and started to repair the damage. In a society where you don't have to worry where your next meal is coming from (even though it may be vegetarian), where your job is guaranteed, where, as Zoila mentioned, you are taken to the emergency hospital and operated on before anyone even asks your name, let alone if you are "eligible," where 96 percent voted in favor of Communist Party candidates in secret elections (voters could invalidate their ballots if they so wished, and international observers are always on the scene), where everyone has relatives who were in the attacks on Batista's government on 13 de marzo, 1957, or 26 de julio, 1953, or fought at Playa Girón in 1961. People remember what it was like before and know it is better now. This Cuba is an example to a collapsed Latin America where, as in Brazil, death squads shoot orphans on the street because "there are too many of them."

This example is what terrifies Washington. There is no free trade agreement in Cuba. Cubans may not have much, but it is theirs.

Not have much? You can't walk down the street without somebody inviting you into their house for coffee or a shot of rum. Cubans love to talk, and they insist you sit down and share with them. Moreover, every neighbor within earshot will come and sit, uninvited, and join in. What Cubans do have is an unlimited alegría de vivir, an optimism, a dignity, a willingness to share. Not for them the stressful nine-to-five, six days a week. In capitalist countries one person does the work of three. In Cuba three people do the work of one. In spite of the blockade, they have something more precious: time to enjoy life for its own sake. The volunteers who go to the fields finish their day singing and dancing. Everywhere people are sitting in parks and playgrounds, beaches and porches, chatting, gossiping, bullshitting. I doubt if there is a single ulcer on the island.

1994: The Forbidden Island

The big news this year is the dollarization of the economy. First, everyone who had been arrested for illegal possession has been released. I immediately asked the taxi driver from the airport if things were 1) better, 2) worse, or 3) the same.

He felt they were better, because now if you needed, say, a blender, you could buy it at the INTUR store. Of course, as a taxi driver, he was likely to have saved up a bunch of dollars. Later I asked an ordinary housewife with no access to dollars and got a long lament on how things were getting worse. Cada quien habla según le va en la feria. The driver reiterated what I have heard many times: no one in Cuba goes to bed hungry. The problem is that having enough to eat is a very low minimum to go on for very long. People need consumer goods. Not personal computers, but razors and toothpaste. These are very scarce indeed. People are still healthy, but seem thinner than last year.

No matter what, Cuba is still Cuba. I checked into my hotel for mostly Cubans, at the beach, and felt that old tingle: the warm breeze, the musical Cuban speech, the warm smiles, the kisses. My first lunch at the hotel restaurant provided me with a trio of guitarists who sang as if they had just come down from heaven. I gave them six dollars, two for each person, and they almost fainted at my largesse. (Last year the black market exchange was one dollar to forty pesos; now it's one to one hundred.) The next song was dedicated to me. "Para usted, de todo corazón y con mucho amor." How can one resist such people? They sang a Mexican bolero that could have easily put them into the Hollywood Bowl under other circumstances. The chicken was meaty, tough, and full of flavor, the way chickens used to be before they were reduced to a hormone-laden mush by the multinationals in the United States. The first day the waiter bowed in a courtly manner—rather charming, since the sea breezes were blowing and everyone was dressed in shorts. The second day, since he now knew me, he gave me a hug. There are not many restaurants in the world where the waiter greets you with a hug.

My suite, for twenty dollars, included a sitting room, a nonfunctioning kitchen, the bedroom and bath, and not much water. The air conditioner wasn't that great, either. Through the open door, a beetle was trying to get into my room. Well, we're in the tropics, I thought with a shrug. Without injuring it, I kicked it outside. Curious as to what it would do, I watched it turn around several times trying to orient itself. Without warning a lizard shot out of the bush and in a flash had swallowed it. I was left to muse how much the lizard and the empire had in common, except that Cuba is one of the beetles that got away.

The old woman at the hotel gate, in charge of letting people in or out, had not spoken to me more than a minute when she pointedly told

me she was Spanish—that is, both her father and her mother had been born in Spain. Her husband had died years ago, and now all she had was her little dog. She never had children, "eché, cuatro barrigas": they had all miscarried. She had been in a convent as a girl, thinking of becoming a nun, and like a good Christian had taught her little dog to bark at Black people.

I went tootling out to the Reparto Eléctrico to see my friend Rafael. The Reparto is a complex of condominium-type buildings on the outskirts of Habana. It was built to get people out of slum houses in town. Rafael's family's house was literally falling down when the government gave them the apartment (living room, dining room, two bedrooms, bath, and kitchen). His mother is paying twelve and a half pesos a month. She owes seven hundred pesos, and then it will be all hers. She is going to give it to her son, although she can sell it to anyone she chooses. With a coat of paint on the outside, sorely lacking, the Reparto would be quite lovely. Even now, the palm trees, guayaba, mango, banana trees, and bougainvillea give it an attractive air.

Rafael was full of stories of his adventures in the merchant marines. He said that when he was offshore Canada (the crew was not allowed to disembark), a Canadian national on board had died and had to be unloaded. A friend of Rafael, El Pichi, whom everybody thought was crazy anyway, jumped on the casket as they were unloading it and refused to get back on ship. The Communist Party official in charge of handling the morale of the ship was sent to talk El Pichi into surrendering, promising that nothing would happen to him if he behaved reasonably. The official went and after a brief discussion also refused to get back on board. Last thing he had heard, related Rafael amid shouts of laughter, was that they had opened a restaurant with their savings from working in Canada.

Another story was closer to home. Rafael had just gotten married. (I suspect he married only to get the all-expense-paid two-week vacation the government gives him.) A first marriage involved a Spanish woman staying at the hotel who was later found in Rafael's bed by his bride. That marriage lasted less time than the honeymoon, but that is yet another story. His second honeymoon was at the luxury Itabo hotel, compliments of the Revolution. Again, the couple had been befriended by Spanish tourists. They were asked to visit the tourists in their room, to be given some presents: a magazine, a scarf. Nothing important. Rafael was stopped by the conserje, who said guests were not allowed to visit in each other's rooms. (While this is true, Rafael is convinced that it was because he is Afro-Cuban.) They explained that there was no funny business, and the conserje let them go, saying he was not responsible. After the visit, Rafael received another visit from security, who said he was under arrest for stealing five hundred dollars from the Spaniards. Rafael was taken to the police station. Some honeymoon! As it happened, the person involved in the investigation was an old school chum of his, and he assured Rafael that he would not be found guilty. In due course, Rafael was released.

This, however, was only the beginning of the story. Rafael found out later that the cajera at the desk was aware that the Spaniards had put all their money in a safety deposit box—all except five hundred dollars, which they had in their room. The conserje had let Rafael go as an easy mark to blame for taking the money. When the conserje was called into the police station, Rafael's old school chum took half of the five hundred dollars in return for not charging him. The cajera was left out in the cold and spilled the beans. All three, cajera, conserje, and school chum, are all doing time.

Rafael did not know if the Spaniards ever got any of their money back.

Another story involved Rafael del Pino, a high government official in the Communist Party who had flown to freedom from the horrors of Castro's Cuba. He was received as a hero by the US press, who neglected to mention that he was responsible for the near starvation of tens of thousands. As the person in charge of administering a province, in an attempt at sabotage, he deliberately created a riot by withholding milk, eggs, and cooking oil (some of it donated), among other staples, and diverting these to other provinces. The ensuing investigation forced his hand, and he flew to "freedom"—that is, to escape criminal charges.

The human rights commission has persuaded the Cuban government to release the captive AIDS-infected people from the Los Cocos hospital, where they were being cared for and had a better diet than most Cubans, but were not allowed out without supervision. The AIDS patients can now walk free again. Since most of them were prostitutes to begin with, AIDS in Cuba has started to take hold as never before. Thank you, human rights commission.

Cubans with relatives in the United States can legally receive three hundred dollars a month. (There is no limit to the underground network.) Since one dollar is worth one hundred pesos, this means that some Cubans make thirty thousand pesos a month without lifting a finger, while others work their butt off and make only two hundred—incredibly, five dollars a month. The sincere, uncorrupted Communist cannot buy at the dollar stores while the Cuban with the gusano family in Miami can buy gasoline, a car, a vacation, toys for his kids. The Communist has a difficult time feeding his children, let alone going on trips and buying toys. Monthly rations last up to the fifteenth of the month; after that, it's

black market all the way for those who can afford it.

The gusanos are not well liked by the neighbors, not so much for political reasons, but because they tend to lord it over everyone else. Gusanos tend to be white in a black population. One gusana who had been drinking rather heavily said at the beach, "If all the men in the world disappeared, and the last man was Black, I would just die." A gusano family in the Reparto had already been caught in a boat trying to reach Florida. They were sent back and fined. When they heard I was from the United States, the man came over conspiratorially, as if we were kindred souls united against the trashy Cubans. I set him straight about the United States, telling stories of drugs, riots, and killings, to say nothing of pollution and pesticides. He didn't believe me. He invited me to his neat-as-a-pin apartment with its new refrigerator, its microwave, its stereo, and its satellite dish showing HBO, MTV, and the Discovery Channel. HBO was showing a sleazy movie about a cop who tries to hit on another man's wife. The gusano looked at it as if were the sacred word. I told him those movies were a dime a dozen, and boring, and left. His son, a pale, blue-eyed, rat-faced boy, who went around the neighborhood saying "fuck you" to everyone (his only English), accompanied me down the stairs without comment. The gossip has it that the family is trying for another boat sortie. This time they'd better make it. The second try earns them jail time.

No es fácil. The peasants in the countryside have grain, fruits, vegetables, hogs, eggs. They bring their produce (illegally) into the cities, and, unwilling to sell at government prices, sell to individuals for dollars. Some are quickly becoming a privileged class, much as the kulaks of yore. People are hoarding money to the extent that the government can't pay its workers. A recent proposal was to charge for

sports events in an effort to get the Cuban peso circulating. (Some players are Pan American gold-medal superstars, yet all sports events are free.) In the Reparto, electricity and water have gone off for hours at a time since the beginning of the year. The people in one building also have no gas and are reduced to cooking with charcoal and using Coleman lanterns for light. Some hospitals have no water, and patients have to bring their own sheets. The Community Party official in charge of one building gets extra gas rations and sells the gas for dollars to buy meat for his children. Events are free. The five main problems in Cuba are electricity, water, food, clothing, and transportation. All are traceable to the blockade. To say that the United States should be brought to justice at a Nuremberg-type tribunal is not to overstate the case.

A girl from the Reparto came over and asked me if I wanted to be saved. I said no.

A young, smiling doctor, dressed in a spotless tunic and complete with stethoscope, came by the Reparto on Monday. Someone had called him, and he took advantage of the occasion to look in on some of his older patients. His clinic is just two blocks away and is available without an appointment and is, of course, free. Everywhere in Cuba there are clinics within walking distance. In the United States, walking distance will get you to a 7-Eleven.

El Babalawo. Santería is pervasive in Cuba, although not always obvious. I had been in Rafael's house a week before I realized that behind a table, on the floor, was a coconut shell adorned with cowrie shells to make a face, and also a knife, a candle, and a saint. His grand aunt gives readings and "consultas." In addition, I was assured that when Fidel Castro was in Nigeria was the only time he was dressed all in white. He had received his initiation and become a Babalawo, a supreme leader.

Cuban television. Many areas do not have electrical shortages. Those who live in those areas and have color TV, and possibly a satellite dish, have all the TV they can use. Even so, in the Reparto, on only one station one Saturday, I saw the following.

Interviews with the survivors of the university uprisings that led to the triumph of the Revolution, an interview with Benny Moré (now deceased), a remembrance of Nicolás Guillén, Aretha, Janet Jackson, Rod Stewart, Bruce Springsteen, Los Van Van, and all the salsa you could take for one evening. The movie (complete with dildos) was *Amos and Andrew*, with Nicolas Cage, somewhat bewildering to my Afro-Cuban friends, who found it hard to see how a movie that had bloodhounds set on a Black man could be funny. The Sunday night movie was *Hello, Dolly*, with Barbra Streisand. Interspersed among the program breaks were ads urging the use of condoms.

The succès de scandale of the season is the prize-winning *Fresa y Chocolate*, about a gay man who falls in love with a UJC university student. The general opinion in the Reparto was that people have a right to live as they wish and not be persecuted "like before."

I inadvertently let on that I was having a birthday. Rafael immediately set about buying a huge cake made with black-market flour. There are people in the Reparto that can supply almost anything. We invited the neighbors (or more correctly, they invited themselves) and had a small party. They sang the Spanish version of "Happy Birthday":

Mucha Felicidad
En el día de hoy
Te deseamos, Antonio
Mucha felicidad.

As I looked around at their open, smiling faces, completely lacking in guile, I was reminded once again of what a great people

the Cubans are. Nothing stops them. Ultimately, there is *Life*. Lush, pulsating, big booty tropical life. Every adult takes care of every child (and scolds him if necessary). People are always coming and going, looking for that jabalí that was slaughtered, that tank of crude beer on the black market, the next party. The chickens scratch, the hogs grunt, the puppies whine, people laugh, cry, gossip, make love, get drunk. Being in Cuba is like being in other Latin American countries, but it is not like being in the United States. A kind of pall hangs over American cities, a kind of ominous silence under the noise of the helicopters. In the Reparto there was noise at the base— a happy noise, a comforting family noise. The lights went out, and it was not long before the neighborhood was sitting outside in the dark. First the older people sang the old songs, by José José, José Alfredo Jiménez, Pedro Vargas. Then the young people started with Nelson Ned and Whitney Houston. It was not long, however, before the whole thing had melted down to the rumba. Someone brought a spoon to mark the rhythm, others beat on chairs, others chanted "gumbayé" and "babalú," and West Africa sailed effortlessly into the Reparto, carried in by the soft warm winds. Cuba was being Cuba. Indestructible, anchored in its history, confident of the future, unimpressed by hardship, ready to take on all comers, fighting if necessary, but ever ready to extend a hand in friendship and with the most unconditional love on the planet.

1995: Cuba under the Dollar

The new economic policy of allowing foreign companies to set up merchandising in Cuba has the economy reeling. The stores are bursting with goods. Foreign companies have taken over Cuban stores that had closed, fixed them up, hired whomever they want, and fired the rest—unheard of in Cuba. And they started charging high prices—also unheard of. The resulting unemployment has created a serious problem for the Revolution. Instead of solving the problem in a socialist direction, it has palliated it with small-time capitalism. Farmers can sell their goods (with a fee and a permit, of course) and keep the profits. The workers who have been fired by the foreign companies can sell on the street to take up the slack, and they do. The problem is that under capitalism, true to form, the big fish eats the little fish. Gusanos once again come out on top. They can, with initial capital from Miami, contract a furniture maker in pesos who can make an expensive living room set, and the entrepreneur can sell at a profit in dollars. Who has dollars? Other gusanos, people in tourism, and thieves. Last year everyone complained that there were no consumer goods; this year everyone complains about the muggings and hijackings (welcome to capitalism). Those without dollars can do little to improve their lot. I saw some pitiful tables of the unemployed on the street, who were offering to sharpen scissors and mend shoes. The unemployed still get their free medical care and education, they still get their libreta (rations), but they still have to come up with about two hundred pesos a month to cover costs (about five dollars). Habaneros look prosperous, have gained weight, and are still better off than the rest of Latin America. What will happen in the future is anybody's guess.

Ordinary people are not fooled, however. Amparo said she would rather work in a socialist store than a capitalist one, because in the government store you can sit down, you can chat with the customers, the hours are shorter, and you cannot be fired. In a capitalist store you have to stand up all day, work harder and longer (because the others have been fired), and you are still paid in pesos.

There are now three economies in Cuba: the divisa, the convertible peso, and the Cuban

peso. The divisa is the dollar. The job of the tourist is to turn over his dollars to the government by buying Cuban. Naturally, the Cubans themselves want to buy in the dollar stores, so there is a mad scramble for dollars akin to the Gold Rush. So that dollars don't get "lost" in the shuffle, there is the convertible Cuban money, which can be exchanged for dollars within Cuba, while the government hangs on to as many "real" dollars as it can by using the proxies. Third, there is the Cuban peso, which pays all salaries and buys all purchases with the libreta. Thanks to a booming tourist economy the government has been able to lower libreta prices on basic foodstuffs. An example of how this works: Caracol, a Cuban government store chain that manufactures and sells beach clothes in Europe, Latin America, and the Caribbean, sold 63 million dollars worth of goods last year. Thirty-three percent was used to buy food, fuel, and medicines for the population. The Junta Central de Planificación has a long-range program to make everything in dollar stores available at libreta prices to workers, at which point the dollar will become a useless and obsolete relic.

The socialist economy works like this: You are given a monthly libreta. There is one for clothes and one for food and over-the-counter medicines. Goods are very cheap. As an example, with an income of two hundred pesos a month, one can buy a three-peso pair of tennis shoes (about ten cents USD). With the food libreta you can get a special medical diet, if applicable, which includes meat, chicken, vegetables, and milk. Other rations are cookies and vinegar. Monthly rations are rice, other grains, oil, lard, sugar, compote, tomato preserves, soap, detergent, coffee, kerosene, butane, alcohol, cigarettes, matches, toothpaste, and rum. These goods are the cheapest and can be had by anyone (sometimes they are scarce, however). Even if you are not working, you still get the libreta and get the basics, as long as you can rub two hundred pesos together—about five dollars. On the other hand, the government has raised prices on utilities and a few other things to motivate jobholding among those who have left the work force voluntarily. Too many people found it profitable quit their job, find money through other means, and still get their rations.

The next most expensive rung on the ladder is the sale of Cuban merchandise in government stores and (now) in the open markets, accessible in worker's pesos. Here all manner of things can be had, relatively cheap but no longer subsidized. I went to a mercado agropecuario, which had the look and feel (and smell) of any market in Latin America, although it was perhaps cleaner than most. Here the peasants from the countryside profit with a frenzy. Garlic and onions were two pesos each (five cents USD), and housewives were screaming bloody murder at how expensive everything was. Still, the market did not go begging for customers.

The top rung on the ladder is the dollar economy. Those with dollars can buy the same things available anywhere else, from Granny Goose potato chips packed in Anaheim to VCRs to Mitsubishi cars. I even saw a woman in a parked car talking on a cellular telephone.

US Americans might tend to think that somehow Cuba is on the verge of becoming Americanized. I don't think so. It is still very much Latin America, and its orientation lies elsewhere. I took a walk down embassy row in Miramar and realized how there is a whole other world that US Americans have no knowledge of. Here were the embassies of Iran, Iraq, Congo, Benin, Angola, Mozambique, Western Sahara Republic, Vietnam, Laos, Palestine— everything except the US embassy. Foreign capital comes from Spain, Japan, and Latin America, and it is doubtful that the Cubans, socialist or otherwise, will ever accept US domination again.

The scramble for dollars has created big and little corruption. I went to the Feria Internacional del Libro, where books are supposed to be available to all Cuban workers and are therefore in worker's pesos. The girl selling them charged me eight pesos (twelve cents USD). Since I only had dollars, she made a deal and wanted to charge me four dollars (one hundred sixty pesos), until my friend Rafael, furious, threw the eight pesos on the counter.

All my friends in the Reparto came over to greet and kiss; I wonder how much of that is motivated by hopes of a gift of a few dollars.

Just as one thing is true, the opposite is also true. I spoke to Sara, who, along with her husband, has been a Communist since before the Revolution. She is a sweet old lady who was trying to make an addition to her tiny house (con muchos sacrificios) so her grandchildren could come and visit her. We had a nice chat about the current situation in the United States, the national struggle of Latinos, the takeover of Congress by the right. She was, of course, perfectly informed as to circumstances. As I left, I tried to give her, in friendship, a few dollars to help in the construction. Ten dollars would buy huge amounts of cement. With great dignity, she refused. It is this stalwartness that makes it likely for Socialism to continue in Cuba.

Depressing news on the psychosexual front. Homosexuals and prostitutes still can get up to two years in jail. There have been raids around the Cine Yara and at Habana's one gay bar. In spite of the recent liberalization with *Fresa y Chocolate*, and an ongoing gay character in the current Cuban novela (played as burlesque), jurisprudence has not caught up with real life. Most people consider the old laws anachronisms. A foreigner was caught making pornos with two Cuban girls on his camcorder and got fined thousands of dollars. The girls got two years in jail.

I went to the house of Rosita Fornés, the monstruo sagrado of Cuban musicals cum zarzuela. La Fornés has nothing but contempt for the gusanas such as Celia Cruz who have left la patria by selling themselves to the empire. She is now seventy-four years old and still beautiful. I did not meet her, but I met the next best thing: a drag queen who impersonates her. Officially this young man is the housekeeper, hired by the star to take care of her beach house. She was gracious enough to put on a show with La Fornés's own costumes. In fact, I got the impression that the only thing that would have stopped her would have been a fire hose.

The queens got together and pressured the government to let them put on a show at the Bellas Artes. After they came up with the idea of making it an AIDS benefit, the Minister of Culture gave in. La Fausse Fornés did not go for fear that it might be police trap, but on February 28, everything went off without a hitch, standing room only, and the show was even broadcast on TV as a cultural event.

The CDR manages to keep on top of things as far as hanky-panky in the neighborhood is concerned. There is the president, the vice president, the vigilance committee, and the ideological propaganda, maintenance, and volunteer work committees. All live within a few houses of each member of the community. The lady from mantenimiento came by Rafael's house to have him sign for a Wednesday meeting to discuss painting and clean up, part of a national beautification campaign. The government is at long last supplying the paint for the Reparto. The discussion was to be about each household keeping their allotment of paints and supplies at home and being responsible for it so that it wouldn't get stolen. Rafael went to the beach instead.

There is an appalling lack of seriousness among ordinary citizens. For example, they sit, hypnotized, watching the telenovelas and

go through writhing agonies of suspense as it unfolds. "Alabao, she's going to find out her husband is cheating!," they'll scream. In some ways, socialism has bred a complacency that things will get done anyway, and it is a victim of its own success.

While people living in the Reparto will not get much attention paid to their complaints (mostly because if the electricity goes off, for example, nothing can be done about it, since it is being rationed), people in a job context can and do get some satisfaction. They got rid of Carlos. When I went to visit my friends at the Gran Vía, they were happy to tell me that complaints about Carlos (pronounced "Calo") trying to score points with the Party by running an efficient operation and working them to death had their effect. Now some nice old lady is the administrator, and Carlos is working someplace else. This reminded me of how 120 workers out of 180 signed a petition against the administrator at my jobsite, and the administrator is still there, trying to take revenge on the signatories.

I had been unable to get rid of a cough I imported into the country, and Isabel came to take me to the clinic. We walked two short blocks, no appointment, and sat down. After five minutes, she poked her head into the doctor's office and asked if we could come in. She explained that she had a "guest." The doctor finished with her current patient and asked me to sit down. She asked me my name, age, and where I was staying. She listened to my breathing, took my blood pressure, asked me a few other questions, and made out a prescription for a cough medicine. She made an appointment for a chest X-ray the next day (it was 7:00 p.m.). We thanked her and walked out. No muss, no fuss, no fee. I couldn't help but think how foreigners are treated in US clinics. If anyone should suggest they receive free medical care, half the doctors stateside would have a heart attack.

Cuba is very much aware of the mistakes of the ex-USSR. Rather than dogmatically shielding itself from the need for change, the Party is flexible enough to tread the dangerous path of the new economic policy in order to solve some of the most pressing needs of the population, but without forsaking the gains made. Humanism and anti-bureaucratism rule, as does the dialectic. In spite of charges of elitism, most things are still substantially for the people. Cuba is small enough that it is hard to become isolated from daily problems. Party people are in the thick of things and are often the agents of change. The future is in their hands as never before, and as long as they maintain close ties with the masses, who continue to support the system, socialism in Cuba will endure.

1996: Santiago de Cuba

Since the US government refused to give him a visa, Eddy had thrown himself into the ocean as a balsero and had been picked up and taken to Guantanamo naval base for a year and a half. Now he showed up at my house, full of dreams of getting rich and buying a Lamborghini (in two or three months, as soon as he was settled). A high school dropout, speaking a thick Cuban patois, unable to speak English, and Black, he really thought he could live like in the US movies. He swore he would never go back to Cuba. A few weeks of trying to get a job and working by the day, pouring out cement or sweeping out a business for thirty-seven dollars a day, cooled his bird for awhile. Finally he blurted out, "Este pais es tremenda mielda." He started sneaking my videotapes of Cuba that I had taken in previous years, full of nostalgia and homesickness.

Eddy was a good source of information that is never available to US Americans. When they arrived at the naval base, the Cubans were greeted with lunches of free beef, pork,

or chicken every day, a sixty-inch color TV twenty-four hours a day with shows in Spanish from Miami, stores so they could shop, gambling, prostitution, and pornos. Gloria Estefan took her whole show down there to keep up the spirits of the victims of Godless communism. The US government, the one that mercilessly beats the Mexicans who founded the Southwest if they catch them trying to get back to their ancestral lands, gives the Cubans, most of whom are lowlifes who want to marry some rich American, a work permit, airfare to the destination of their choice, two hundred dollars a month welfare, eight months free medical care, and job referrals. (The last thing most of them want to do is work.) Eddy did not get an apartment because I had agreed to sponsor him, or the government would have found an apartment for him.

The Revolution, of course, is aware of the problems. *Granma* last year published an analysis of what was going on. Cuba must preserve socialism, yet undergo changes consistent with the world and its realities. It has undergone a diminishing of its economy, financial imbalance, disdain for work, social lack of discipline, and a loss of values. Foreign investment has increased, the dollar has become current, the land can be used partly for profit, farmer's markets have opened up, people can work for themselves upon payment of a tax. On the upside, Cubans must solve their own problems and depend less on the paternalism of the state. Some graduates have trouble finding jobs unless these come out of tourism, biotechnology, or the agrarian sector. There is a downward trend from social property to private property, from industrial labor to manual, artisan or agrarian labor, from technological work to service jobs. With unemployment comes the black market, theft, and other illegal activities. Untouched by the changes are health, education, and social security. The challenge

is to preserve socialist gains as well as Cuban roots, spirituality, and solidarity. Effort and heroic action are needed more than ever before.

I landed in Mérida, with very little money, on a Wednesday, and went straightway past the Zapatista demonstrators to the ticket office. Some of my expenses: Ticket to Mérida, $350. Hotel in Mérida, $11. Ticket to La Habana, $126. Most meals, $10. Last year flights to La Habana had been Thursdays and Sundays only. Now flights are daily. If Jesse Helms could see this!

La Habana has become so familiar I swear I know it better than Los Angeles (my own neighborhood excepted). I asked the taxi driver from the airport the standard question: Are things better or worse? For the first time in years the answer was they were better. Apparently the "período especial" has turned a corner. "The lights don't go out nearly as much, and there is plenty of water. Now that we can buy in the shops, people save up and get all the consumer goods they want." I was able to confirm this later. For the first time, people are selling on the street and the stores for Cubans, in pesos, are full of cheap clothes and other goods. Some stores feature stoves, refrigerators, and freezers (sorry, available in dollars only, but still people buy them). Thus I was unprepared for Rafael's hard-luck story of how his mother had no money to pay the light bill this month. He said he had been studying and had gotten a further degree as an able-bodied seaman, first class with basic English, but he said there was no work. He said he could get work in his area, but jobs were sold for two hundred dollars. Later I asked several people, and all said this was not true. Apparently Rafael was trying to soak me. He was wearing a little thin. When I got back, Eddy said he had been fired for raping a co-worker. Rafael's story is that he had been going with the girl, and when he tired of her she made up the story in revenge. Whatever the

truth, in Cuba if you are fired, you have to take a lower job or go back to school and improve your qualifications, but you cannot go back to your original job level. Rafael has the choice of going to work in the fields or improving his skills and trying another area of work.

I was getting a little tired of La Habana. It is a great, romantic city full of glamour and culture, but the mad dash for dollars has created a really demented class of hustlers. One private taxi driver called me four times at the hotel to make sure I hadn't forgotten that I had promised him the ten dollars to take me to the airport the next morning. Beautiful, beautiful dusky girls stop you every few feet and offer love's delights. Many of them are intelligent girls going to the university, but female emancipation and the traditional Cuban sensuality makes them unable to see anything "wrong" in what they do. Cubans are about as far removed from the puritanical Americans as you can get, and these attitudes are probably what is most attractive about them. Nevertheless, I was tired of the same old hustles I had seen before. I wanted some new hustles. I decided to go to Santiago.

The flight to Santiago, via Cubana de Aviación, was crowded, but orderly. There didn't seem to be any of the bureaucratic snafus that mar underdeveloped societies, where everything is very complicated and in triplicate. (Although airline tickets are of course computerized, many offices elsewhere still do things by hand, with carbon paper for copies.) We walked to the gate with an hour to spare. The only thing available to eat at this point were some sandwiches and some TropiCola, at a small bar run by a young, very typical Cuban woman. The lunch cost six pesos (here transport is for Cubans, and everything is in pesos). I remarked that I hadn't had lunch and the sandwich was just a starter, and she insisted in giving me a chicken leg from her own lunch.

She refused the dollar tip I tried to give her (20 pesos—down from last year). The loudspeaker calmly announced Cubana flights: Habana-Paris, Brussels, and Munich. Would that Jesse Helms could see this! Finally, on time, the flight to Santiago was announced.

Getting on a plane in Cuba for a local flight has a time-warp feeling. There are few airport buses. Usually you walk to the plane, like in a 1950s movie. The flight was at 8:00 p.m., and the lighting was correspondingly muted. I buckled my seat and saw smoke filling the aisle. The plane was on fire! Since no one seemed concerned, I stifled my screams. On closer examination, I noticed it was a refreshing vapor that cleared the stale air. I remarked to my seat partner that they had this clouds-beneath-your feet effect so that in case the plane crashed, you would feel at home in heaven. A kind of free sample. I looked around. The plane seemed quaint, like a renovated military plane.

A sign in Cyrillic next to the call buttons betrayed its origin. Since Cuba is a small island, no flight is over two hours. This is an excuse not to serve any food. (Mexicana serves food, but charges thirty dollars more to Santiago.) The flight attendants are mostly decoration. At the halfway point they saunter down the aisle with candies and tiny half-filled cups of coffee. The rest of the time they close the curtains and gossip.

My seat partner was an interesting older lady with blonde hair that did nothing to cover up her mulatto features. I asked her something I was curious about. If I, as a tourist, was charged one hundred fifty dollars, how could Cubans afford such a price? The plane was filled to the brim with Cubans. She explained that Cubans were charged one hundred pesos, a fortune to them, but five dollars to me, for the same ticket. She further went on to explain that if a Cuban got a package tour (I suspect one has to qualify), he could get an all-expense-paid, three-day

package for five hundred pesos (twenty-five dollars) at the Hotel Santiago, which would cost me one hundred dollars a day just for the room. So that's how they do it, I thought. Tourism really helps the Cubans. No wonder Jorge Mas Canosa froths at the mouth.

After the modern, clean, and inviting Antonio Maceo airport, I had a look around Santiago. It is a tropical dream. Fecund, mountainous, it is the hero city near where the guerrillas hid out in the Sierra Maestra. Following the suggestion of my seat partner, I went to the university youth hostel, past the luxury Santiago and Las Americas hotels to the exuberant tropical setting of my twelve-dollars-a-day room. No hot water, share the bath with one neighbor. The hotel was relaxed and homey, and I was soon exchanging gossip with the desk clerk and recipes with the cook. I showed Felipe, the clerk, a jar of chile de árbol that I had taken with me to liven up the bland Cuban food, stating that there was no chile hotter than a tomato in Cuba. He pretended to argue, saying with a straight face that some chiles were very hot, that there were three degrees of picante in Cuba: "Picante, más picante, y la puta de tu madre." He collapsed in gales of laughter. A hotel guest walked up and Felipe burst into a tirade of fluent German. He had been in the DDR for six years.

The cook put his two cents in, manifesting the most spectacular misinformation regarding chiles, clearly a rationalization for people who fear them. He solemnly assured everyone that chiles provoke ulcers, hemorrhoids, rectal bleeding (he seemed to have some sort of an anal obsession), and high blood pressure, and that they would give you a hard on that would last for hours—this last demonstrated with a clenched fist and raised forearm. No amount of reasoned argument could get him to change his mind.

Still, Santiago was so peaceful that I almost missed the shootings near my house in Los Angeles. I took a taxi to Siboney.

Siboney! As a child I had known the song by Lecuona and never imagined it was a real place. There it was in all its glory. A fishing village, it doesn't even have a hotel. I scrounged around and rented a room for fifteen dollars (a fortune!) from a lovely retired teacher and her husband. They had turned their second floor over to the infrequent tourism that came their way. I went out on the verandah. The Caribbean broke against the low cliffs twenty feet from their house. The bay was set in the lush, tropical, rain-foresty green of the hills above, the water was a deep blue that reminded me of the Indian Ocean. I thought I had died and gone to heaven. Mrs. González came out with my dinner—a whole lobster, mounds of rice, mashed potatoes, and spanking-fresh salad and the quintessential Cuban coffee (with refills)—all for seven dollars. These Cubans think they're poor, but in a capitalist country the González house would have been razed to build a five-star oceanfront hotel. People never know what they have until they lose it.

Before he retired, Mr. González had been a technician in dialysis machine production. As such, he had been invited to tour Eastern Europe in the grand and glorious Soviet days. Ostensibly a technical forum, much of the junket was devoted to uniting people from the USSR, Korea, Vietnam, etc., in pleasure trips that rewarded them for being good socialists, sometimes including sex with female delegates and local women. He related how the Cuban delegation arrived in Romania one night in fifteen-degree-below-Celsius weather. Each of the Romanians greeted them with two overcoats on. Ceausescu had cut off the electricity to help finance his grandiose projects, and there was no heat in the airport. The Cubans were taken to a hotel, also with no heat and little light. There

was no food in the restaurant. After some argu-
ing, the cook was able to scrape up some bread,
cheese, and wine. After the Cubans had eaten,
the middle-level dignitary politely asked if they
had had their fill. When they said yes, he care-
fully gathered the wine, cheese, and bread that
were left and put them in his pockets to take
home. Mr. González said that the Romanians
hated Ceauşescu's guts, and there was general
rejoicing when he was brought to justice.

Out of money, I regretfully bade farewell to
my gracious hosts and was cast out of para-
dise. I made a last minute sortie to the Parque
Céspedes in Santiago to look at some excel-
lent books on the Revolution and another on
Mexican cinema. Full of illustrations. Almost
every Latin American writer was represented
in shiny new editions. La Casa de las Améri-
cas has just published Borges's complete works,
although it must be said Vargas Llosa is still
missing. At this point, all I could do was look.
In the park I was surrounded by mulattos who
invited me home, or to have a drink, or any-
thing, and would not let me go. Apparently I
was endlessly fascinating. Santiagueros have a
reputation for hospitality, and it is not unwar-
ranted. They also have a naive curiosity and
a provincial directness which is distinctly
refreshing after big, bad Habana. At last I had
found what I had been looking for: real people
who said what they felt and meant what they
said. At least seemingly so.

I discovered a pizza place with pizza for six
dollars and, grateful for the air conditioning,
sank into my chair and started to write some
notes while I waited for my pizza. Santiago
is the home of the Casa de la Trova, and sure
enough, some troubadours came around and
sang what I know as "bombas veracruzanas,"
which consist of the lead singer making up a
rhyming song on the spot to you and about
you. As soon as he saw me, the singer made a
song up to the effect that I was writing notes

and he did not wish to disturb me, but he was
moved to welcome me to his city. We parted
with a hug.

I had saved some of my dwindling funds
to get an original edition of *Paradiso*. Back
in La Habana, I was offered one with José
Lezama Lima's signature for fifty dollars, but,
although tempted, I declined. There was a gold-
embossed leather-bound *Don Quixote* to die
for, but I didn't even bother asking the price.
Finally I found a bookseller (the plaza in front
of the cathedral has been turned into wall-
to-wall bookstalls) who sent his scouts, and
in half an hour had the original in my hands,
albeit without the signature. While we waited,
he chatted, naturally. He was a retired archi-
tect. His brother had fought in the Habana
urban guerrillas in the 1950s, but had gone to
Miami a couple of years after the triumph of
the Revolution because he had become "disillu-
sioned." They hadn't spoken in thirty-five years.
I remarked it was a good thing that the Revolu-
tion had allowed small businesses, like his, to
spring up. He referenced Che, saying "You can't
nationalize shoe shine boys. It doesn't make
economic sense." I retorted by referencing Sta-
lin: "All small businesses must be stamped
out, because they grow like a cancer. A small
entrepreneur wants to become a big one, then
tries to obliterate the competition and become
a monopoly." We agreed that the solution had
to be some kind of synthesis: allow people free
enterprise up to a certain point, not enough
to allow them to become rich and exploit oth-
ers. He agreed (maybe a little regretfully?). He
remarked that he could sell books but could
not become a private architect. That job was
reserved for state employees.

Changing the subject, he chatted on in
amazed tones that in Denmark there was a pro-
posal to allow same-sex marriages. I said this
was an issue in the United States, and again
we agreed that the issue was a red herring that

was designed to make people feel passionately about something as long as it took their minds off the real problems: unemployment, health care, jobs, and housing.

Broke, with the now familiar lump in my throat because I was leaving my endlessly fascinating island, I woke up promptly at 5:00 a.m., packed my Lezama Lima, and got a taxi to the José Martí. Because of the early hour, some people were late and Mexicana held the flight. They turned out to be seven male US bimbos who had been in Cancun and had taken it into their empty heads to go to La Habana for a lark. They came pouring in, some of them still drunk, batting their eyelids like owls in the bright lights of the plane, while the Japanese businessmen on board clapped sarcastically. Blond, blue of eye, long of hair, bronzed to a turn, they looked like they had stepped out of a surfer movie. I was reminded again why Cuba was so wonderful—there were no Americans there. These imperialist wannabes ignored the other passengers and acted like they were alone in the plane, shouting at each other from one end of it to the other. "Hey Kevin" (or something), "how many girls did you fuck?" leered one of them to a friend twenty seats away. "Fifteen whores in three days, dude," screamed Kevin back. "Yaaoow!" "Mine was real ugly," muttered another, making a face.

I hope you get AIDS, I thought, disgustedly. One thing that has to be said. The blockade has its good aspects. I fear for Cuba when the floodgates for American tourists are open, as they must someday be. At least I got to know my patria chica while it was still unspoiled.

Back in Mérida, the taxi driver asked me how things were in Cuba. I tried to explain, but to no avail. Less sophisticated than most taxi drivers I have met, he faithfully reported a wild story that had, according to him, appeared in the Mexican news. A Yucatecan had tried to smuggle dollars (!) into Cuba, was caught,

tortured, and killed. I tried to explain that it did not make sense, since the Cuban government wants dollars to come into the country, but it was clear he was sticking to his story.

Again at the airport (because of the blockade I had to take four planes just to get home), the cleaning lady in Mérida came by inches from me as she emptied the ash trays. I kept waiting for her to meet my eyes so that I could say "good morning." She kept her glance studiously on the floor, acting as if I were not there and she were invisible. I reflected how different it was in the Santiago airport, where a similar situation developed and I had a nice chat with the cleaning lady there. In Cuba even cleaning ladies expect to be greeted as valued human beings and not be treated as part of the wallpaper. *Granma* was right. The challenge is to maintain Cuban roots, spirituality, and solidarity. Effort and heroic action are needed more than ever.

1997: Matanzas and Santiago de Cuba

I wanted to go to Veracruz. This meant taking ten planes for the round trip, but there was no other way of finding out if there were flights to La Habana from there, or better yet, a ship I could take. The taxi driver from the airport, in typically Mexican fashion, thought I wanted to stay at an expensive hotel, although I told him otherwise, and took me to the Mocambo at eighty dollars a night. It was semana santa, my first mistake, and everything was sky high. After I told him that was my hotel budget for four days, he took me to a whorehouse. Mexican whorehouses are everywhere. They are relatively cheap, very clean, and highly recommended. The taxi drove into the bungalow and the iron curtain snapped shut behind the car. If a king-size bed is the largest, this was an emperor bed, and on a platform. Mirror on the ceiling. I felt trapped, since the doors were closed tightly and there were no windows. It

was late, there was no food—indeed, no restaurants nearby—and I had to make do with some mineral water. The charming thing about the place was a tiny, private tropical garden that could be seen through plate glass windows in the back. Otherwise, I couldn't get out of there fast enough. Being closed in is no fun if you don't have company.

I called for a taxi and told the driver to take me on a tour of the city. God bless taxi drivers. You can find out everything that's going on from them, even things you don't want to know. He launched into a tirade against the PRI, the assassinations, the corruption, the drug dealing. He took me along the oceanfront, on the Boulevard Camacho, to show me the houses of the rich drug dealers. Gorgeous houses. One wonders how one missed out on such a bonanza. Finally past the battleship *Manuel Azueta* docked in the bay, reminding everyone of the Yankee invasion and the young sailor, among others, who gave his life defending his city. To the Hotel Baluarte: twenty-eight dollars, air conditioned, clean, color TV, telephone, and excellent restaurant. This was more like it. I took a walk along the Malecón and heard two men speaking a strange language. I asked them what it was, and they answered with shy pride, "Nahuatl." I was thrilled.

Still, I hadn't come to stay, and money was going fast. Ignoring the date on my ticket, I went to the airport the next day and asked to change it. I have learned the trick of *not* going to the travel agency—they make things difficult. At the airport the object is to load as many people as possible on that particular flight, and I have never failed to get on with a change of schedule. The catch in this case was that the plane I was given was an old propeller one that sounded like a washing machine out of control. I am not afraid of flying, but I was glad to see familiar Mérida again. The plane was full of tourists (some of them Cubans) on their way to legendary La Habana. I looked enviously as they transferred to a modern Mexicana flight, while I had to stay to arrange transportation from Mérida, since I did not have a through ticket.

At the CubaMex ticket office, more bad news. Sold out for the next two weeks! My whole vacation ruined! The girl took pity on me and sent me to Aerocaribbean, where I was able to get a ticket the same day on some third-rate flight. The girl insisted on spelling my name wrong, even after I made her do it over. Because of this, I was worried there would be trouble at the border. But I sailed through customs as always, without as much as a glance at my luggage, just a big welcoming smile from the customs agent.

Cuba! The more I see you the more I love you! (Cuba, que linda es Cuba, quien la defiende la quiere más.) The taxi driver seemed like an old friend, the road through Boyeros barrio seemed like home. I told him Hotel Vedado and was soon in the familiar lobby downtown.

Another rude shock! Tourism is up 20 percent from last year, and the socialist economy is not going to subsidize the tourists, but the other way around. Prices for tourists have risen, prices for Cubans have fallen. The Vedado, which was thirty-five dollars last year, was now asking sixty and getting it. I love Habana, but let's get out of here, I thought.

While I waited for the next day, I went to Miramar to look for the Santería tapes. The government has produced a series of five tapes with everything you need to know about Santería. They were not available in VHS, but instead I talked to Lázaro Mont, a santero who had produced his own video on Ogún, for which I gave him fifteen dollars. Even though it was a state store, since I was in his office, I am sure he pocketed the money and no one was the wiser. The tape, by the way is fascinating. Ogún is the African Vulcan, and he is tempted by the

Yoruba Venus, Oshún, who gives him honey, which he had never tasted, and brings him back to the village to usher in the Iron Age.

Prosperity is as obvious today as scarcity was obvious in years past. Things are for sale everywhere, people are well dressed, there is plenty of food. Two hundred sixty major companies are functioning with foreign capital: petroleum, tourism, nickel and other mining, heavy industry, and transportation. Forty two of these have signed on since passage of the Helms-Burton Act. Still, la Calzada Infanta is just as grimy as ever. One would like to get cans of paint and just start painting. It would take hundreds of thousands of gallons and many months, but Habana would look gorgeous if it were done. The architecture is superb.

Matanzas. I got another taxi driver in an ancient car and asked him to take me to Matanzas. (Matanzas province is where the revanchists landed, expecting to be greeted as liberators, and were soundly beaten back in three days. ("La primera derrota del imperialismo yanqui en América Latina.") The driver grumbled that he had to go on the country roads so that he would not be stopped and fined, since he did not have a tourist license. He heavily implied that I should pay him more, but I stuck to my thirty dollars for the ninety-odd kilometer trip. Finally we arrived and, incredibly, there was not a single hotel with rooms "en divisas" in Matanzas. There were three old tourist hotels for Cubans, dark and dismal, one of which was being renovated. The driver took me to the outskirts to a spanking new hotel built by Cubans for Cubans, but en divisas. Air conditioned, color cable, telephone, twenty-eight dollars, swimming pool, restaurant, and a lovely view of the Canímar river. paradisal atmosphere was enhanced by the dozen tropical birds in cages in the lobby, which was an open atrium of steel and glass. I sauntered to the restaurant and ordered whatever they

were serving. I got orange juice, a thick minestra soup, potato salad with mayonnaise, green salad, a large milanesa steak, fried potatoes and congrí (of course), coffee and beer for ten dollars. The restaurant was empty, but tables were covered with fine linen, glasses and wine goblets, and full service at the ready. Without warning, about forty Cubans came in, joking and laughing, and sat down. They looked at me curiously. I found out later that I wasn't really supposed to be there. The restaurant for guests was a way farther down the tropical path, but I had been served anyway. *This* restaurant was reserved for work brigades that had distinguished themselves and were having their vacation. Free, of course.

Tired, I went to bed and learned what it was to pay for one's sins. Compliments of the ingrate Canímar, hordes of mosquitos descended upon my helpless body. If I covered myself, it was too hot to sleep (the air conditioner could do just so much). If I uncovered myself, the bites were so painful that I kept jumping up every half hour and scratching myself furiously. I had planned to get Repele, an effective mosquito repellent, but they had been sold out. And with good reason, I thought bitterly. I lay there until dawn, scratching, slapping, bleeding, while the mosquitos smugly performed dogfights over my head. Finally, gorged and happy at dawn, they went to sleep, and I was able to close my eyes for a couple of hours.

Matanzas had been a mistake. Not only was there nothing there, now I had to double back to Ciudad Habana to try to get to Santiago, my real objective. I talked a driver into taking me to the José Martí airport for the same thirty dollars. So far, so good. The plane left in the evening, as before. I got the last seat, in the back. My seatmates on one side asked the steward conspiratorially to bring some coffee cups, and he answered mechanically that coffee would be served later. The seatmates mumbled

and winked, and the steward brought the cups. The seatmates broke out the Havana Club rum, and pretty soon several people around, including the steward, were having their snorts. As long as the pilot stays out of it, I thought.

I looked at a lady sitting across the aisle from me. She had long hair, a beatific smile, and wore, unusually, something that looked like a cotton sari. I recognized her! She had been on TV the night before, kissing and shaking hands with Fidel. The government had convoked cadres from all over the island to congratulate them for their outstanding work. I asked to see her reconocimiento. It was a framed picture of Che, his hands high in a salute, and over it the legend, "To Josefina Velazquez Mata, in grateful recognition for your selfless work for the People, for the Patria and for Socialism." Signed, Fidel Castro Ruz. It is hard to express what Josefina must have felt. She couldn't stop smiling. To win the approval of the whole country, to shake hands with Fidel, to be feted as a guest of honor of the Revolution, was almost more than she could stand. She radiated. It turned out the plane was full of cadres de reconocimiento. The trip was a joyous one for everybody. It would not be necessary to add that the awards, framed, would be placed in the most honored corner of their parlor.

Aeropuerto Internacional Antonio Maceo. A relatively small airport, it is one of the most comfortable I have been in. The driver took me to the university hostel, as before. There was only one problem. A large bus was parked in front and the hotel was crawling with young people. No room at the inn. I saw Felipe and gave him his two bottles of antacid that I had promised him.

Felipe is dying. If he weighed 140 pounds last year, he surely weighs 120 now. He looks like a little bird. I told him to eat well, to relax, study yoga, take acupuncture, retire, take care of himself. He listened gravely with his eyes

on the floor. We both knew it was useless. We parted sadly.

There was no help for it but to go to Las Américas, a snazzy hotel with a blaring salsa nightclub. . This one was thirty-eight dollars, still more than I wanted to pay. However, the cable was astounding. Programs that I has seen advertised as coming attractions when I left home were being shown right on schedule: *Ghost, Selena, The Second Civil War, Panther, Rocky Horror Picture Show, Clockwork Orange, Vegas in Space, Semana Santa in Seville, Larry King Live* were all being broadcast on CNN, Cinemax, Showtime, HBO, the Cartoon Network, VH1, TV Espanola, Deutsche Welle, and TNT complete with McDonald's commercials, to name a few. I watched, fascinated because of the context, until very late.

Next morning I had breakfast at the hotel's sidewalk café. A prostitute and her friend boldly asked if they could sit at my table. Security immediately came over and tried to evict them, but she argued that they weren't bothering anybody and had been asked to sit there. "Are we bothering you?" asked Spokes-puta. "Didn't you say we could sit here?" I agreed, amused. Security left us alone, but with a very sour look. I made sure he saw the girls leave without me. His disapproval of their presence was palpable.

I didn't care for Las Américas. Too touristy. Besides, the manager notified me that they needed the room, since I had not paid in advance and they had a lot of people coming in with reservations. She arranged for me to stay at the Hotel San Juan. Muttering under my breath, I slung my suitcases into the hotel taxi. Complaining loudly to the driver, I told him what I thought of their precious Américas—loud music, terrible food, and too expensive. I said the San Juan was probably no better. Calmly he suggested I stay at his house for

fifteen dollars. What a great idea!! He lived exactly four blocks from there.

His house was like those beautiful old houses in the Vedado, in La Habana. Gracious Corinthian façade, but terribly run down. Mr. Sánchez took me to the front bedroom, overlooking the street. He introduced me to his lovely young wife, Natasha. They had poured every cent into a cleanly painted, comfortable room with a queen-size bed and a closet. Their own quarters were dark and ugly, with a curtain instead of a door. The kitchen was composed of cement walls and floor with a hot plate and a refrigerator. Natasha told me later that her husband worked almost around the clock. Their goal was to fix up the house to its former glory.

I took a nap and in the early evening went into the living room to join my hosts. It was there that I witnessed what the Cuban people really think of Fidel. The couple live with Natasha's father, who was sitting in front of the black and white TV set. Fidel was saying, "I know someone who has brought ninety-nine people to Habana. They build a shack, they tap into the electricity, and there they stay. There's no water, there's no transportation. Habana is too crowded for this reason. There is a lack of social discipline that needs to be addressed. Everyone knows who the squatters are, so they go into another barrio to steal because they don't have jobs. There are plenty of jobs outside La Habana, but they don't want to go there. On the other hand, there are people who work for themselves and make large sums, more than a hospital worker or a teacher. These people come from Oriente. I hope Habaneros don't start becoming xenophobic against them, as one finds in Paris or California with foreign immigrants. [Laughter.] The ones who make ten times the average salary, at least let them pay taxes. They are the first to complain,

yet they benefit from the free services and the low prices of the Revolution."

They hung on every word. These people had listened and watched Fidel for thirty years, yet there was no sound for the duration of the two-hour-long speech, except when they laughed at his jokes. It was as if they couldn't get enough of him.

At the Parque de los Estudiantes I made a date with two young men, Manuel and Israel, who were going to take me sightseeing. The driver was my tocayo, Antonio. In no time at all we were like old friends. Antonio drove along the coast so I could see the beaches and the Caribbean—beautiful, but not good for bathing along this stretch. Then he drove back to town and took me to see the Cuartel Moncada, the Santa Ifigenia cemetery, the docks, the church of Nuestra Señora de la Caridad del Cobre, the Parque Céspedes, and the grand Soviet-style statue of Antonio Maceo. Each sight was grander than the last. Antonio suggested he take me to Siboney, and we went back to Natasha's to get my bags.

In Siboney, Mrs. González had an interesting guest. He was a charming six-foot, four-inch Israeli with blue eyes who was working for a German electronics firm, installing hardware for his company in Cuba. He had just installed a fax for the González's. I was anxious to know what he thought of Israeli politics and questioned him at length. As his English was spotty (he was fluent in Hebrew and German), he answered rather abruptly, "yes" or "no," to my questions.

Question. Would you consider Israel socialist?

No.

Question. Would you consider Israel a democracy?

Partly. First are the Ashkenazim, then the Sephardim, then the Ethiopian Jews, then the Arabs at the bottom. It's a class society.

Question. Would you call it a theocracy?

Yes. They have civil law, but all marriages are performed by the rabbits.

He pronounced Israel a mess and changed the subject. Another swig of Havana Club. He wanted to talk about his girlfriend—a mulatta, of course. He had just broken up with her because they had been invited to go in a pickup to some "festivitations" and she was too grand to ride in a pickup. He blew his breath out, annoyed. "I make a quarter of a million Deutsche marks a year, and I don't mind riding in a pickup. I won't see her again," he said indignantly. The party had been great. They had slaughtered a goat, and there was plenty of rum and rumba.

The waves thundered against the nearby rocks. In the deep night one could see the evening star and the lights of the fishermen night fishing on the water. The wind rustled the palm trees. An old German gentleman who had dozed off mumbled something incomprehensible, and Dovidl answered back effortlessly. I went down and had a late supper of the heavenly lobster in garlic that Mrs. Gonzalez had prepared for me—same as last year. I went to bed.

The next morning I sat on the same balcony as the sun came up. Three boys about ten years old came walking along the path below and started speaking to me in Italian, thinking I was Italian. They wanted a dollar. I looked at them. To me they represented Cuba in perfect ethnicity. One was white, one was brown, and one was black. They were good friends and were going to share the dollar. I relented and threw down a dollar each, and they were overjoyed. One of them put his hand to his mouth and then flung his arm wide in the gesture of a kiss.

Manuel and Israel, the two guides, came from Santiago to pick me up. We went to have breakfast while we waited for Antonio to bring the car. My plane left for Ciudad Habana at 7:00 p.m., so we had all day. The boys stuck close to me, reveling in the treat of being tourists. In Santiago we had lunch at El Rápido, socialism's answer to MacDonald's. You walk in the same way, order the food, and sit at a table. Everything very clean and shiny. A hamburger, one dollar. Chicken and fries, one dollar. TropiCola, thank you very much. We left for the Maceo airport.

Back in La Habana, I was bent on trying my old trick again of changing my schedule. While waiting for my luggage, I struck up a conversation with two Parisiennes who had been on the Santiago flight and were changing flights back to Paris. They didn't like the food, but they looked like snobs anyway. They must have liked the sun, because they looked like fried shrimp. I tried to see the Aerocaribbean people, but it was late and they had all gone home. The next flight was at 5:00 a.m. two days later, and I would have to pray for cancellations. True to form, the taxi driver, Roberto, invited me to his house for the standard fifteen dollars.

Roberto lives nearby, in Boyeros, in the same type of multifamiliar that Rafael lives in. Of course, he lives on the top floor, and there's no such thing as an elevator. However, I was pleasantly surprised at how prosperous he was. He shared his spacious apartment with his son. Three bedrooms, bath, kitchen, living room, TV room (color TV and VCR), and toilet paper in the bathroom. Since I had arrived unannounced, I was able to see what he really had in the refrigerator. Milk, unheard of years back, and a plateful of half a dozen steaks. After a huge meal of steak and salad, I went to bed.

The next day my plan was to go back to the airport, but since Roberto had to continue working, we decided it would be more practical for me to ride along so he wouldn't have to waste gas coming back to pick me up again. He made some fake entries in his taxi log and off we went.

Roberto is divorced, and he went to pick up his daughter to take her to the dance academy. He was very proud of her: she had appeared on TV. She had talent, he underlined. He honked his horn outside his ex-wife's house, and she came running out to sit in the car and tell him the latest. A vivacious Cuban woman in full bloom, she related that the daughter was attending a very rundown dance academy, and the wife wanted the academy improved. "You know Magdalena," she told Roberto, "she's in the CDR. She told me to write a letter telling of the bad conditions and suggesting improvements, asking why our children are not better served." Magdalena had told her not to say it was just for her daughter, but for everybody. I suggested that she put in the letter that if the instruction is inferior, it lowers the cultural level of the whole country, and she thought this was a great selling point. "I've written the letter, but I'm going to rewrite it and send copies to the Central Committee, the CDR, the FEU and the UC. If you see a car parked in front of my house," she joked, "you know I'm in trouble." The daughter came out, and we went to drop her off.

Roberto took me to the airport. I had always been in transit there and had never really looked around. It turns out that there are three Habana terminals: international from Europe, international from the Americas, and national flights. And over on the other side, where there are no terminals now, is a fourth being built! It will consolidate all international flights and promises to be finished this year, spanking new and shiny, ready to receive more visitors than ever.

Aerocaribbean's computer was down, and they could not tell me if the flight was full. There was no help for it but to get up at 4:30 a.m. and be there at 5:00.

Back at Roberto's, someone from the CDR came with a flyer announcing a meeting the next evening. I asked him if he went. He said yes, and if he couldn't go his son stood in for him. He said he used to speak up at the meetings. But he had given it up. "It's easy to point out that something is wrong," he said, "but if there's no money to fix it with, what's the use of complaining? Nothing is going to be done anyway." He was most upset by the bad roads that messed up his taxi. During the conversation, I mentioned the Zapatista slogan "mandar obedeciendo"—to lead by serving—and explained that that was why subcomandante Marcos called himself a subcommander, because the people were in command. He grunted in surprise, as if he had never thought of that before. He seemed to like the idea.

True to his word, he was up at 4:30 sharp, and we trundled off to the airport with my bags. Despite the early hour, the airport (Latin American flights) was packed with Cubans leaving for Cancún. I watched fascinated as blacks and whites, all members of the same family, cried and hung on each other's necks as the others were seen off. Hell will freeze over before families in the United States are black and white like that, I thought enviously.

I went to Aerocaribbean—the personnel had finally arrived—and anxiously inquired about my prospects. The flight was full! My heart sank. A very helpful young woman grabbed me by the arm and in a stage whisper told me not to leave, however, because something was in the offing. It turned out that someone had an expired passport and could not leave with the others. I had my seat! Impatiently I wondered

why the desk clerk was so slow, until he whispered that things would go a lot faster if I gave him a tip. Furious, I gave him five dollars and he stamped my boarding pass.

Flight to Cancún as day broke, transfer in Mérida to a Mexicana flight bound for México City, with another transfer to Los Angeles. At the México City airport I went into my loud routine about how it is the worst airport in the world, just to piss off the attendants. In Los Angeles, nothing to declare, and I sailed onto the street and home again. I was left to wonder what I had done to make the US Congress consider me a criminal. It was obvious that they had never experienced the delights of the waves hitting the rocks at Siboney, or Mrs. Gonzalez's lobster.

1998: La Habana

Cancún (the golden serpent) is fabulous. I had never wanted to go, thinking it to be a sort of Las Vegas by the sea, which it is, but I instructed the taxi driver to take me to a cheap hotel downtown, and he complied. (Twenty-five dollars.) The Mexican city, as opposed to the international jet-set city, is a little Mayan town with wide streets, typical ambiance, and great food. Flights to La Habana are daily, and I had my choice of Aerocaribbean, Mexicana, or Cubana de Aviación. I chose the latter and had the familiar Soviet-era plane that had so impressed me before. Many people on the plane were surprised and looked around to see if anything was amiss. I finally realized that fully half the plane was loaded with Americans! At customs I saw their blue passports. The other half of the plane had Cubans taking tons of stuff back to their friends and relatives. The blockade is all over but the shouting.

Upon arrival at José Martí, the thing that is most noticeable at first glance is that there is a greater crackdown on "anomalies." Apparently the Party has taken the path of not letting things get out of hand. Non-tourist taxi drivers are more tightly policed. (Coincidentally, on my arrival back in Los Angeles, I found that pirate taxis had been barred and only airport taxis were allowed at LAX.) Each "casa alquilada," that almost sacrosanct alternative to an expensive hotel, must now register, pay taxes, and take your passport number, or be closed down. However, another way of looking at it is that the illegal has now become legal. For example, so many tourists were staying at private homes—draining away a state resource, hard currency from hotels, while, at the same time, tourism is booming—that the Revolution simply decided to cash in on all that free money floating around. While the scramble for dollars is a fact of life, people are noticeably better dressed and better fed than ever. After all, a half a chicken at a restaurant costs only two dollars, and is available to Cubans and tourists alike. Cubans may not be able to buy a new Mitsubishi, but they can afford to go out to dinner, and do.

I tried staying at the Vedado, as before, but was horrified to find that it had been remodeled and prices had doubled, from thirty-five to seventy dollars. I talked to the clerk after staying one night, and he surreptitiously gave me the address of a relative within walking distance: Paquita Pèrez, who lived in a perfect middle-class house, complete with piano, and whose daughter was in the Ballet de Cuba. For twenty-five dollars I got the key to the front door, a king-size bed, air conditioning, and my own bathroom, while Paquita and her daughter watched TV in the front room or sat in the kitchen and cooked for themselves and gossiped.

Habana by night is simply sizzling. Many places are open twenty-four hours. Huge numbers of people from the provinces crowd the streets, looking for excitement. This in turn has led to restrictions on internal migration.

By leaving the provinces, people have drained them of talent and created a crowded and chaotic situation in the capital. While Habana is still a safe city, it has become big and bad, nearly a world capital. Night clubs are jumping, restaurants are overflowing, prices are relatively high. Girls, some of them in their early teens, compete in seeing who can wear the tightest and most revealing dresses, the highest heels, the richest tourist on their arm. At the same time more state money is poured into housing, jobs, medical care, and all the rest. Many houses, even the multifamiliares in the outskirts, are being carefully painted and restored, giving the city a scrubbed, European look. A toothless old woman, who was selling maní, complained to me that she wanted to get her teeth fixed, but there was no material at the free clinic, so she needed twenty dollars to buy the material herself and get her whole mouth fixed. She made it sound like a tragedy, but it's a safe bet that she can raise twenty dollars in a short time selling peanuts to tourists.

I went to El Conejito, whose specialty is conejo al vino. In its elegance and simplicity it looks like a Tudor mansion, with great hardwood beams crossing the ceiling in a bóveda. Prices range from five to ten dollars. A party of Frenchmen with their mulattas was slowly getting drunk in a corner, laughing and talking loudly, while a pianist tried to make himself heard above the din. He played some light pieces while the party remained completely unaware of his presence—that is, no tips. Finally he finished a piece with a flourish and in frustration stood up and sarcastically clapped for himself. The frogs didn't even look up. Amused, I went over, put five dollars in the tray on his piano and told him how well he played. He thanked me profusely. When I went back and sat down, he broke into a piece by Agustín Lara. I gave him the thumbs up and he saluted with his hand. When he finished, he

came over and I asked him to sit down at my table. It turned out that he was now retired, but had played for years over Cuban TV and radio, had accompanied all the big names, and had toured with some of them in Latin America. We talked about Toña la Negra, Rita Montaner, Pedro Vargas, María Félix, Jorge Negrete, and the golden age of Cuban music. I told him that if he played something by Ernesto Lecuona, I wouldn't get mad, and he played a concert piece with great flourishes. He was thrilled to have an audience that knew something about Latin American culture. After my excellent rabbit and some wine, we parted with a hug.

In Santiago, Antonio took me to the department store. It is a modern two-story building where everything conceivable can be found (in dollars), from refrigerators (three hundred to one thousand dollars) and TV sets (five hundred dollars) to watches to rum to canned goods, dry goods, clothing, etc. Fresh fruits, vegetables, and meats can be had at the mercado agropecuario in pesos. Later he invited me to meet his charming wife and son, and we sat down in the kitchen to a typical Cuban meal of juice, sliced tomatoes and cucumbers, ají, congrí, tostones (fried plantains), and huge pieces of deep fried pork, identical to carnitas, topped off with café con leche at my special request. Then we retired to the living room and discussed life, violence in the United States, and Tina Modotti, whose biography I had just finished.

Antonio's parents were guajiros, and he takes pride in his peasant background, but the Revolution, for whatever reason, has turned him into a taxi driver. The result is a mixture of simplicity and sophistication. Able to discuss politics and things in the world, he reiterated that the only thing that he wanted in life was for his son to finish college and "never disrespect anyone."

Still, there is a way to go before Cuba becomes totally functional. Back in Habana, I tried to reach my friend Magaly on the Isla de la Juventud, but the lines were jammed. I tried buying an air ticket—there were no seats for several days. I took a taxi to the bus terminal, where I could go by bus to Batabanó, where I could take the hydrofoil to the island. It was so much trouble, so complicated because this was for Cubans and not for tourists, that I gave up. It would have meant standing in line and roasting in a bus for close to two hours just to reach the dock. But even here, as opposed to a few years ago, the cafeteria was fully stocked (available in dollars and pesos), and there was a bookstore and tourist shop (for Cuban tourists). I got a book on African etymologies in Cuban Spanish, which was forty pesos (two dollars), a practice frowned upon in the past.

On the Malecón, I met David, who said he was seventeen but is only fifteen, who manfully tried to pimp some girls to me. I scolded him, calling him a "padrote" to which he replied, "you're Mexican." I gave him five dollars. His mother had been killed in an accident, and his father had remarried. His father beat him, and David had denounced him to the authorities. The father had been put in jail, but David was afraid to stay with him after that, so he came to La Habana. He was on his way to see an aunt and stay with her. David was limping because his cheap tennis shoes had rubbed his heel raw. I gave him a Band-Aid and a pair of socks and took him to dinner. He had a huge plate of spaghetti and a pair of fried eggs, all of which he wolfed down in a hurry. I urged him to go back to school and get some sort of career. He asked me when my plane was leaving. I told him early, 6:00 a.m. He answered, with tears in his eyes, "I'll come by and say goodbye." Sure enough, as I left Paquita's in the early morning darkness, David's small figure could be seen in the gloom across the street, waiting to say goodbye. I hugged him, gave him some money, and made him promise to get to his aunt's and get back in school posthaste. In front of the Capri I took a Turistaxi and reached the plane with plenty of time for boarding.

Antonio Bernal's Paintings

A Selection and Overview, 1968–2018

The sixty-nine works by Antonio Bernal that are presented in the color plate section and the black-and-white section that follows represent his career as an artist from the 1960s until 2018.[1] Most are oil paintings on canvas, but also included are his two murals and a number of drawings. Except for the Del Rey mural (1968), none has been reproduced before in an academic publication. Bernal produced art for a range of patrons, including galleries and political groups, and a number of his pieces are currently in private collections. Most of his oil paintings were lost and possibly destroyed, however, when the Los Angeles gallery that housed them closed in 1995. We hope that this book will lead to the recovery of some of these works.

The works that are reproduced here reflect the subjects that interested Bernal as an artist. They are organized into a set of color plates and the following section of black and white images, which are arranged thematically into three groups—"Places," "People," and "Politics"—in loose chronological order. Works in the first group, "Places," reflect Bernal's love of and formative years in Mexico, his time living in Los Angeles, and his world travels. City views, landscapes, paintings of pueblos, markets, and people present a view of Mexico as a place marked by "multitemporality"—that is, the co-existence of ancient, colonial, modern, and postmodern modes of being.[2] Present-day renditions of Mexico City, its surrounding highway, and other locales co-exist with traditional views of pueblos, people, and Catholic churches. In line with his politics, Bernal glorifies people at work: merchants, bricklayers, and campesinos. His politics are never far removed from his art, as seen in his satirical representations of tourists, his Zapatistas, or the canvas titled *Fuck Bellas Artes* (page 122), a condemnation of Mexico's major fine arts institution. The inclusion of a number of preparatory drawings, such as that for his finished painting *Acapulco* (page 126), allows us to witness his creative process. An expert still life from 1985, *Flores de jardines* (page 125), recalls Bernal's first artwork, a drawing of a flower created at the age of ten.[3] Although his paintings are overwhelmingly representational and figural, and in line with social realist work created in Mexico, the United States, and elsewhere, Bernal has experimented with abstraction. This is particularly noticeable in his portrayals of cityscapes, such as *Abstracto periférico*, a fragmented, chaotic portrayal of the main highway surrounding Mexico City (page 132).

Bernal's talents in portraiture are reflected in the second section, "People." With bold strokes of paint he captures not only the physical features but also the inner psychology of his subjects. His sitters include family members: his former wife, Belén, their children, his sister,

his father. In a powerful self-portrait from 1978, Bernal confronts the viewer directly, in a frontal pose (plate 3). Unclothed from the chest up, the portrait shows his powerful physique. Hints of grey hair reveal him to be a man in his forties, in the prime of life. His brown eyes, open wide, directly meet the beholder, and something in their stare and his furrowed brow betrays sadness, perhaps even anxiety. Another self-portrait, done in pencil, is undated, but it registers the features of a seemingly older man, perhaps in his fifties (page 140). Here Bernal looks more pensive, his eyes almost brooding. The portrait evidences the passage of time in its careful rendition of his face, which is now fuller and slightly lined. In his portraits of friends and loved ones, Bernal captures a speaking likeness, a sideways glance, a modest smile. His portrayals of athletes, although not properly portraits, demonstrate his skill at capturing human anatomy, particularly the heroic male body. Portraits of performers reflect Bernal's own career on the stage.

Bernal's political commitments are reflected in many of his works. *Star Wars*, painted in 1978 and initially titled *Hiroshima*, is one example: it was carried in an antiwar demonstration in Los Angeles in 2003 by Bernal's son, Alex (page 8). The final section, "Politics," includes a selection of pieces that are explicitly and directly political. Paintings such as *Star Wars* and *Vietnam* (2018, page 146) picture the horrors of war. Others valorize Bernal's political heroes, including Fidel Castro, Malcolm X, Che Guevara, and Steve Biko. Some canvases glorify everyday people fighting for higher wages, for human dignity, and to end capitalism. One critiques US support of

the anticommunist contras in Nicaragua (page 147). Another, *20 de noviembre* (page 148), celebrates the beginning of the Mexican Revolution. Interestingly, these explicitly political works are Bernal's most complex paintings, incorporating elaborate multifigural compositions, vibrant color, and often text that underscores his message. His visual strategies align perfectly with his political commitments.

Bernal's artwork articulates several themes: pride in Mexican culture and history, an appreciation of Mexico's diversity and especially its indigenous populations, a commitment to Black-Brown coalition building, and international solidarity within revolutionary political movements. His style blends social realism with influences from abstract expressionism, as seen particularly in his daring, gestural brushwork. Bernal, now eighty-four, is still painting, continuing an artistic career that begin in 1947 at the age of ten. Currently, he is at work on an homenaje to his farmworker friends in Fresno.

Charlene Villaseñor Black

Notes

All images in the two plate sections are courtesy of Antonio Bernal.

1. Bernal's artistic training is discussed the biography of Bernal in this volume.

2. The concept of multitemporality was theorized by Néstor García Canclini. See Néstor García Canclini, "Modernity after Postmodernity," in *Beyond the Fantastic: Contemporary Art Criticism from Latin America*, edited by Gerardo Mosquera (London: Institute of International Visual Arts, 1995), 27–28.

3. For a discussion of this work, see the biography of Bernal in this volume.

Places

Mercado de Pátzcuaro, 1978. Oil on canvas, 36 × 24 inches. Location unknown.

Vendo las riquezas, 1978. Oil on canvas, dimensions unknown. Private collection.

Propiedad privada, 1978. Oil on canvas, dimensions and location unknown.

Nuestra Amada Madre Iglesia, 1978.Oil on canvas, dimensions and location unknown.

Día de los muertos, date unknown. Oil on canvas, dimensions and location unknown.

Los turistas, date unknown. Oil on canvas, dimensions and location unknown.

La madre, 1979. Oil on canvas, dimensions and location unknown.

Cinco hermanos, 1980. Oil on canvas, dimensions and location unknown.

Plaza, 1981. Oil on canvas, dimensions and location unknown.

Parque Chapultepec, 1981. Oil on canvas, dimensions and location unknown.

Eucalipto, 1981 (unfinished). Oil on canvas, dimensions and location unknown.

Los albañiles, 1981. Oil on canvas, dimensions and location unknown.

El albañil, date unknown. Oil on canvas, dimensions and location unknown.

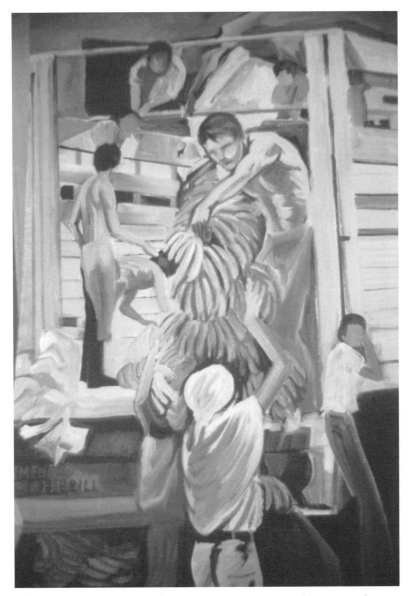

Plátanos de la Merced, 1981. Oil on canvas, dimensions and location unknown.

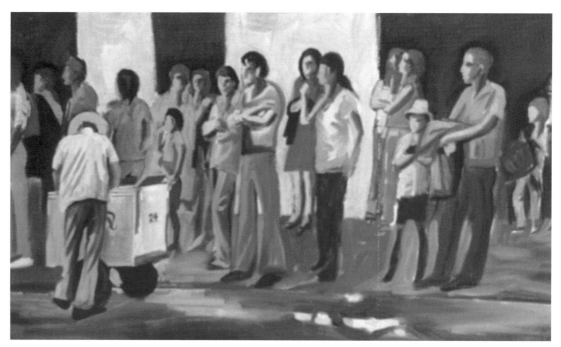

Esperando el pinche camión, 1981. Oil on canvas, dimensions and location unknown.

Esperando el camión, 1981. Ink on paper, dimensions and location unknown.

Agua fresca, 1981. Oil on canvas, dimensions and location unknown.

Fuck Bellas Artes, 1982. Oil on canvas, dimensions and location unknown.

El pueblo de México es, 1982. Oil on canvas, dimensions and location unknown.

Tianguis, 1982. Oil on canvas, dimensions and location unknown.

Carnicería, 1985. Oil on canvas, dimensions and location unknown.

Flores de jardines, 1985. Oil on canvas, dimensions and location unknown.

Acapulco, 2011. Oil on canvas, 24 × 36 inches. Location unknown.

Acapulco, 2011. Ink on paper, 16 × 24 inches. Location unknown.

Centro, date unknown. Ink on paper, dimensions and location unknown.

Merced, date unknown. Ink on paper, dimensions and location unknown.

Mujeres en mercado, date unknown. Oil on canvas, dimensions and location unknown.

Obreros, date unknown. Ink on paper, dimensions and location unknown.

Zapatistas, date unknown. Ink on paper, dimensions and location unknown.

El pueblo 1, date unknown. Oil on canvas, dimensions and location unknown.

El pueblo 2, date unknown. Oil on canvas, dimensions and location unknown.

Pueblos, date unknown. Ink on paper, dimensions and location unknown.

Campesinos, date unknown. Oil on canvas, dimensions and location unknown.

Abstracto periférico, date unknown. Oil on canvas, dimensions and location unknown.

Ciudad Los Angeles, date unknown. Oil on canvas, dimensions and location unknown.

Downtown Los Angeles, date unknown. Oil on canvas, dimensions and location unknown.

Desierto, date unknown. Oil on canvas, dimensions and location unknown.

Germany (Europe), date unknown. Oil on canvas, dimensions and location unknown.

Mercado de Xochimilco, date unknown. Oil on canvas, dimensions unknown. Private collection.

People

Portrait of Belén, 1976. Oil on canvas, 20 × 16 inches. Location unknown.

Belén y los niños, 1981. Oil on canvas, dimensions and location unknown.

Belén y los niños, 1981. Ink on paper, dimensions and location unknown.

Portrait of Ann, 1985. Oil on canvas, dimensions and location unknown.

Autorretrato, date unknown. Ink on paper, dimensions and location unknown.

Forrest Padre, date unknown. Ink on paper, dimensions and location unknown.

Latino Art, date unknown. Oil on canvas, dimensions and location unknown. Alternate titles: *María Félix*; *La María*; and *La Marcha de la Cucaracha*.

Atletas, 1980. Ink on paper, dimensions and location unknown.

Atletas, 1980. Oil on canvas, dimensions and location unknown.

Jugadores de futbol, date unknown. Ink on paper, dimensions and location unknown.

Hombre 1, date unknown. Oil on canvas, dimensions and location unknown.

Buddies, date unknown. Oil on canvas, dimensions and location unknown.

Tres muchachos, 1980. Oil on canvas, dimensions and location unknown.

Democracia y más salario, 1981. Oil on canvas, dimensions unknown. Private collection.

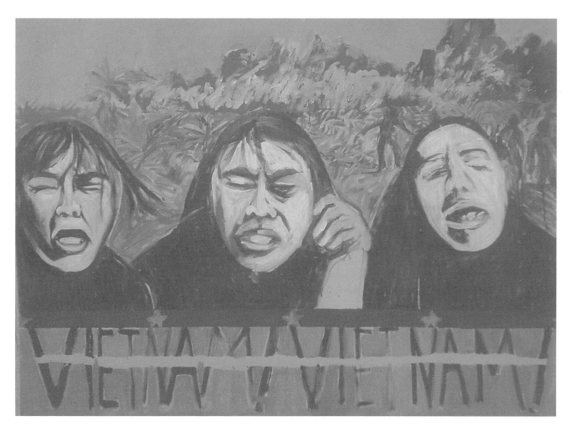

Vietnam, 2018. Oil on canvas, 24 × 36 inches. Private collection.

Politics

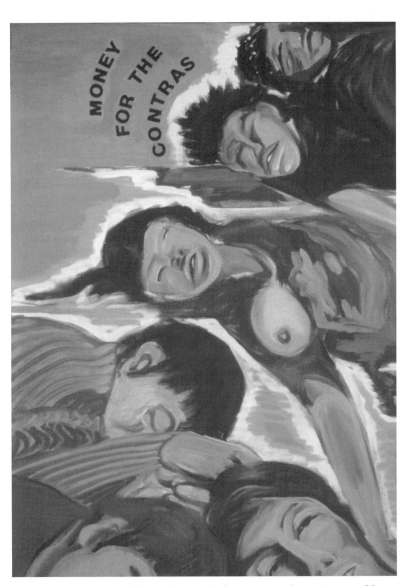

Money for the Contras, date unknown. Oil on canvas, dimensions and location unknown.

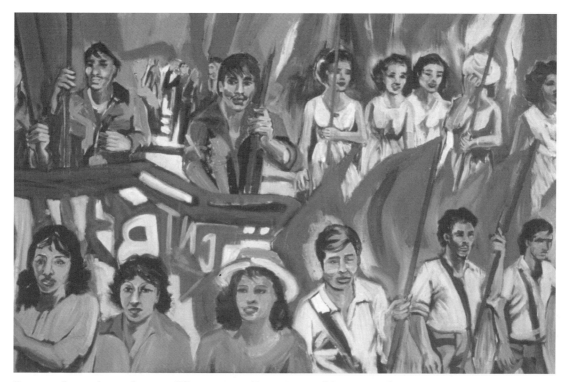

Protesta obrera, date unknown. Oil on canvas, dimensions and location unknown.

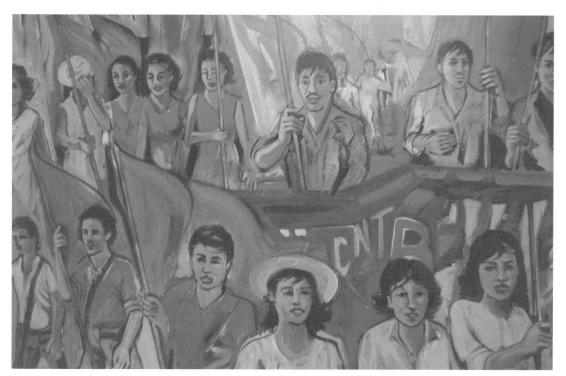

20 de noviembre, date unknown. Oil on canvas, dimensions and location unknown.

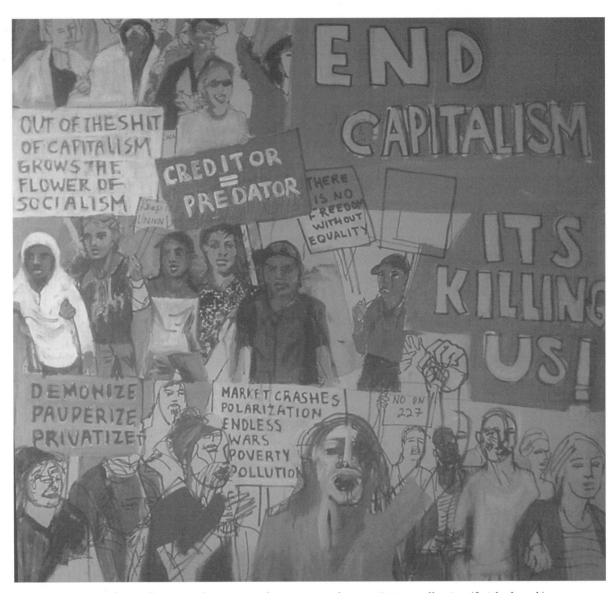

End Capitalism (unfinished), 1976. Oil on canvas, dimensions unknown. Private collection (finished work).

Finding Aid and Note on the Collection

Prepared by Xaviera S. Flores

Summary Information

Bernal (Antonio) Papers
1884-2019, bulk 1970s-2000s

Repository:	Chicano Studies Research Center Library
Creator, art:	Bernal, Antonio (Forrest Antonio Bernal Hopping Jr.), 1937–
Title:	Antonio Bernal (Hopping) Papers
ID:	CSRC.2018.003
Date:	1884–2019, bulk 1970s–2000s
Physical description:	4.5 linear feet, 8 boxes (there is no box 5)
Physical location:	Physical materials are stored offsite at SRLF. Digital materials are stored on the CSRC Digital Repository. For access please contact the librarian.
Language of the material	English

Abstract

Antonio Bernal (born Forrest Hopping Jr. in 1937) is an activist, actor, artist, teacher, and writer. His collection includes correspondence, personal writings, photographs, and audiovisual materials documenting his travels, artwork, and the Kaweah Colony, which his great-grandfather helped found. Materials date from the mid-1880s to 2019, with the bulk of the collection dating from 1970 to 2000.

Scope and Contents

The Antonio Bernal Papers include select personal correspondence, personal writings, photographs, and audiovisual materials documenting Bernal's travels, artwork, and family history. Materials date from the mid-1880s to 2019, with the bulk of the collection dating from 1970 to 2000.

Series I. Artwork. Addresses Bernal's artwork, including: finished and in-progress pieces; media ranging from gouache to mixed media; paintings; fashion drawings; murals; digital works. The works include scenes of quotidian life and intimate portraits of strangers, relatives, and friends; and political art commenting on war, colonialism, capitalism, and religion.

Series II. Audiovisual. Contains material on his travels; interviews with people he met; some works that remain unknown because formats are obsolete and/or the library does not have the playback equipment needed to ascertain subject matter, people, places, or dates..

Series III. Correspondence. Contains emails and letters written to friends and family.

Series IV. Oral History Project. Contains sound recordings and film of the oral history conducted by Charlene Villaseñor Black, Gabriela Rodriguez-Gomez, and Xaviera Flores. Includes photographs taken during visits with Bernal and during the acquisition of the collection, as well as research on and documentation of his existing works and archival materials at other institutions.

Series V. Personal Family Papers. Includes photographs, genealogy information, articles, and research materials collected by Bernal on his family history, dating back to the formation of the Kaweah Colony in 1886.

Series VI. Photographs and Slides. Subjects are Bernal's travels, artwork, and some political events he attended. Materials remain mostly undated at this time.

Series VII. Writings. Contains materials written by and about Bernal and includes materials and articles he collected from other authors and on subject matters he researched and/or in which he was interested. Most prominent are four works by Bernal: "Breaking the Silence," "Dialectics Bilingual," "The Life of Joaquin Murrieta," and "World History." The materials are a mix of drafts, revisions, corrected versions, and notes. Materials are in English and Spanish.

Currently, all materials in series III, IV, V, and VI are digital objects. For access, please contact the CSRC librarian.

Arrangement

Materials are arranged into seven series: Series I. Artwork; Series II. Audiovisual; Series III. Correspondence; Series IV. Oral History Project; Series V. Personal Family Papers; Series VI.

Photographs and Slides, Undated, 1997–1998; and Series VII. Writings.

Series IV. Oral History Projects is divided into three sub-series: A) Correspondence; B) Interviews; and C) Photographs.

Series VII. Writings is divided into three sub-series: A) Works by Bernal; B) Works by Others; and C) Works by Subject Matter.

Administrative Information

Publication Statement

Chicano Studies Research Center Library
144 Haines Hall
Box 951544
Los Angeles, California 90095-1544
librarian@chicano.ucla.edu
URL: http://chicano.ucla.edu

Conditions Governing Access

Open for research. Audiovisual materials may not be immediately available due to formatting issues. Access varies. Permission from the librarian needed.

Immediate Source of Acquisition

Accessions 2018-003 and 2018-009. Materials donated by Antonio Bernal, 2018.

Conditions Governing Use

These materials are made available for use in research, teaching, and private study, pursuant to US Copyright Law. The user must assume full responsibility for any use of the materials, including but not limited to, infringement of copyright and publication rights of reproduced materials. Any materials used for academic research or otherwise should be fully credited with the source. The original authors may retain copyright to the materials.

Processing Information

These materials include both physical and digital archives. The finding aid describes these intellectually to give the full scope of the creator's oeuvre. Collection processed by Sarah Corona and Xaviera Flores.

Related Materials

CARA (*Chicano Art: Resistance and Affirmation*) Records—Part 1, CSRC-10, Chicano Studies Research Center, University of California, Los Angeles.

El Teatro Campesino Archives, CEMA 5, Department of Special Collections, UC Santa Barbara Library, University of California, Santa Barbara.

Shifra M. Goldman Papers, CEMA 119, Department of Special Collections, UC Santa Barbara Library, University of California, Santa Barbara.

Sierra Club Pictorial Collection, The Bancroft Library, University of California, Berkeley.

Controlled Access Headings

- Activism
- Artists, Chicano—California—Los Angeles—Archival resources
- Chicano Art
- Chicano movement

Collection Inventory

Title/Description	Instances	
Artwork, Undated		
Abstracto periférico, painting (digital and print), undated		
Acapulco, drawing (digital and print), 2011	Box 9	Folder 23
Acapulco, painting (digital and print), 2011	Box 9	Folder 23
Agua fresca, painting (digital and print), 1981	Box 9	Folder 17
albañil, El, painting (digital), undated		
albañiles, Los, painting (digital and print), 1981	Box 9	Folder 31
Apolonia, painting (print), undated	Box 9	Folder 20
Architecture drawings (digital), undated		
Atletas, drawing (digital and print), 1980	Box 9	Folder 42
Atletas, painting (digital), 1980		
Autorretrato, drawing (digital and print), date unknown	Box 9	Folder 26
Autorretrato, painting (digital and print), 1978	Box 9	Folder 26
Avestruz, poster (digital and print), undated	Box 9	Folder 74
Belén y los niños, drawing (digital and print), 1981	Box 9	Folder 29
Boys with Guitars, mixed media (digital), undated		
Buddies, painting (digital and print), undated	Box 9	Folder 7
Campesinos, painting (digital), undated		
Caravaggio's Supper at Emmaus (1610) (print)	Box 9	Folder 2
Carmen, poster (digital and print), undated	Box 9	Folder 47
Carmen Amaya, drawing (digital), undated		
Carnicería, painting (digital and print), 1985	Box 9	Folder 19
Cementerio, mixed media (digital and print), undated	Box 9	Folder 10
Centro, drawing (digital and print), undated	Box 9	Folder 37
Ciclovital, story board (digital), undated		
Cinco hermanos, painting (digital and print), 1980	Box 9	Folder 35
Cocina improvisada, painting (digital and print), undated	Box 9	Folder 56
comadres, Las, painting (digital and print), undated	Box 9	Folder 55
Contact sheets (digital), undated		
Cuba: Fidel, painting (digital and print), 1995	Box 9	Folder 27
Cuidad de México, painting (digital and print), 1976	Box 9	Folder 57
Cuidad Los Angeles, painting (digital and print), undated	Box 9	Folder 58
Del Rey mural (digital), 1968		
Democracia y más salario, painting (digital and print), 1981	Box 9	Folder 6
Desierto, painting (digital and print), undated	Box 9	Folder 14
Día de los Muertos, painting (digital), undated		
Dog Eat Dog, painting (digital and print), undated	Box 9	Folder 70
Dos mujeres, painting (digital and print), 1979	Box 9	Folder 15

Title/Description	Instances	
Downtown Los Angeles, painting (digital and print), undated	Box 9	Folder 54
Elías, painting (digital and print), undated	Box 9	Folder 53
El Salvador—Made in USA, poster (digital), undated		
End Capitalism (unfinished), painting (digital and print), 1976	Box 9	Folder 1
Esperando el camión, drawing (digital and print), 1981		
Esperando el pinche camión, painting (digital and print), 1981	Box 9	Folder 68
Eucalipto, painting (digital and print), 1981	Box 9	Folder 3
Eucalipto (unfinished), painting (digital and print), 1981		
Evil eyes, painting (digital and print), undated	Box 9	Folder 52
Evita, poster (digital), undated		
Familia, painting (print), undated	Box 9	Folder 46
Familia 1, painting (digital), undated		
Familia 2, painting (digital), undated		
Familia proletaria, painting (digital and print), 1978	Box 9	Folder 32
Fashion drawings (digital), undated		
Flores de jardines, painting (digital and print), 1985	Box 9	Folder 67
Forrest Padre, drawing (digital and print), undated	Box 9	Folder 62
Fuck Bellas Artes, painting (digital and print), 1982	Box 9	Folder 24
Garfield High School mural (digital and print), circa 1970s	Box 9	Folder 28
Germany (Europe), painting (digital), undated		
Germany (Tübingen), painting, 1984	Box 9	Folder 13
Ghost, mixed media (digital), undated		
Great American Cookout, The, mixed media (digital), undated		
Guadalupe, painting (digital and print), undated	Box 9	Folder 39
Hermanos Coreanos, painting (digital and print), undated	Box 9	Folder 73
Hiroshima [Star Wars], painting (digital and print), 1978	Box 9	Folder 72
Hombre 1, painting (digital and print), undated	Box 9	Folder 51
Hombres Swapmeet, mixed media (digital), undated		
Huelga, mixed media (digital), undated		
Huelga en catadral, mixed media (digital), undated		
Huestes de la guerra, mixed media (digital), undated		
Jugadores de futbol, printing (digital and print), undated	Box 9	Folder 63
Karen Glow, mixed media (digital), undated		
Latino Art (also known as María Félix), mixed media and painting (digital), undated		
Madness, mixed media (digital), undated		
madre, La, painting (digital and print), 1979	Box 9	Folder 30
Malecón, mixed media (digital), undated		
Manifestación, mixed media (digital), undated		
Marcha de la Cucaracha, La (print), undated	Box 9	Folder 60
Mártires por la libertad (print), undated	Box 9	Folder 38

Title/Description	Instances	
Max Beckmann, Still Life, painting (digital), undated		
Maya, drawing (digital), undated		
Men on Bikes, mixed media (digital), undated		
Mercado, drawing (digital and print), undated	Box 9	Folder 64
Mercado de flores, mixed media (digital), undated		
Mercado de Pátzcuaro, painting (digital and print), 1978	Box 9	Folder 69
Mercado de Xochimilco, painting (digital), undated		
Merced, drawing (digital and print), undated	Box 9	Folder 65
Mermaid, mixed media (digital), undated		
Mexico, general files (digital), undated		
México, DF, painting (digital), undated		
Miami, mixed media (digital), undated		
Money for the Contras, painting (digital and print), undated	Box 9	Folder 50
Mujeres en mercado, painting (digital), undated		
Nicaragua, poster (digital), undated		
Nuestra Amada Madre Iglesia, painting (digital and print), 1978	Box 9	Folder 25
Nunca más guerra, painting (digital), undated		
Obrero, drawing (digital and print), undated	Box 9	Folder 21
Obreros, drawing (digital and print), undated	Box 9	Folder 66
Olmeca, drawing (print), undated	Box 9	Folder 61
Parque, painting (digital and print), undated	Box 9	Folder 36
Parque Chapultepec, painting (digital), 1981		
People (print), undated	Box 9	Folder 48
Plátanos de la Merced, painting (digital and print), 1981	Box 9	Folder 44
Plaza, painting (digital), 1981		
Police—Police Brutality, mixed (digital), undated		
Portrait of Ann (Hopping), painting (digital and print), 1985	Box 9	Folder 16
Portrait of Belén, painting (digital and print), 1976	Box 9	Folder 76
Poster 1, mixed media (digital and print), undated	Box 9	Folder 49
Poster 2, mixed media (digital), undated		
Poster 3, mixed media (digital), undated		
propiedad privada, La, painting (digital and print), 1978	Box 9	Folder 5
Protesta obrera, painting (digital and print), undated	Box 9	Folder 43
pueblo 1, El, painting (digital and print), undated	Box 9	Folder 4
pueblo 2, El, painting (digital and print), undated	Box 9	Folder 11
pueblo de México es, El, painting (print and digital), 1982	Box 9	Folder 75
Pueblos, drawing (print), undated	Box 9	Folder 59
Ranch Market, mixed media (digital), undated		
Respuesta de Sor Juana, La, painting (digital and print), undated	Box 9	Folder 41
Service, mixed media (digital), undated		
Soulfood, mixed media (digital), undated		

Title/Description	Instances	
Spanish Golden Age, painting (digital), undated		
Star Wars [Hiroshima], painting (digital and print), 1978	Box 9	Folder 72
Taco Men, mixed media (digital), undated		
Tianguis, painting (digital and print), 1982	Box 9	Folder 9
Toma de Garfield, mixed media (digital), undated		
Tortillería (print), undated	Box 9	Folder 8
Tres muchachos, painting (digital and print), 1980	Box 9	Folder 34
Triptych, painting (digital), 1981		
turistas, Los, painting (digital and print), 1978	Box 9	Folder 12
turistas, Los, painting (digital and print), undated		
20 de Noviembre, painting (digital), undated		
Untitled (DSCOO369) (print), undated	Box 9	Folder 40
Vendo las riquezas, painting (digital and print), 1978	Box 9	Folder 18
Vermont, mixed media (digital), undated		
Vietnam, painting (digital and print), 2018	Box 9	Folder 71
Virgin, painting (digital), undated		
Xochipilli, painting (digital and print), 1982	Box 9	Folder 33
Zapatistas, drawing (digital and print), undated	Box 9	Folder 22

Audiovisual

Title/Description	Instances	
Audio cassettes, undated	Box 6	
Compact video cassettes, undated	Box 7	
Mini digital video (DV) cassettes, undated	Box 5	
Correspondence		
"Amparo Miramar—Celbas, La Havana—2 girls, Mercados, Isabel—El Chino, 95," compact video cassette, 1995	Box 6	Object 15
"Ana Gabriel," audio cassette, undated	Box 7	Object 1
"Ana Gabriel," audio cassette, undated	Box 7	Object 2
"Angel Pinga, Taxi Ride, Santeria, 94 (back side: VBA 94, x Car Sante)," compact video cassette, 1994	Box 6	Object 16
"Arabic Music," audio cassette, undated	Box 7	Object 3
"Bailando, cementerio," compact video cassette, undated	Box 6	Object 17
"Bailando Tacos Mex (back side: Titulos)," compact video cassette, undated	Box 7	Object 37
"Bush Keeps Us Scared," mini digital video cassette, undated	Box 7	Object 16
"Callas," audio cassette, undated	Box 7	Object 4
"Cuba X," compact video cassette, undated	Box 6	Object 18
"Demonstration, 11/3/94," compact video cassette, 1994	Box 6	Object 19
"Die Marlene 1," audio cassette, undated	Box 7	Object 5
"Die Marlene 2," audio cassette, undated	Box 7	Object 6
"Die Marlene 3," audio cassette, undated	Box 7	Object 7

Title/Description	Instances	
"Dreigroschen," audio cassette , undated	Box 6	Object 1
"Dreigroschen," audio cassette, undated	Box 6	Object 2
"Dreigroschen, Dreigroschenoper 2," audio cassette, undated	Box 7	Object 8
"VIII," compact video cassette, undated	Box 6	Object 12
"18 Parque," compact video cassette, undated	Box 6	Object 14
"Entartete Musik," audio cassette, undated	Box 7	Object 9
"15–16a, Frank Mayra," compact video cassette, undated	Box 6	Object 13
"Final Bailando, 20," compact video cassette, undated	Box 7	Object 38
"V, VI, VII," compact video cassette, undated	Box 6	Object 11
"Fone, Cena Fone, 9-10-11," compact video cassette, 2011	Box 6	Object 20
"Fone, Diablin 4–8 Cesar (back side: scenes 4, 8)," compact video cassette, undated	Box 6	Object 21
"405 Caracas III," mini digital video cassette, undated	Box 6	Object 4
"Frank Mayra, 16 (B)," compact video cassette, undated	Box 7	Object 39
"Gardel Varela," audio cassette, undated	Box 7	Object 10
"Garf, 97," compact video cassette, 1997	Box 6	Object 22
"Gran Via, Bus Stop Carlos—Gerente, Boys Beach—Pinga, Girls Beach, Ambulance Workers, Mi cayito ITAB, Huracan, 93 (back side: Cuba, 93)," compact video cassette, 1993	Box 6	Object 23
"Guanabo Houses, Boys Beach—Kids, Fev. cementerio Eblon, Plaza Revolución, Construction Workers, Museo Revolucion, 93," compact video cassette, 1993	Box 6	Object 24
"Hector y Jon," mini digital video cassette, undated	Box 7	Object 17
"Internet EVO 1-06," mini digital video cassette, 2006	Box 7	Object 18
"Internet TV 5/1/06," mini digital video cassette, 2006	Box 7	Object 19
"Iris Varela—Charlize," mini digital video cassette, undated	Box 7	Object 20
"Isla Margarita," mini digital video cassette, undated	Box 7	Object 21
"Litoral," mini digital video cassette, undated	Box 7	Object 22
"LL-05 Internet Video," mini digital video cassette, undated	Box 7	Object 23
"London 2," compact video cassette, undated	Box 7	Object 40
"March, Venice HS, 93," compact video cassette, 1993	Box 7	Object 41
"Merida, La Habana, Santiago, Sidney, 95," compact video cassette, 1995	Box 6	Object 25
"Musica Cubana," audio cassette, undated	Box 6	Object 3
"Net—Dec," mini digital video cassette, 2006	Box 7	Object 24
"Net Flicks 10-06," mini digital video cassette, 2006	Box 7	Object 25
"9/05 Caracas II," mini digital video cassette, 2005	Box 7	Object 15
"Olvera St. Locations, 94 (back side: Video, Cal State 5/15, SacTV 5/22)," compact video cassette, 1994	Box 7	Object 42
"Om Kalthom—Middle East Sound," audio cassette, undated	Box 7	Object 11
"Om Kalthom, Sono Cairo," audio cassette, undated	Box 7	Object 12
"Parque 12-14-18," compact video cassette, undated	Box 7	Object 43

Title/Description	Instances	
"Picks on Beach, 95," compact video cassette, 1995	Box 6	Object 27
"Playa Hermosa de Noche, Eddy-Angel Casa Alquilcapa, Alberto, Boys Beach Pingas, 94 (back side: Cuba 94, Playa Hermosa)," compact video cassette, 1994	Box 6	Object 28
"Phone, Stock Shots, 9," compact video cassette, 1994	Box 6	Object 29
"Phone 4, Tacos 7," compact video cassette, undated	Box 6	Object 26
"Rigoletto Lucia," audio cassette, undated	Box 7	Object 13
"Script Olvera 4, 94 (cover notes: Koln, Berlin, Lond)," compact video cassette, 1994	Box 6	Object 30
"SDR, Juana Breakdancers," compact video cassette, undated	Box 7	Object 44
"Street Interviews," compact video cassette, undated	Box 6	Object 31
"XIII, IX, XII," compact video cassette, undated	Box 7	Object 36
"13 Casa Mama Noemi," compact video cassette, undated	Box 7	Object 35
"Titles," compact video cassette, undated	Box 6	Object 32
"Toma de Posesión—EVO," mini digital video cassette, undated	Box 7	Object 26
"Trojillo II Bach—[cutoff text]," mini digital video cassette, undated	Box 7	Object 27
"TV Caracas 2," mini digital video cassette, undated	Box 6	Object 5
"TV Internet," mini digital video cassette, undated	Box 7	Object 28
"TV—Teleférico," mini digital video cassette, undated	Box 6	Object 6
"2 Beer Run, 3 Licor," compact video cassette, undated	Box 6	Object 10
Untitled, audio cassette, undated	Box 7	Object 14
Untitled, mini digital video cassettes, undated	Box 6	Objects 7–9
Untitled, mini digital video cassettes, undated	Box 7	Objects 29–33
"Windy Beach, Guanabo Houses, 93," compact video cassette, 1993	Box 6	Object 33
"WTO—911 Part One," mini digital video cassette, 2001	Box 7	Object 34
Oral History Project		
Correspondence, 2017–2019		
Oral History Interviews		
Interview conducted by Charlene Villaseñor Black, audio files, 2018 July 23		
Interview conducted by Charlene Villaseñor Black and filmed by Gabriela Rodriguez-Gomez, notes taken by Xaviera Flores, 2018 March 24		
Photographs		
Archival materials at University of California, Santa Barbara, circa 2018		
Bernal mural at Garfield High School, 2018 August		

Title/Description	Instances	
Pickup of materials donated to University of California, Los Angeles, 2018 March 24. Trip to visit Bernal by Gabriela Rodriguez-Gomez and Charlene Villaseñor-Black, July 23–24, 2018		
Personal Family Papers		
Bernal, Antonio (Forrest Hopping Jr.), undated		
Bernal, Maria Luisa (mother), undated		
Genealogy, undated		
Hopping, Forrest R. (Ricardo) (father), undated		
Hopping, Gabriela (daughter), undated		
Kaweah Colony, undated		
Photographs and Slides, Undated, 1997–1998		
Artwork research, photographs (digital), undated		
Barrio, photographs, undated	Box 2	Folder 9
Clouds, photographs, undated	Box 2	Folder 6
Cuba: La Habana, photographs, undated	Box 3	Folder 3
Cuba: La Habana, photographs and postcards, undated	Box 3	Folder 2
Cuba, photographs, 1997 April	Box 2	Folder 5
Cuba, slides, undated	Box 8	Folder 1
Demonstration, photographs (digital), undated		
France: Paris, photographs, undated	Box 3	Folder 7
General, film rolls, undated	Box 7	Objects 45–48
General, negatives, undated	Box 3	Folder 8
General, photograph envelopes, undated	Box 4	
General, photographs, undated	Box 3	Folder 9
General, photographs, undated	Box 3	Folder 11
General, photographs, undated	Box 4	Folder 1
General, photographs and postcards, undated	Box 3	Folder 10
General, slides, undated	Box 1	Folders 2–5, 7
General, slides, undated	Box 8	Folders 4–6
Germany: Berlin, photographs, 1998 April 25	Box 3	Folder 4
Germany: Koln, photographs, 1998 April	Box 3	Folder 6
Germany, slides, undated	Box 8	Folder 2
Graffiti, photographs, undated	Box 2	Folder 1
Hollywood demonstration, photographs (digital), undated		
Mexico: Cancun, photographs, undated	Box 2	Folder 4

Title/Description	Instances	
Mexico, photographs, undated	Box 3	Folder 12
Mexico, slides, undated	Box 8	Folder 3
Mexico, slides, undated	Box 1	Folder 6
Mexico: Veracruz, photographs, 1997 April	Box 3	Folder 5
Potential Paintings, photographs, undated	Box 1	Folder 1
Restaurants, photographs, undated	Box 2	Folder 7
School, photographs, undated	Box 3	Folder 1
Sur: Chile, Brazil, Argentina, postcards, 1997 May	Box 2	Folder 2
Sur, photographs, 1997 May	Box 2	Folder 3
United Food and Commercial Workers rally, photographs (digital), undated		
Xerox, ATM, Buzones, photographs, undated	Box 2	Folder 8
Writings, Undated		
Bernal, Antonio, Undated		
Breaking the Silence, undated		
Dialectics Bilingual, undated		
Life of Joaquin Murrieta, The, undated		
World History, Undated		
Others, undated		
Subject, undated		

Selected Bibliography

Articles and Books

Aguilar-Moreno, Manuel. *Handbook to Life in the Aztec World*. New York: Facts on File, 2006.

Anzaldúa, Gloria E. *Borderlands/La Frontera: The New Mestiza*. San Francisco: Aunt Lute, 1987.

———. "Glossary." In *The Gloria Anzaldúa Reader*, edited by AnaLouise Keating, 319–23. Durham, NC: Duke University Press, 2009.

Barnet-Sanchez, Holly. "Radical *Mestizaje* in Chicano/a Murals." In *Mexican Muralism: A Critical History*, edited by Alejandro Anreus, Robin Adèle Greeley, and Leonard Folgarait, 243–62. Berkeley: University of California Press, 2012.

Barnett, Alan W. *Community Murals: The People's Art*. Philadelphia: Art Alliance Press, 1984.

Berdan, Frances, and Patricia Rieff Anawalt. *The Essential Codex Mendoza*. Vols. 2 and 4 of *The Codex Mendoza*. Berkeley: University of California Press, 1997.

Cucher, Michael. "Concrete Utopias from the Central Valley to Southern California: Repurposing Images of Emiliano Zapata in Chicana/o Murals." *Aztlán: A Journal of Chicano Studies* 43, no.1 (2018): 25–57.

Dabbs, Jack Autrey. Preface to *The French Army in Mexico, 1861–1867: A Study in Military Government*, 5–7. The Hague: Mouton, 1963.

———. "Preliminary French Maneuvers for Position." In *The French Army in Mexico, 1861–1867: A Study in Military Government*, 13–31. The Hague: Mouton, 1963.

Gaspar de Alba, Alicia. *Chicano Art Inside/Outside the Master's House: Cultural Politics and the CARA Exhibition*. Austin: University of Texas Press, 1998.

Goldman, Shifra M. *Dimensions of the Americas: Art and Social Change in Latin America and the United States*. Chicago: University of Chicago Press, 1994.

———. "How, Why, Where, and When It All Happened: Chicano Murals of California." In *Signs from the Heart: California Chicano Murals*, edited by Eva Sperling Cockcroft and Holly Barnet-Sánchez, 23–53. Albuquerque: University of New Mexico Press, 1993.

Goldman, Shifra M., and Tomás Ybarra-Frausto. *Arte Chicano: A Comprehensive Annotated Bibliography of Chicano Art, 1965–1981*. Berkeley: Chicano Studies Library Publications Unit, University of California, 1985.

Griswold del Castillo, Richard, Teresa McKenna, and Yvonne Yarbro-Bejarano. *Chicano Art: Resistance and Affirmation, 1965–1985*. Los Angeles: Wight Art Gallery, University of California, 1991.

Hamill, Hugh M. "The First Phase." In *The Hidalgo Revolt: Prelude to Mexican Independence*, 117–50. Gainesville: University of Florida Press, 1966.

Jackson, Carlos Francisco. "Art and the Chicano Movement" In *Chicana and Chicano Art: ProtestArte*, 60–85. Tucson: University of Arizona Press, 2009.

Klein, Cecelia F. "The Devil and the Skirt: An Iconographic Inquiry into the Pre-Hispanic Nature of the Tzitzimime." *Ancient Mesoamerica* 11, no. 1 (2000): 1–26.

Kushner, Sam. "Comment: Campesino Culture." *People's World*, May 4, 1968.

Latorre, Guisela. *Walls of Empowerment: Chicana/o Indigenist Murals of California*. Austin: University of Texas Press, 2008.

Meyer, Michael C., William L. Sherman, and Susan M. Deeds. *The Course of Mexican History*. 9th ed. New York: Oxford University Press, 2011.

Miner, Dylan A. T. "Claiming: Claiming Art, Reclaiming Space." In *Creating Aztlán: Chicano Art, Indigenous Sovereignty, and Lowriding across Turtle Island*, 101–4. Tucson: University of Arizona Press, 2014.

Reed, T. V. "Revolutionary Walls: Chicano/a Murals, Chicano/a Movements." In *The Art of Protest: Culture and Activism from the Civil Rights Movement to the Streets of Seattle*. Minneapolis: University of Minnesota Press, 2005.

Rodríguez O., Jaime E. "From Royal Subject to Republican Citizen: The Role of the Autonomists in the Independence of Mexico." In *The Independence of Mexico and the Creation of the New Nation*, edited by Jaime E. Rodríguez O., 19–43. Los Angeles: UCLA Latin American Center Publications; Irvine: Mexico/Chicano Program, University of California, 1989.

———. Introduction to *The Independence of Mexico and the Creation of the New Nation*, edited by Jaime E. Rodríguez O., 1–15. Los Angeles: UCLA Latin American Center Publications; Irvine: Mexico/Chicano Program, University of California, 1989.

Sorell, Victor A. "Articulate Signs of Resistance and Affirmation in Chicano Public Art." In *Chicano Art: Resistance and Affirmation, 1965–1985,* edited by Richard Griswold del Castillo, Teresa McKenna, and Yvonne Yarbro-Bejarano, 141–54. Los Angeles: Wight Art Gallery, University of California, 1991.

Ybarra-Frausto, Tomás. "The Chicano Movement/The Movement of Chicano Art." In *Exhibiting Cultures:*

The Poetics and Politics of Museum Display, edited by Ivan Karp and Steven D. Lavine, 128–50. Washington, DC: Smithsonian Institution Press, 1991.

Film

Through Walls. Wight Art Gallery, University of California, Los Angeles, and UCLA Office of Instructional Development. 1990. 8 minutes.

Oral Histories

Bernal Hopping, Forrest Antonio. Interview by Shifra M. Goldman, November 14, 1987, Montebello, CA. Audio recording. Shifra M. Goldman Papers, CEMA 119. Department of Special Collections, University Libraries, University of California, Santa Barbara.
———. Interview by Charlene Villaseñor Black and Gabriela Rodriguez-Gomez, July 23, 2018, Fresno, CA. Audio recording. UCLA Chicano Studies Research Center.

Archives

El Teatro Campesino Archive, CEMA 5. Department of Special Collections, University Libraries, University of California, Santa Barbara.
El Teatro Campesino Archives. El Teatro Campesino, San Juan Bautista, California.
CARA (Chicano Art: Resistance and Affirmation) Records, Part II. Collection 11. UCLA Chicano Studies Research Center, Los Angeles.
Shifra M. Goldman Papers, CEMA 119. Department of Special Collections, University Libraries, University of California, Santa Barbara.

The CSRC Library

The UCLA Chicano Studies Research Center is a proven and dynamic resource that promotes diverse and inclusive participation across the campus and in the community. It provides a vital point of access to the university through its research, press, library, archive, and programming, and it works in partnership with civic leaders, community-based groups, other public institutions, and international programs.

Today, with Chicana/os and Latina/os constituting the emerging majority in Los Angeles and California, the CSRC's dedication to the development of scholarly research on the Chicana/o-Latina/o population is more important than ever, and the CSRC Library is integral to that mission. Founded in 1969, the library was the first of its kind anywhere. It was established to serve the research needs of students and faculty who did not find adequate resources and subject expertise on the Chicana/o experience in college and university libraries. Chicana/o studies libraries were soon established at a number of other universities in California and the Southwest.

The CSRC Library, now the last freestanding Chicana/o studies library in the United States, continues to serve the needs of students, faculty, and researchers across the globe. The holdings of the library and its archive reflect the rich and diverse heritage of Chicana/os, Mexican Americans and those of Mexican descent, and other US Latina/o communities. The documentation, preservation, and teaching of their stories underscores their value and significance and serves as a source of pride to their communities.

The library provides information resources, reference services, and bibliographic instruction for anyone seeking information on Chicana/o and Latina/o history and culture. It has one of the largest and most important research collections on the Chicana/o and Latina/o experience in the United States, comprising an estimated 469,000 holdings, with over 11,500 books and monographs, 1,885 periodicals, 1,047 reports and similar publications, 1,068 theses and dissertations, and 432,289 digital objects. In addition, the library has more than 1,000 prints and posters and 3,300 audiovisual holdings in various formats.

For over fifty years the CSRC has worked with Chicana/o and Latina/o individuals and organizations who have donated their papers to the CSRC Library. The CSRC houses over 700 archival collections totaling more than 6,000 linear feet of historical material. Archival projects have received grants from institutions such as the National Endowment of the Humanities and the California State Library.

Patrons have online access to an increasing number of the CSRC's image and sound collections, including the historic Arhoolie Foundation's Strachwitz Frontera Collection of Mexican and Mexican American music (digital.library.ucla. edu/frontera).

For more information about donating to the CSRC Library or conducting archival research, contact the CSRC librarian and archivist at (310) 206-6052 or, via email, at librarian@chicano. ucla.edu.

Contributors

CHARLENE VILLASEÑOR BLACK is professor of art history and Chicana/o studies at the University of California, Los Angeles, editor of *Aztlán: A Journal of Chicano Studies*, and founding editor-in-chief of *Latin American and Latinx Visual Culture*. She publishes on a range of topics related to contemporary Latinx art and the early modern Iberian world. Her recent books include, with Mari-Tere Álvarez, *Renaissance Futurities: Art, Science, Invention* (2019); *Chicano Studies Reader* (fourth edition, 2020); and *Autobiography without Apology: The Personal Essay in Latino Studies* (2020). Her 2006 book, *Creating the Cult of St. Joseph: Art and Gender in the Spanish Empire,* won the College Art Association's Millard Meiss award. She has held grants from the Fulbright, Mellon, Borchard, and Woodrow Wilson Foundations, the NEH, the ACLS, the Getty, and the University of California Multicampus Research Programs and Initiatives. In 2016 she was awarded UCLA's Gold Shield Faculty Prize for Academic Excellence.

XAVIERA S. FLORES is the librarian and archivist at the UCLA Chicano Studies Research Center. She has worked in libraries since 2004 and holds an MS LIS with a concentration in archives management and audiovisual preservation. Her work focuses on providing the Chicano-Latino population with greater access and agency over their cultural history and significance. In 2016, Flores stepped in as project director for the La Raza digitization project, supported by the Council on Library and Information Resources and Andrew W. Mellon Foundation. That same year she also stepped in as co-principal investigator on the National

Endowment for the Humanities (NEH) grant "Providing Access to Mexican American Social History in Los Angeles, 1960s and 1970s." Her work has been recognized by the California State Legislature (2018) and the Los Angeles City Historical Society (2019 Archives Education and Advocacy Award), and in 2020 she was named Open Archive Fellow for the Alliance for Media Arts and Cultures. She is currently the co-principal investigator on the NEH grant "Religion, Spirituality, and Faith in Mexican American Social History, 1940s–Present." When not working, Flores dives into back-issue boxes in comic shops across Los Angeles with her partner, cartoonist Jeaux Janovsky. Readers can follow Flores's archival adventures on Instagram at @xaviera.flores.

CHON A. NORIEGA is distinguished professor of film, television, and digital media at the University of California, Los Angeles. His work explores Chicano and Latino arts through their aesthetic, social, and institutional histories. In conjunction with his own research, Noriega has actively archived the works and papers of individual filmmakers and artists, art groups, and community-based arts institutions. He has also curated and co-curated numerous museum exhibitions and film series, including, most recently, *Immersive Distancing: Carmen Argote and Zeynep Abes*. He is a co-founder of the National Association of Latino Independent Producers, and he helped establish the Mellon Undergraduate Curatorial Fellowship Program at six comprehensive art museums in minority-majority cities. From 2002 to 2021, he served as director of the UCLA Chicano Studies Research

Center. Noriega is a Guggenheim Fellow for 2021-22 and is working on a book about Destructivist artist Raphael Montañez Ortiz (b. 1934) that applies the artist's notion of "destructuring the structure" to the study of the artist's life and body of work.

GABRIELA RODRIGUEZ-GOMEZ is a PhD candidate in Chicana/o and Central American studies, with a specialization in the history of murals created during the Chicana/o art movement. She holds a BA in art and the history of art and visual culture from the University of California, Santa Cruz, an MA in art history from the University of California, Riverside, and an MA in Chicana/o studies from the University of California, Los Angeles. Her master's thesis, "Chican@ Time Warp: The Enduring Legacies of Chicano Muralism Displayed in Guillermo "Yermo" Aranda's and Los Toltecas en Aztlán's Mural la Dualidad (The Duality)," was completed in 2019. For her dissertation project, Rodriguez-Gomez is reexamining the history of Chicano muralism and identifying womxn artists and their portable murals as part of the mural movement in the United States and Mexico. She received the Edward A. Dickson Fellowship in the History of Art for 2021-22 and wrote the introduction for *Califas: The Ancestral Journey/El Viaje Ancestral*, edited by Felicia Rice (2020).

MIGUEL SAMANO is a PhD student in the Department of English at UC Berkeley specializing in Chicana/o/x and comparative US multiethnic art and literature since the mid-1960s. He also has interests in literature and linguistic anthropology, affect studies, and non-hermeneutic approaches to reading. Miguel earned a BA in comparative literature, with departmental honors, and Chicana/o-Latina/o studies from Stanford University. His research is supported by a UC Berkeley Mellon–Chancellor's Fellowship.